PN 1995. 9. E98 TUR

THE FILMING OF MODERN LIFE

The Return of the Real: The Avant-Garde at the End of the Century, by Hal Foster

October: The Second Decade, 1986–1996, edited by Rosalind Krauss, Annette Michelson, Yve-Alain Bois, Benjamin H. D. Buchloh, Hal Foster, Denis Hollier, and Silvia Kolbowski

Infinite Regress: Marcel Duchamp 1910–1941, by David Joselit

Caravaggio's Secrets, by Leo Bersani and Ulysse Dutoit

Scenes in a Library: Reading the Photograph in the Book, 1843–1875, by Carol Armstrong

Bachelors, by Rosalind Krauss

Neo-Avantgarde and Culture Industry: Essays on European and American Art from 1955 to 1975, by Benjamin H. D. Buchloh

Suspensions of Perception: Attention, Spectacle, and Modern Culture, by Jonathan Crary

Leave Any Information at the Signal: Writings, Interviews, Bits, Pages, by Ed Ruscha

Guy Debord and the Situationist International: Texts and Documents, edited by Tom McDonough

Random Order: Robert Rauschenberg and the Neo-Avant-Garde, by Branden W. Joseph

Decoys and Disruptions: Selected Writings, 1975–2001, by Martha Rosler

Prosthetic Gods, by Hal Foster

Fantastic Reality: Louise Bourgeois and a Story of Modern Art, by Mignon Nixon

Women Artists at the Millennium, edited by Carol Armstrong and Catherine de Zegher

"The Beautiful Language of My Century": Reinventing the Language of Contestation in Postwar France, 1945–1968, by Tom McDonough

The Artwork Caught by the Tail: Francis Picabia and Dada in Paris, by George Baker

Being Watched: Yvonne Rainer and the 1960s, by Carrie Lambert-Beatty

Robert Ryman: Used Paint, by Suzanne P. Hudson

Hall of Mirrors: Roy Lichtenstein and the Face of Painting in the 1960s, by Graham Bader

Perpetual Inventory, by Rosalind Krauss

The Absence of Work: Marcel Broodthaers 1964–1976, by Rachel Haidu

The Filming of Modern Life: European Avant-Garde Film of the 1920s, by Malcolm Turvey

The Filming of Modern Life

European Avant-Garde Film of the 1920s

Malcolm Turvey

An OCTOBER Book

The MIT Press
Cambridge, Massachusetts
London, England

MIT Press books may be purchased at special quantity discounts for business or sales promotional use. For information, please email special_sales@mitpress.mit.edu or write to Special Sales Department, The MIT Press, 55 Hayward Street, Cambridge, MA 02142.

This book was set in Bembo by Graphic Composition, Inc. Printed and bound in the United States of America.

Library of Congress Cataloging-in-Publication Data

Turvey, Malcolm, 1969–.
The filming of modern life : European avant-garde film of the 1920s / Malcolm Turvey.
 p. cm.—(October books)
"An October book."
Includes bibliographical references and index.
ISBN 978-0-262-01518-9 (hardcover : alk. paper)
1. Experimental films—Europe—History and criticism. 2. Art and motion pictures—Europe.
3. Art and society—Europe—History—20th century. 4. Modernism (Art)—Europe. I. Title.
II. Title: European avant-garde film of the 1920s.
PN1995.9.E96T88 2011
791.43'61109409042—dc22
 2010020908

10 9 8 7 6 5 4 3 2 1

For Lisa

Contents

ACKNOWLEDGMENTS

The idea for this book took root in the first class I taught on avant-garde film, in the communication arts department at the University of Wisconsin, Madison, in the fall of 1999. I thank the graduate students in that seminar, particularly Vincent Bohlinger, Jinhee Choi, Patrick Keating, and Jonathan Walley, for their numerous insights into the avant-garde. The book's thesis was further developed in the pages of *October*, and as will be apparent, it owes as much to art history as it does to film scholarship; I thank my coeditors at the journal, George Baker, Yve-Alain Bois, Benjamin H. D. Buchloh, Leah Dickerman, Hal Foster, Denis Hollier, David Joselit, Rosalind Krauss, Carrie Lambert-Beatty, Annette Michelson, and Mignon Nixon for their companionship. I'm grateful to Roger Conover and Anar Badalov at MIT Press for shepherding the book through production, and to Judith Feldmann for her meticulous editing. A Bogert grant for release time from teaching as well as funds for indexing and images from Sarah Lawrence College helped me complete the manuscript, as did my research assistant, Ava Tews, who checked every quotation and footnote with terrific speed and accuracy. Federico Windhausen, who has seen more avant-garde films than anyone I know, made helpful suggestions in the final stages, and Richard Allen offered encouragement throughout.

I first learned about most of the films discussed in the pages that follow from my beloved teacher and friend Annette Michelson, whose own work on the avant-garde has been seminal. Although I sometimes disagree with her, nobody has written with more brilliance, profundity, and originality about the period I cover, and my enormous debt to her will be obvious. Finally, I must thank *October* once again, for it is through the journal that I was lucky enough to meet my dear wife, Lisa Turvey. Without her support and expert editorial advice, this book could not have been written. I dedicate it to her with all my love and gratitude.

In the 1920s, the cinema was embraced by the European avant-garde, and the result was an outpouring of creativity.[1] Avant-garde filmmakers and artists experimented with the medium in radical ways, often writing film theory and criticism in tandem with their filmmaking. Artists working primarily in other mediums, such as the painters Hans Richter and Fernand Léger, as well as film-makers belonging to avant-garde movements, principally Dada, surrealism, and constructivism, made some of the most enduring and fascinating films in the history of cinema. *Rhythm 21* (Hans Richter, 1921), *Ballet mécanique* (Fernand Léger and Dudley Murphy, 1924), *Entr'acte* (Francis Picabia and René Clair, 1924), *Un chien Andalou* (Salvador Dalí and Luis Buñuel, 1929), *Man with a Movie Camera* (Dziga Vertov, 1929), and other avant-garde films of the period continue to influence artists and filmmakers to this day. They are also still studied and written about, frequently shown in museums, galleries, and art house cinemas, and regularly taught in film and art history classes.

Although much has been written about these films, they tend to be treated separately from each other, perhaps because they appear quite dissimilar. Their formal and stylistic attributes vary greatly, and each was the product of differ-ent, often conflicting, agendas. As I show in the pages that follow, however, they all share a concern with modern life and the sometimes rapid and dislocating

changes it was bringing about. Their makers thought in depth about modernity, and their films are very much the result of this thinking. Each chapter of this book analyzes an exemplary avant-garde film and provides the theoretical and historical context necessary to understand its stance toward modernization; this introduction and the final chapter address major theoretical debates about the avant-garde and its relation to modern life. I place particular emphasis on the writings of the filmmakers themselves and their theories of modernity, which have often been overlooked in previous treatments. Although the views expressed by filmmakers should not be considered conclusive in interpreting their films, their intentions do matter, as philosophers such as Paisley Livingston have shown in criticizing claims about the irrelevance of authorial intentions, and I take these intentions seriously here.[2]

I also challenge the standard story told about the European avant-garde of the early twentieth century to which the cinema made such an important contribution. It has long been assumed that, in spite of its variety, its dispersal across many different, often conflicting individuals and groups, the avant-garde was unified by what the historian Matei Calinescu has called "a radical criticism of the past and a definite commitment to change and the values of the future,"[3] a stance the poet Guillaume Apollinaire identified in 1917 as a "New Spirit which . . . promises to modify the arts and the conduct of life from top to bottom in a universal joyousness."[4] According to Calinescu and others, though the avant-garde's dedication to transformation was shared with much modern art in general, it was more uncompromising and extreme in character: "The avant-garde is in every respect more radical than modernity. Less flexible and less tolerant of nuances, it is naturally more dogmatic. . . . [It] borrows practically all its elements from the modern tradition but at the same time blows them up, exaggerates them."[5] And as Apollinaire's words make clear, this commitment to change was social as well as aesthetic. The avant-garde desired not only to do away with preexisting artistic conventions and traditions but to fundamentally alter "the conduct of life" itself. In the Soviet context, scholar Boris Gasparov has claimed that the urge to transform "not merely the conventions of art and language but . . . life as a whole" was so extreme that the avant-garde

would not bow to any constraint—be it aesthetic traditions, conventions of language and social behavior, or natural laws as established by nineteenth-century "positivist" or "bourgeois" science. Even the most fundamental conditions of biological existence, such as mortality, were not seen as insurmountable for the human spirit, once its creative power had been freed from the limitations of the previous century's "positivist" mentality.[6]

As this remark hints, what the avant-garde desired to change, according to many commentators, was bourgeois modernity. "At some point during the first half of the nineteenth century," writes Calinescu,

> an irreversible split occurred between modernity as a stage in the history of Western civilization—a product of scientific and technological progress, of the industrial revolution, of the sweeping economic and social changes brought about by capitalism—and modernity as an aesthetic concept. Since then, the relations between the two modernities have been irreducibly hostile. . . . The [aesthetic] modernity, the one that was to bring into being the avant-gardes, was from its romantic beginnings inclined toward radical antibourgeois attitudes. It was disgusted with the middle-class scale of values and expressed its disgust through the most diverse means, ranging from rebellion, anarchy, and apocalypticism to aristocratic self-exile. So, more than its positive aspirations (which often have very little in common), what defines cultural modernity is its outright rejection of bourgeois modernity, its consuming negative passion.[7]

Although Calinescu acknowledges that there was "a variety of mutual influences" between the "two modernities,"[8] he ultimately sees them as opposed, and he is by no means alone in this. "The most aggressive outrider of the movement," avers the sociologist Daniel Bell, "is the self-proclaimed *avant-garde* which calls itself Modernism [and which] has been a rage against order, and in particular,

bourgeois orderliness."[9] The philosopher Theodor Adorno conceived of modern art in general and avant-garde movements such as surrealism in particular as dialectically resisting the dominance of the instrumental rationality he saw as definitive of bourgeois modernity since the Enlightenment. And according to the literary scholar Peter Bürger, because avant-gardists purportedly viewed the "dissociation [of art] from the praxis of life" in late-nineteenth-century movements such as aestheticism as "the dominant characteristic of art in bourgeois society," they set out to "attack . . . the status of art" by making it part of life again.[10]

What is it about bourgeois modernity that avant-gardists supposedly wanted to change? Indeed, what is bourgeois modernity? "Modernity" is the subject of much debate, both about what it means and when it began. Dated by historians as beginning anywhere from the Renaissance in the fourteenth century to the industrial revolution in the nineteenth, it is generally agreed that it had arrived in Europe, to varying degrees depending on the country, by the 1920s. As for its meaning, rather than attempt a definition, I will briefly list the most important changes the term commonly refers to: industrial capitalism, urbanization, rapid technological development, globalization, scientific progress and rationalization, secularization, liberalization and individualism, and the rise of mass education and literacy along with mass consumerism and culture. The word "bourgeois," too, has a number of meanings, and historians of the bourgeoisie routinely point to the category's vague, indeterminate boundaries.[11] In the 1888 English edition of the *Manifesto of the Communist Party* (1848), Friedrich Engels stated in a footnote that "by bourgeoisie is meant the class of modern capitalists, owners of the means of social production and employers of wage labor."[12] He was referring primarily to the owners of the factories who employed workers to produce goods for burgeoning domestic and global markets as the industrial revolution replaced agriculture-based feudalism. However, the term was applied much more broadly in the nineteenth century, and it continues to be so used today. At its most general, it refers to those whose income and standard of living places them in the middle classes somewhere between the aristocracy on the one hand and laborers and peasants on the other—in other

words, everyone from Marx and Engels's industrialists as well as the merchants who trade their goods and the bankers who finance their production, to those in the so-called liberal professions such as law, medicine, the church, and education, to landlords, small business owners, and shopkeepers, down to the armies of clerks and sales personnel needed to run businesses and sell their wares. The enormous variety in wealth, attitudes, and lifestyles among those in this pyramid goes some way toward explaining the word's imprecision.

"Bourgeois" is also used, however, to characterize the *values* of the middle classes. This is how the artistic avant-garde typically employed the term, usually derisively, and it is why someone who is middle class, as nearly all European avant-garde artists of the 1920s were, can nevertheless claim, by rejecting these values, not to be bourgeois. Principal among these is a dedication to improving one's material well-being using instrumental reason—to creating wealth and acquiring property through means-ends calculations—and it is this, more than anything else, that the avant-garde is thought to have opposed. "This indictment," writes historian of the bourgeoisie Peter Gay, "amounts to the charge that in their crassness, their mechanical rationality, bourgeois converted all of life into merchandise, all of experience into the cool operations of adding and subtracting."[13] Owing to their calculating, ruthless pursuit of material improvement, the bourgeoisie are also associated with economic and social revolution, the destruction of older forms of production, and the social structures attendant upon them. Marx and Engels said it best in this famous passage from *The Communist Manifesto*:

> Constant revolutionizing of production, uninterrupted disturbance of all social conditions, everlasting uncertainty and agitation distinguish the bourgeois epoch from earlier ones. All fixed, fast frozen relations, with their train of ancient and venerable prejudices and opinions, are swept away, all new-formed ones become antiquated before they can ossify. All that is solid melts into air, all that is holy is profaned.[14]

However, because of what Marx and Engels refer to above as the "everlasting uncertainty and agitation" that results from constantly revolutionizing the means of production, the bourgeoisie are also connected, somewhat paradoxically, to the desire for order, stability, and control, the wish to slow down if not arrest the dislocating pace of change they had unleashed. There emerged among them, Gay argues, an

> elemental urge . . . toward the rationalization of life, away from the comforts of unquestioned belief and the sway of unresisted impulse. The rejection of the direct expression and public gratification of bodily needs, which had begun in the Renaissance with such cultural inventions as the fork and the pocket handkerchief, continued and intensified. The thresholds for feelings of shame and disgust were steadily lowered. Respectable nineteenth-century culture found the imagination a dangerous companion, and instead celebrated delay, modulation, control.[15]

The association of the bourgeoisie with the wish to rationally control the body, mind, and life in general is pervasive among the avant-garde. Hence, they are further connected in the avant-garde imagination with a resistance to social change through an embrace of "conservative" values such as religion, the family, and sexual restraint, as well as with an equally strong resistance to cultural transformation in the form of a rejection of artistic experimentation and novelty, a resistance often dismissed by the avant-garde as philistinism.

Because the bourgeoisie are supposedly concerned only with creating wealth using instrumental reason, they are seen as approaching life with a view to maximizing profit and minimizing loss, thereby denuding everything of value except insofar as it can improve material well-being. "Again and again," remarks the philosopher Charles Taylor, "in a host of different ways, the claim has been made that an instrumental society, one in which, say, a utilitarian value outlook is entrenched in the institutions of a commercial, capitalist, and finally a bureaucratic mode of existence, tends to empty life of its richness, depth, or meaning."[16]

This instrumentalism putatively extends even to other human beings. In criticizing the bourgeois exploitation of wage laborers, Marx and Engels wrote in *The Communist Manifesto* that "the bourgeois sees in his wife a mere instrument of production."[17] Instrumentalism is also said to result in atomization, the breakdown of society into individuals each selfishly and indiscriminately seeking his or her own material improvement, with nothing to connect them to each other but this goal.

Such criticisms of bourgeois modernity are not confined to the European avant-garde of the 1920s; they originate in the Romantic reaction against the Enlightenment and the industrial revolution in the late eighteenth century and are still very much with us today. "*Utility* is the great idol of our age," Friedrich Schiller lamented in his second letter "on the aesthetic education of man" (1795), "to which all powers are in thrall and to which all talent must pay homage,"[18] an argument the art historian T. J. Clark intentionally echoes in his recent definition of modernity:

> Is it not the case that the truly new, and disorienting, character of modernity is its seemingly being driven by merely material, statistical, tendential, "economic" considerations? We know we are living a new form of life, in which all previous notions of belief and sociability have been scrambled. And the true terror of this new order has to do with its being ruled—and obscurely felt to be ruled—by sheer concatenation of profit and loss, bids and bargains: that is, by a system without any focusing purpose to it, or any compelling image or ritualization of that purpose.[19]

Yet, as Taylor is concerned to point out in his retrieval of the moral sources of modern identity, utilitarianism, instrumental rationality, and materialism have for many held great value and meaning. Not only is instrumental reason—the capacity to reflect on and decide for oneself what will make one happy and to determine how to get it—associated with values such as freedom from authority, self-responsibility, control, and therefore dignity, but so is the ability to provide

materially for oneself and one's family without the help of others. Furthermore, allowing individuals the freedom to pursue their own material wants is widely seen as a civilizing force, one that makes peace more likely by uniting people in a shared self-interest in material well-being and a common desire to avoid anything that will interrupt it, such as war. And it is the unleashing by industrial capitalism of the productive power of individuals in their pursuit of their own well-being that promises to lift, and indeed for many has lifted, people en masse out of degrading poverty and cushion them from the ravages of nature that so afflicted premodern existence, something that even Clark is forced to acknowledge.[20] Taylor refers to this set of values as "the affirmation of ordinary life":

> This "bourgeois" ethic has obvious leveling consequences, and no one can be blind to the tremendous role it has played in constituting modern liberal society, through the founding revolutions of the eighteenth century and beyond, with their ideals of equality, their sense of universal right, their work ethic, and their exaltation of sexual love and the family. What I have been calling the affirmation of ordinary life is another massive feature of the modern identity, and not only in its "bourgeois" form: the main strands of revolutionary thought have also exalted man as producer, one who finds his highest dignity in labor and the transformation of nature in the service of life. The Marxist theory is the best known but not the only case in point.[21]

Taylor further points out that these values are so pervasive and foundational in modern life that even those who oppose them share them to some extent, however much they may overlook them, as artists and intellectuals in the Romantic-Marxist tradition such as Clark tend to. As for the related conception of the bourgeoisie as ruthlessly mercantile so popular among avant-garde artists, even the philosopher Friedrich Nietzsche, himself no stranger to caricatures, recognized this to be an exaggerated distortion of some aspects of bourgeois life.[22]

But however hypocritical and inaccurate, it was this critique of bourgeois modernity, according to the standard story, that motivated the avant-garde's desire for radical social and artistic change. Avant-garde artists thus tended to eschew realism in their artistic practice. Rather than an imitator of life as it is, the European avant-gardist of the 1920s was either a "constructionist," offering an "intimation of what can be," as surrealist André Breton put it; or one literally attempting to participate in the construction of a new society on a practical level when conditions allowed, as the Soviet constructivists aimed to do; or a "destructionist," typified by the nihilist wing of Dada, which was supposedly dedicated to destroying bourgeois modernity.[23] Furthermore, argues the standard version, it was the avant-garde's uncompromising commitment to both aesthetic and social revolution that set it apart from other artistic trends and movements of the period, including the movements of the 1930s (such as socialist realism) that were to varying degrees enforced by the totalitarian governments of Italy, Germany, the Soviet Union, and later France. Unlike the avant-garde, these rejected aesthetic transformation by perpetuating the older aesthetic conventions and traditions of realism and classicism. And again unlike the avant-garde, they were much more likely to reject social change by advancing "reactionary" political and ideological positions.

In this book, I challenge this standard story. The view of the avant-garde as implacably opposed to bourgeois modernity is belied by the fact that, as we shall see, avant-garde artists disagreed, often vehemently, about what aspects of modern life needed transformation and how such transformation should be accomplished. This disagreement is very much part of the broader conflict about the utilitarian, rationalistic, materialist outlook associated with modernization at least since the late eighteenth century. Far from opposing forces such as industrial development, technological progress, and instrumental rationality, some avant-garde movements, such as futurism and constructivism, viewed these forces positively and argued that society should be altered by their acceleration. Others, including Dadaists and surrealists, certainly tended to evaluate such forces negatively, and believed that society should be transformed by subverting

and rejecting them and finding alternatives. But the point is that the avant-garde did not simply oppose bourgeois modernity; its response was more varied than that.

Furthermore, as recent revisionist scholarship in art history and elsewhere has shown, not only was there considerable disagreement between avant-garde movements, the positions of individual avant-garde artists were themselves complex. For example, careful empirical research by art historians has revealed that the avant-garde's commitment to artistic transformation and its aesthetic differences from the realism and classicism of contemporary artistic trends and movements were not nearly as extreme as the standard version assumes and the avant-garde's own rhetoric suggests. As we shall see in chapter 2, scholars such as Kenneth Silver and Christopher Green have demonstrated how the French avant-garde was gripped by a so-called call to order after World War I that manifested itself in a variety of self-conscious attempts by avant-gardists to ground their artistic practice in classical traditions of the past.[24]

Others have questioned the assumption that it was its uncompromising commitment to social change that set the avant-garde apart from other artistic trends and movements of the period. The work of art historian Romy Golan on the post–World War I French avant-garde and its relationship to the "reactionary" pastoralism of French middlebrow art is a good example. Golan has argued that, far from being marginal political and ideological positions that became dominant only in the 1930s, pastoralist themes such as "the disenchantment with technology, . . . the turn to the rural and, in more general terms, to the organic became ever more pervasive in French art" of the 1920s. "Instead of the *tabula rasa* predicated by high modernism," Golan argues that the 1920s were dominated by

> a collective ethos driven toward the restoration of what had been *before* [World War I]: a world stilled, and a vision infused . . . by nostalgia and memory. . . . [O]rganic retrenchment deeply affected all of the major modernists working in France. By the late 1920s, even hardliners like Fernand Léger, Le Corbusier, and Amédée Ozenfant

would shift towards organicism, distancing themselves from the unconditional embrace . . . of the machine aesthetic that had previously informed their work.[25]

As the 1920s progressed, according to Golan, French avant-gardists such as Léger, Ozenfant, and Le Corbusier compromised their commitment to the radical social transformation envisaged by their "machine aesthetic" by incorporating "reactionary" political and ideological positions into their artistic practice, especially pastoralism and the cultural and political discourse surrounding it.

Whether or not one agrees with the specific conclusions of these scholars, the general picture of the avant-garde that emerges from their work is of a much more complicated, even contradictory phenomenon than the standard version and the avant-garde's own rhetoric—both of which suggest that the avant-garde's commitment to aesthetic and social transformation was extreme and uncompromising—acknowledge. As Dada scholar Richard Sheppard has put it, "critics are increasingly seeing that both modernism as a whole and individual modernist movements, *oeuvres*, and works involve profound inner contradictions and conflicts."[26] Or as historians of Russian art and literature John Bowlt and Olga Matich have suggested, the avant-garde was a "multifarious phenomenon . . . represent[ing] the most contrary philosophical positions: mechanistic and organic, mathematical and lyrical, primordial, classical, and modern."[27]

This revisionist view of the avant-garde has not emerged in film studies to the extent it has elsewhere. A recent book on avant-garde film of the 1920s and 1930s, for example, continues to claim that "the avant-garde rebelled against prior historical styles, against the traditional networks and institutions of the art system; it attempted to do away with everything that came before it in one *tabula rasa*–gesture."[28] But as I show in the pages that follow, it was rarely the case that any European avant-garde filmmaker's rejection of the past was so unequivocal. Christopher Green's conclusion about French art in the first four decades of the twentieth century also holds true for European avant-garde filmmaking of the 1920s: "To speak of or to represent things considered utterly modern did not mean that the pre-modern, the anti-modern or the traditional

were necessarily set aside or even marginalized. Aviation and fossils, the Eiffel Tower and the Three Graces, modern thinking and the 'epoch of the Greeks' could all come together within the mentalities that produced 'modern' images between 1900 and 1940."[29] Nor is this insight about the complex interplay between change and stasis in art that addresses the transformations in modern life a new one, even though it has been ignored by standard-version historians. In his seminal essay "The Painter of Modern Life," published in 1863 just as modernist and avant-garde art was beginning to emerge in Europe, Charles Baudelaire essentially made the same point: "By 'modernity' I mean the ephemeral, the fugitive, the contingent, the half of art whose other half is the eternal and the immutable."[30] Thus, although it is undoubtedly true that aesthetic and social change was a major preoccupation of the European avant-garde of this period, it inspired in avant-garde filmmakers fear as well as awe, anxiety as well as Apollinaire's "joyousness"—and European avant-garde films were often just as much an imaginative "cure" or "antidote" for sweeping change as an embrace of it. Indeed, we will often find avant-garde filmmakers trying to reconcile change with stasis, the future with the past, and bourgeois modernity with its critics. T. J. Clark says it best when he writes of modernism in general as being "caught interminably between horror and elation at the forces [of change] driving it."[31]

Why was the avant-garde's relationship to bourgeois modernity and social and aesthetic change so complex? One reason, I suspect, is that in spite of the invective that avant-garde artists routinely, even predictably, rained down on the bourgeoisie and their attitudes, the avant-garde was nevertheless a fundamentally bourgeois phenomenon acting out the contradictions of middle class existence. In other words, rather than attacking the bourgeoisie from the outside, its assault was an expression of a "conflict that arose at its very heart."[32] This is how the historian Jerrold Seigel characterizes bohemia in his study of bohemian Paris in the nineteenth and early twentieth centuries. He shows that artists and bohemians often shared the same desire for personal success and material affluence as the bourgeoisie they so despised, and they courted their recognition and depended on their patronage—and could be highly self-disciplined and instrumentally minded in doing so. They could behave in such a contradictory fashion because,

in being free to develop experimental styles and forms of art as well as cultivate new lifestyles, they benefited from the individual freedom and in many cases the material well-being enabled by bourgeois modernity even while they were critical of, and tried to compensate for, its costs. As Seigel puts it, "this was often an opposition from within; the energy modernists drew on to mount their attacks flowed at least as much from the ground they, sometimes unconsciously, shared with other members of society, as it did from their ability to inhabit different regions."[33] Seigel's account also explains why the bourgeoisie have always proved remarkably receptive to avant-garde art to the point of patronizing it and enshrining it in museums and other institutions, even though it attacks them. Just as the avant-garde benefits from bourgeois modernity even while criticizing many of its consequences, so the bourgeoisie can agree with and even embrace these criticisms even as they continue to work to advance modernization with all of its consequences. The members of both, to varying degrees, experience the conflict at the heart of bourgeois modernity—between a desire for the personal freedom and material well-being it brings about and a disgust at some of its consequences.

In failing to recognize the complexity of the avant-garde's relationship to modernization and change, the standard version also overlooks the complexity of modernity itself, which brings us to the second reason for the avant-garde's complicated attitudes and behavior. As the political scientist Marshall Berman in particular has argued, modernity itself is experienced as fundamentally contradictory. Seizing on Marx and Engels's dictum from *The Communist Manifesto* that in "constantly revolutionizing the instruments of production, and thereby the relations of production, and with them the whole relations of society," the bourgeoisie causes "all that is solid" to melt "into air," he suggests that

> To be modern is to live a life of paradox and contradiction. . . . It is
> to be both revolutionary and conservative: alive to new possibilities
> for experience and adventure, frightened by the nihilistic depths to
> which so many modern adventures lead, longing to create and to
> hold on to something real even as everything melts. We might even

13

say that to be fully modern is to be anti-modern: from Marx's and Dostoevsky's time to our own, it has been impossible to grasp and embrace the modern world's potentialities without loathing and fighting against some of its most palpable realities.[34]

Berman has in mind the way in which the forces of change at work in modernity are experienced as simultaneously libratory and oppressive. Industrial capitalism and globalization, for example, continue to lift millions out of degrading rural poverty, as we are currently witnessing in China and to a lesser extent in India and elsewhere in Asia, yet they create instability and at the same time have failed to eradicate inequality, as is particularly evident whenever a recession takes hold.[35] Without bureaucracies, social services that are so vital to personal development and freedom, such as health care and education, could not be delivered en masse to modern populations; yet bureaucracies are widely detested for the power they wield and their dehumanizing, instrumental character. City life can give rise to new forms of community yet can also be deeply alienating and lonely. And even as modernity frees individuals from the oppressive hierarchies of the feudal era, in which identity was predetermined by the family one was born into and the authority of the church and the nobility was unquestioned and ruthlessly enforced, it also creates the desire for the stability and order lost with the dissolution of these traditions, and the nihilistic fear that, with the disappearance of the certitudes of religion and other premodern forms of belief, there are no longer any certain values or truths.

For Berman, the modernists of the nineteenth century, among whom he includes philosophers such as Marx and Nietzsche as well as artists, were particularly alive to these contradictions: "They can illuminate the contradictory forces and needs that inspire and torment us: our desire to be rooted in a stable and coherent personal and social past, and our insatiable desire for growth—not merely for economic growth but for growth in experience, in pleasure, in knowledge, in sensibility—growth that destroys both the physical and social landscapes of our past, and our emotional links with those lost worlds."[36] However, their "twentieth-century successors have lurched far more toward rigid polarities and

flat totalizations," Berman claims. "Modernity is either embraced with a blind and uncritical enthusiasm, or else condemned with a neo-Olympian remoteness and contempt," he continues, citing avant-garde movements such as futurism as examples.[37] Although Berman is perhaps right about the avant-garde since World War II, he is wrong with regard to European avant-garde artists and film-makers of the 1920s, who were rarely if ever either anti- or promodernization. Rather, like their nineteenth-century predecessors, they welcomed some aspects of modernity while criticizing others, and their work typically incorporated modern and antimodern elements simultaneously.

Most historians distinguish five trends within European avant-garde film, which flowered in the 1920s before being curtailed, to some extent, by the coming of sound around 1929 and the political turmoil and repression of the 1930s: the abstract animation of nonrepresentational shapes and colors; "cinema pur," or pure cinema, which foregrounds the plastic properties that a variety of concrete things have in common, such as shape and texture; Dada film; experimental narrative films, especially of the surrealist variety; and innovative documentaries about cities, often referred to as city symphonies.[38] In order to reveal the complexity of the cinematic avant-garde's relation to changes in modern life, I analyze five canonical films in this book, each of which exemplifies one or more of these trends: *Rhythm 21*, an example of both abstract and Dada film (chapter 1); *Ballet mécanique*, a cinema pur film (chapter 2); *Entr'acte*, a Dada film (chapter 3); the surrealist film *Un chien Andalou* (chapter 4); and *Man with a Movie Camera*, a city symphony (chapter 5). Much has been written about these films, especially their formal and stylistic innovations. As a result of the hold of the standard version, however, their complicated stance toward modernization has tended to be overlooked, and consequently their aesthetic features are often misinterpreted. By carefully examining these features, as well as the intentions of their makers and the historical contexts in which they were made, I demonstrate that all five films, in different ways, both embrace and resist specific, concrete transformations in modernity, sometimes simultaneously.

In so doing, I largely eschew an argument that is often found in scholarship on cinema and modernity in film studies and other disciplines. This is the

so-called modernity thesis, which originates in the writings of Siegfried Kra-
cauer and Walter Benjamin in the 1920s and 1930s. It claims that the cinema
is linked to modernity by virtue of the "distracted" perceptual experience it
creates for viewers, which replicates the perceptual experience of the modern
world. There are many problems with the modernity thesis, some of which have
been pointed to by film scholar David Bordwell, among others, and in chap-
ter 6 I offer my own criticisms. I do so not only because I think the moder-
nity thesis is wrong, but because it attributes avant-garde characteristics to the
cinema as a whole, thereby minimizing the radical aesthetic distinctiveness of
avant-garde film. While I reject the standard view of the avant-garde as dedi-
cated unequivocally to social and aesthetic change, I remain convinced that
European avant-garde films of the 1920s were radical on an aesthetic level,
pursuing forms and styles largely unavailable in mainstream filmmaking. It is
this aesthetic sense of the avant-garde that I wish to insist upon in criticizing
the modernity thesis.

Abstraction and *Rhythm 21*

Abstract filmmaking first emerged around 1912, when painters pursuing abstract styles became interested in film owing, as film scholar Standish Lawder puts it, to "its kinetic dynamism, the very fact that film was a *moving* picture."[1] Cubism has often been credited with introducing the impression of motion into painting by depicting subjects from multiple perspectives, and it was a cubist painter, Léopold Survage, who was one of the first to plan an abstract film, which he called *Colored Rhythm*. The film was never made owing to the outbreak of World War I, but a number of drawings for the film survive that indicate, along with Survage's writings, that the analogy with music that recurs throughout the discourse on abstract art was crucial to the project's conception: "It is the mode of succession in time which establishes the analogy between sound rhythm in music and colored rhythm—the fulfillment of which I advocate by cinematographic means."[2] Meanwhile, a year before Survage, two brothers in Italy, Arnaldo Ginna and Bruno Corra, who were also interested in visual music, had succeeded in making a number of abstract color films by painting directly onto celluloid.[3] Ginna and Corra belonged to the futurist movement, whose painters depicted kinetic modern subjects such as trains and urban crowds, rather than the traditional static subjects of cubism, in order to make their viewers experience the strong sensations and violent emotions they associated with the dynamism and destruction of modern

life. Of particular concern was imparting to the canvas the physical sensation of movement, and Ginna and Corra apparently used their films to create an abstract "chromatic music" of colors in motion. Unfortunately none survive, and probably because of the war as well as technical and financial constraints, no other abstract films were made during the 1910s.

The first extant European abstract films were made in the early 1920s by several avant-garde painters. One was Hans Richter, who made three abstract animated films: *Rhythm 21* (1921) (originally called *Film ist Rhythmus* [Film is Rhythm]), *Rhythm 23* (1923), and *Rhythm 25* (1924).[4] In general, Richter's art is known for synthesizing different, seemingly mutually exclusive avant-garde ideas and movements, and there is an important reason for this synthetic approach that has to do with Richter's theory of modernity. To elucidate this theory and show how it informed his abstract filmmaking, we must first consider Richter's association with Dada. This began when, having been wounded in the war, he moved in the late summer of September 1916 to Zurich, where the movement had officially been launched earlier that year, to take advantage of its neutrality and avoid being remobilized.

Dada will be examined in more detail in chapter 3, but for now suffice it to say that the image of Dada that has tended to predominate since its inception is of an anarchistic avant-garde movement reacting to the horrors of World War I through a destructive assault on art in the name of a nihilistic critique of modernity. As Dada scholar John Erickson has put it, "Despite its varied origin, centers of artistic activity, and personalities, Dada has usually been classified bag and baggage under the rubric of artistic, or antiartistic, anarchy, which is generally taken to mean unswerving dedication to nihilism and disorder."[5] Certainly, if one accepts Dada's public rhetoric at face value and confines Dada to the likes of Tristan Tzara and Francis Picabia, whose ideas will also be considered in chapter 3, such a conclusion might be justified. Yet, if we read the retrospective histories of the movement penned by other participants, it is striking how frequently this image of Dada as nihilistic and merely destructive is resisted. Time and again we find former Dadaists insisting that Dada was also *constructive*, that it aimed not merely to destroy but to create something new, lasting, and valuable, despite the

public rhetoric of the movement. As ex-Dadaist Georges Ribemont-Dessaignes argued in 1931: "Man is unable to destroy without constructing something other than what he is destroying. Consequently, though Dada had the will and the need to destroy every form of art subject to dogma, it felt a parallel need of expressing itself. It was necessary to replace submission to reality by the creation of a *superior reality*."[6]

One form that this creative strain in Dada took was the search for a spiritually satisfying, even mystical alternative to modernity by Dadaists such as Hans Arp and Hugo Ball. Ball, one of the founders of Zurich Dada, was a poet who performed sound poems at the Cabaret Voltaire as the movement was coalescing in 1916. By eschewing conventional words and grammar, he sought in these poems not only to destroy language—which Ball felt had been corrupted and debased by the materialism and utilitarianism of modern life—but to create a "wholeness of body and mind" through the use of rhythm, repeated syllables and consonants, and other linguistic features.[7] "Ball attributes supernatural status to words and sounds," writes Ball expert Erdmute White, "summoning faith that springs from ecclesiastic and shamanistic utterance."[8]

In his own retrospective writings on the movement, Richter constantly exhorts his readers to look "deeper than the wild anti-art propaganda of the movement's published statements" and see that Dada was, in truth, "a tireless quest for an anti-art, a new way of thinking, feeling and knowing. New art in a new-found freedom!"[9] He believed the abstract films he made in the early 1920s to be Dadaist, even though they do not conform to the nihilistic image of the movement exemplified, arguably, by works such as René Clair and Francis Picabia's film *Entr'acte* (1924), which is considered by most commentators to be the quintessential Dadaist film. (In chapter 3 I will argue that *Entr'acte* is not purely nihilistic, but certainly it is the film most often privileged in commentaries on Dadaist cinema.) When compared to *Entr'acte*, the *Rhythm* films appear very different. They are purely abstract, employing geometrical figures in motion organized into patterns, and such a patterned style of abstraction is usually identified not with Dada and its anarchistic techniques, but rather with movements such as de stijl. Furthermore, Richter conceived of his abstract work as a search

for a "universal language," an ideal hardly in keeping with Dada's reputation for destruction.[10] Yet, Richter insisted that "The nucleus of the artistic endeavor of Dada as it appeared in Zurich 1916/19 was abstract art," and that his abstract films, in their patterned use of geometrical forms to search for a universal language, were Dadaist.[11]

By clarifying Richter's definition of Dada, we can see why he believed his *Rhythm* films and other abstract works to be Dadaist. More than this, though, Richter's art demonstrates that there were different types of critiques of modernity within Dada, not just the nihilistic assault on bourgeois society associated with Tzara and Picabia; or the search for a mystical, spiritually satisfying alternative to modern life by Ball. It shows that a more nuanced, complex position in relation to modernity was adopted by avant-garde artists even in the direct aftermath of a catastrophic world war; that they could reject some aspects of the modern world while accepting, even celebrating others; that they did not necessarily condemn modernity in extreme, uncompromising terms by damning it as a "hell," or by searching for an alternative "heaven," to use words Richter borrowed from Arp.

In his first years as an avant-garde painter (1912–1916), Richter was influenced by both cubism and expressionism, and his work evinced a particular concern with rhythm. The surfaces of his paintings and drawings of this period tend to be broken up into planes that alternate between different shades of black and white, thereby creating a rhythmic effect as the eye traverses them. By 1917, however, after he had moved to Zurich and come under the influence of the burgeoning Dada movement there, he was painting what he called "visionary portraits" (fig. 1.1) in a more expressionist style. These colorful, semi-abstract and abstract paintings were made using a relatively spontaneous, free-associative method designed to incorporate a degree of chance into the painting process.

> For my own part, I remember that I developed a preference for painting my ["visionary portraits"] in the twilight, when the colors on my palette were almost indistinguishable. However, as every color

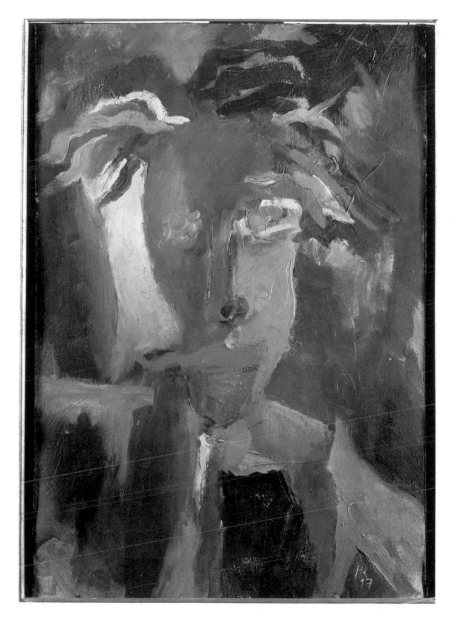

Figure 1.1 Hans Richter, *Visionary Self-Portrait*, 1917. Oil on canvas, 53 × 38 cm (20 7/8"
× 14 15/16"). Musée National d'Art Moderne, Centre Georges Pompidou. Photograph ©
CNAC/MNAM/Dist. Réunion des Musées Nationaux/Art Resource, New York. © Rich-
ter Estate.

had its own position on the palette my hand could find the color it
wanted even in the dark. And it got darker and darker . . . until the
spots of color were going on to the canvas in a sort of auto-hypnotic
trance, just as they presented themselves to my groping hand. Thus
the picture took shape before the inner rather than the outer eye.
(*Dada Art*, p. 55)

At this point in his involvement with Dada, this method of painting seemed
to Richter to be quintessentially Dadaist because it allowed for the "absolute
freedom from preconceptions . . . [from] aesthetic or social constraints . . . from
preconceived ideas about processes and techniques" that he identified, at this
moment, as the essence of Dada (pp. 34, 57). "Chance appeared to us as a
magical procedure by which one could transcend the barriers of causality and of
conscious volition, and by which the inner eye and ear became more acute. . . .
In 1917 I could produce nearly a hundred of my so-called 'visionary portraits,'
three or four a day, provoking the disgust of the critics visiting the Galerie Wolfs-
berg in Zurich in 1918."[12]

However, sometime around late 1917, Richter became dissatisfied with
this way of painting and its results. He began to search once again for a more
structured form of abstraction through which a rhythmical effect could be cre-
ated across the surfaces of his pictures: "The completely spontaneous, almost
automatic process by which I painted my 'visionary portraits' no longer satis-
fied me. I turned my attention to the structural problems of my earlier Cubist
period, in order to articulate the surface of my canvases" (*Dada Art*, p. 61). Thus
began a period of more structured abstraction that resulted in a series of "Dada
heads," scrolls, and the *Rhythm* films conceived in collaboration with the Swedish
painter Viking Eggeling, and, following the dissolution of Zurich Dada in 1919,
Richter's involvement with de stijl, international constructivism, and editing the
journal *G*.[13] Yet, rather than seeing this period as a break with Dada, Richter saw
it as fundamentally continuous. For him, his more structured abstract work was
just as much Dadaist as the nonabstract work of other Dadaists.

It is . . . no accident that the first abstract films were made by two members of the original Dada group, Eggeling and myself. And they certainly did not demonstrate the officially acknowledged spirit of Dada: the *Mona Lisa* with a moustache, the toilet-seat or the nail flatiron. . . . But they grew nevertheless straight from the art-, and -nothing-but-art problems which had drawn us into them. . . .

After I have stated this fact: Dada = abstract art, I happily wish to insist on the other point: Dada = non-abstract art.[14]

Why, therefore, did Richter believe his abstract films to be Dadaist?

To answer this question, we must first clarify Richter's definition of Dada. As the above remark about the equal place of abstraction and nonabstraction in Dada suggests, Richter rejected any essentialist or family resemblance definition of Dada. Dada, he argued, could not be defined by any intrinsic properties common to all Dada (anti-)art works, or overlapping properties common to some. Hence his formal inclusiveness—he allows both abstraction and nonabstraction to be Dadaist.[15] Instead, Richter's definition, as we shall see, is a functionalist one. Dada (anti-)art is defined by the function it performs, not by any intrinsic properties that perform this function.

As with other Dadaists, Richter's definition of the movement is a corollary of his critique of modernity. In this critique, Richter tends to identify rationality as being primarily responsible for the ills of modern life such as the First World War.

Pandemonium, destruction, anarchy, anti-everything—why should we hold it in check? What of the pandemonium, destruction, anarchy, anti-everything, of the World War? How could Dada have been anything but destructive, aggressive, insolent, on principle and with gusto? In return for freely exposing ourselves to ridicule every day, we surely had a right to call the bourgeois a bulging haybag and the public a stall of oxen? We no longer contented ourselves with

reforming pictorial art or versification. We would have nothing
more to do with the sort of human or inhuman being who used
reason as a juggernaut, crushing acres of corpses—as well as our-
selves—beneath its wheels. We wanted to bring forward a new kind
of human being, one whose contemporaries we could wish to be,
free from the tyranny of rationality, of banality, of generals, father-
lands, nations, art-dealers, microbes, residence permits and the past.
(*Dada Art*, p. 65)

Yet when he elaborates on what, precisely, he thinks is wrong with rationality,
it is not rationality per se that he criticizes. Rather, it is the putative *dominance*
of rationality in modernity to the exclusion of what lies outside of rationality,
which he refers to by different names such as "unreason," "the unconscious,"
"chance," "spontaneity," and "contingence."

Our scientific and technological age had forgotten that this con-
tingence constituted an essential principle of life and of experi-
ence, and that reason with all its consequences was inseparable from
*un*reason with all its consequences. The myth that everything in the
world can be rationally explained had been gaining ground since the
time of Descartes. An inversion was necessary to restore the balance.
(*Dada Art*, p. 64)

Again like other Dadaists, Richter defines Dada as a response to, and even a cure
for, the problems of modernity. However, because he identifies the fundamental
problem of modern life as being an imbalance between reason and unreason, he
does not conceive of Dada as a critique of rationality, or as an attempt to find
an alternative to rationality, as, arguably, do other Dadaists such as Tzara, Picabia,
and Ball. Rather, he conceives of it as a critique of the *dominance* of rational-
ity through an attempt to restore the putatively lost balance between reason
and unreason: "The realization that reason and anti-reason, sense and nonsense,

design and chance, consciousness and unconsciousness, belong together as necessary parts of a whole—this was the central message of Dada" (*Dada Art*, p. 64).

Behind this argument is a metaphysical conception of both reality and human nature. Human beings, Richter suggests, are a mixture of opposing characteristics: reason and unreason, conscious and unconscious, civilized and primitive, thought and feeling. Being authentically human, he argues, consists of achieving not a synthesis, but a "balance" between these "opposites":

> We [Dadaists] were forced to look for something which would re-establish our humanity. What we needed to find was a "balance between heaven and hell," a new unity combining chance and design.
>
> We had adopted chance, the voice of the unconscious—the soul, if you like—as a protest against the rigidity of straight-line thinking. We were ready to embrace, or be embraced by, the unconscious. All this . . . developed as a necessary complement to the apparent and familiar side of our natures and of our conscious actions, and paved the way for a new unity which sprang from the tension between opposites. . . .
>
> Proclaim as we might our liberation from causality and our dedication to anti-art, we could not help involving our *whole* selves, including our conscious sense of order, in the creative process, so that, in spite of all our anti-art polemics, we produced works of art. Chance could never be liberated from the presence of the conscious artist. This was the reality in which we worked . . . a situation of conflict.
>
> This conflict is in itself an important characteristic of Dada. It did not take the form of a contradiction. One aspect did not cancel out the other; they were complementary. It was in the interplay of opposites, whether ideas or people, that the essence of Dada consisted. (*Dada Art*, pp. 58–59)

Thus, although Dadaist (anti-)art created through relatively spontaneous methods, such as the "visionary portraits" of 1917, might have sufficed for a time, ultimately it proved unsatisfactory for Richter. If the goal of Dada was to restore the balance between reason and unreason lost in modernity owing to the dominance of rationality, then (anti-)art that simply replaced reason with unreason, the conscious mind with the unconscious, order with disorder, or intentionality with spontaneity, was insufficient. Rather, what was needed was a type of (anti-)art that could effect a balance between reason and unreason. And it was precisely this lack of balance that was, for Richter, the problem with the work of putative nihilists such as Tzara and Picabia and that ultimately led to the disintegration of Zurich Dada. Such nihilists make the same mistake as their antagonists, according to Richter, by simply replacing one type of dogmatic disequilibrium, the dominance of reason, with another, the reign of unreason, instead of attempting to bring about a balance between the two.

> Tzara exploited the same chance factors as did Arp, but while Arp made conscious use of his eye and brain to determine the final shape, and thus made it possible to call the work his, Tzara left the task of selection to Nature. He refused the conscious self any part in the process. Here the two paths Dada was to follow are already apparent.
>
> Arp adhered to (and never abandoned) the idea of "balance" between conscious and unconscious. This was fundamental to me as well; but Tzara attributed important exclusively to the Unknown. This was the real dividing-line. Dada throve on the resulting tension between premeditation and spontaneity, or, as we preferred to put it—between art *and* anti-art, volition *and* non-volition, and so on. This found expression in many ways and was apparent in all our discussions. (*Dada Art*, p. 60)

In advancing this argument, Richter is rejecting one type of modernity critique available in the German tradition in favor of another. Instead of the

nihilistic critique of rationality often associated with Nietzsche and Dada, in which reason is rejected as an illusion employed in the service of self-interested, primitive drives such as the will to power, Richter is allying himself with a different critique of rationality that probably receives its most famous expression in the German tradition in Friedrich Schiller's *On the Aesthetic Education of Man* (1795).

Schiller, writing at the beginning of the period of Romantic counter-reaction to the Enlightenment, felt that art was increasingly at risk of becoming irrelevant in the modern age. He explained: "at the present time material needs reign supreme and bend a degraded humanity beneath their tyrannical yoke."[16] Thus: "Weighed in this crude balance, the insubstantial merits of Art scarce tip the scale, and, bereft of all encouragement, she shuns the noisy market-place of our century."[17] Nevertheless, for Schiller, art and aesthetic education still had a crucial role to play in the modern era, and it was his purpose in *On the Aesthetic Education of Man* to elucidate this role.

According to Schiller, while modernity was making considerable progress in the realm of science and had in many ways attained a higher state of civilization than previous civilizations, it nevertheless had done so at great cost, namely, the "fragmentary specialization of human powers" from which humans "suffer" terribly:[18]

> Once the increase of empirical knowledge, and more exact modes of thought, made sharper divisions between the sciences inevitable, and once the increasingly complex machinery of State necessitated a more rigorous separation of ranks and occupations, then the inner unity of human nature was severed too, and a disastrous conflict set its harmonious powers at variance. The intuitive and the speculative understanding now withdrew in hostility to take up positions in their respective fields, whose frontiers they now began to guard with jealous mistrust; and with this confining of our activity to a particular sphere we have given ourselves a master within, who not infrequently ends by suppressing the rest of our potentialities. While

in the one a riotous imagination ravages the hard-won fruits of the intellect, in another the spirit of abstraction stifles the fire at which the heart should have warmed itself and the imagination been kindled. . . . Everlastingly chained to a single little fragment of the Whole, man himself develops into nothing but a fragment . . . he never develops the harmony of his being.[19]

Because of the specialization imposed on humans by the increasingly rationalized state, rather than a balance between different faculties in each individual human being, one faculty tends to dominate, with disastrous results for the individual and society:

In its striving after inalienable possessions in the realm of ideas, the spirit of speculation could do no other than become a stranger to the world of sense, and lose sight of matter for the sake of form. The practical spirit, by contrast, enclosed within a monotonous sphere of material objects, and within this uniformity still further confined by formulas, was bound to find the idea of an unconditioned Whole receding from sight, and to become just as impoverished as its own poor sphere of activity. . . . We know that the sensibility of the psyche depends for its intensity upon the liveliness, for its scope upon the richness, of the imagination. The preponderance of the analytical faculty must, however, of necessity, deprive the imagination of its energy and warmth, while a more restricted sphere of objects must reduce its wealth. Hence the abstract thinker very often has a cold heart, since he dissects his impressions, and impressions can remove the soul only as long as they remain whole; while the man of practical affairs often has a narrow heart, since his imagination, imprisoned within the unvarying confines of his own calling, is incapable of extending itself to appreciate other ways of seeing and knowing.[20]

What is needed in modernity, argues Schiller, is an "instrument" that can restore the balance or harmony between the different faculties or "drives" basic to humankind but lost in modernity. And that instrument, he declares, "is Fine Art."[21]

Of course, Richter's critique of modernity does not correspond exactly to Schiller's. But he does employ the same basic concepts and arguments in relation to modernization as Schiller, thereby differentiating his critique from the nihilistic one associated with Nietzsche, and indeed from others such as Marx's dialectical critique. Like Schiller, he equates authentic humanity with the "balance" of different human faculties and drives ("wholeness"), and he associates modernity with the loss of this balance as a result of rationalization. And this critique provides him with a functionalist definition of Dada that relates closely to Schiller's argument about the role of art in the modern world. For Richter, Dadaist (anti-)art is defined by its function, which is to counter the dominance of rationality in modernity by restoring the lost harmony between reason and unreason in both human beings and society, thereby creating "whole" human beings and societies again. In late 1917, Richter is searching for a type of (anti-)art that will fulfill his definition of Dada by effecting just such a balance between reason and unreason, conscious and unconscious, order and disorder. What he comes up with is the form of more structured abstraction that includes his *Rhythm* films in their quest for a universal language.

Now that we have a grasp of Richter's functionalist definition of Dada as well as the critique of modernity and metaphysical vision of reality informing it, we can turn to *Rhythm 21* to see how he attempts to put his ideas into practice. Although Richter abandoned his expressionist "visionary paintings" in late 1917 in favor of a more structured form of abstraction, he did not turn his back on the principles of spontaneity and chance that had informed those paintings. Instead, his new form of abstraction was an attempt at balancing these principles with what were, for him, the opposite ones of premeditation and organization: "Organization submitted to chance. Chance gave variety to organization. A balance was achieved" (*Dada Art*, pp. 61–62).[22] As a result of his contact with the

musician Ferruccio Busoni and his long-standing interest in rhythm, Richter began to employ counterpoint as a musical analogy for the type of balanced abstract form he was seeking to develop. And when he first encountered Eggeling in 1918, he found in his work just such a contrapuntal balance: "Eggeling showed me a drawing. It was as if someone had laid the Sibylline books open before me. I 'understood' at once what it was all about. Here, in its highest perfection, was a level of visual organization comparable with counterpoint in music: a kind of controlled freedom or emancipated discipline, a system within which chance could be given a comprehensible meaning. This was exactly what I was now ready for" (*Dada Art*, p. 62).

Counterpoint is a type of polyphonic music consisting of two or more separate melodic lines rather than one melody (monophony) or one dominant melody with chords (homophony). It is typically distinguished from harmony in that it primarily concerns the *relationship* between individual melodic lines in a piece of music (the horizontal dimension) rather than the harmonic interaction between individual notes comprising chords (the vertical dimension). Similarly, Richter makes it clear in his remarks on his abstract films that he was interested not so much in the figures he employed but the relationships between them. He remarked about *Rhythm 21*:

> I went on to take parts of the rectangular screen and move these *parts* together or against each other. These rectangles are not *forms*, they are parts of movement. The definition of Form refers to one's perception of the formal quality of a single object, or several single objects; but, when you repeat this same form over and over again and in different positions, then the relationship between the positions becomes the thing to be perceived not the single or individual form. One doesn't see the form or object anymore but rather the *relationship*. In this way you see a kind of rhythm.[23]

The analogy between counterpoint and Richter's abstract filmmaking should not be taken too far; there are multiple disanalogies between music and abstract

visual art. Nevertheless, a close analysis of *Rhythm 21* shows that the film is primarily concerned with bringing its individual figures into interdependent relationships in the way that counterpoint creates relationships between separate melodic lines. It accomplishes this through what Richter called "a creative marriage of contrast and analogy" in which certain basic elements are repeated in either the same or successive shots, thereby creating a strong impression of organization and premeditation, but are also varied in unpredictable, seemingly spontaneous ways, thereby attempting to balance order and disorder.[24]

The film begins with an example of the marriage between contrast and analogy. The contrast is between figures that move *across* the screen, either horizontally from side to side or vertically from top to bottom, and those that move *into and out of* it. There is also another, subtler contrast between the repetitions of these movements. The analogy or similarity is that the figures are white and rectilinear and are positioned perpendicular to the frame on a black background. They also move at the same speed. We see, first, two white rectangles against a black background, one on either side of the frame, both moving sideways toward its center, where they cross each other and continue on to the opposite sides (fig. 1.2). After the second half of this action is repeated, we cut to a white square in the lower center of the screen receding into the black background (fig. 1.3). Part of this action is also repeated, this time the first half rather than the second. The two white rectangles that cross in the middle return, now beginning their journeys from the top and bottom of the screen rather than the sides (fig. 1.4). Again Richter repeats the second half of this action, but this time there are two repetitions instead of one. By carefully balancing similarity (white rectilinear figures on a black background positioned perpendicular to the frame and moving at the same speed) and difference (lateral versus recessional movement, different parts of which are repeated a different number of times), Richter is able to establish an interdependent relationship between the figures in the same or successive shots while also asserting their independence—much as the melodic lines in counterpoint are both separate but related. Too much difference and the viewer would see them as unrelated; too much similarity and the viewer would not see their separateness.

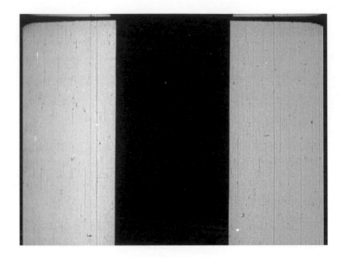

Figure 1.2 Hans Richter, *Rhythm 21*, 1921.

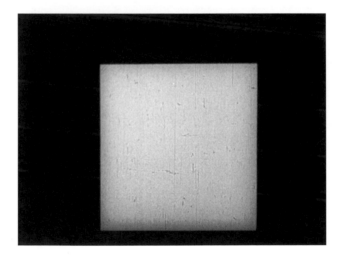

Figure 1.3 Hans Richter, *Rhythm 21*, 1921.

Figure 1.4 Hans Richter, *Rhythm 21*, 1921.

Richter not only draws our attention to the relationship between different figures in this opening sequence but also to the relation between figure and ground by activating the negative space around the figures. As Lawder has noted, "One of the surprising elements in the opening exercises in *Rhythm 21* . . . is the complex spatial illusionism that derives from the dynamic interplay of contrasting areas of black and white. Which forms are foreground figures, which are background elements? At any given moment, these spatial relationships are purposefully ambiguous and constantly changing."[25] I have described the opening shot as consisting of two white rectangles on a black background moving sideways and crossing each other at the center of the screen. However, it could also be seen as a black rectangle contracting and expanding on a white background, or indeed as two white rectangles meeting in the middle and then moving back to the sides from which they came rather than crossing each other. The film is replete with such ambiguities (which are impossible to convey fully in a written description), and they force the viewer to attend to both figure and ground and the relationship between them in order to try to decipher which is which.

Other types of contrast-analogy are used in the second sequence. Two long, thin, vertical rectangles appear on either side of the screen, with the top of a third visible in the bottom right corner (fig. 1.5). As it moves down off-screen, the other two recede in unison. In this action, recessional and lateral movement is contrasted in the same shot rather than between shots as before. Yet this contrast is balanced by figures with the same shape that move in unison and at the same speed. In place of the two rectangles crossing each other in the first shot, a single one then moves across the screen from right to left, thereby repeating the action of the first shot but varying it by subtracting a figure. The two long, thin, vertical rectangles return, but rather than moving backward, they slide up and down, one at top left, which moves down onto the screen first, the other bottom center, which moves up and then down again as the other retreats off-screen. As before, they move in unison at the same speed, but now they do so in opposing directions. The rectangle moving from right to left reappears, but another joins it moving from top to bottom, creating a wonderfully ambiguous diminishing black rectangle that seems to move simultaneously across and into the screen (fig. 1.6).

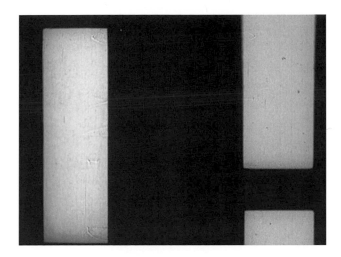

Figure 1.5 Hans Richter, *Rhythm 21*, 1921.

Figure 1.6 Hans Richter, *Rhythm 21*, 1921.

Figure 1.7 Hans Richter, *Rhythm 21*, 1921.

Again, Richter is repeating and varying the film's first shot, this time by moving one rectangle across the screen horizontally, the other vertically. The receding square at the center of the screen returns, but as it does so a long, thin, vertical rectangle on the right advances, thereby contrasting two different shapes as well as a movement into the background with one out of it. Similarity is preserved, however, by synchronizing the movements of the figures so that one advances as the other recedes at the same speed and time. This is repeated, but now the thin, vertical rectangle on the right thrusts into and out of the background, while another, thicker, horizontal rectangle on the bottom left moves forward, thereby contrasting a figure that moves backward, one that moves forward, and one that moves backward and forward (fig. 1.7). Yet, as before, similarity is maintained by synchronizing the time and speed of their movements. The square reappears in the center of the screen, receding and advancing, thereby repeating the second shot of the film, but instead of the continuous movement that Richter employed in that shot, jump cuts are now used to change its position.

Richter thus brings his separate figures into different kinds of interdependent relationships through a careful balance of various kinds of contrast and analogy: repeating different sections of sequences a different number of times; creating ambiguous figure–ground relationships; multiplying and subtracting figures; changing their shapes and the directions of their movements; positioning them vertically and horizontally; moving them in or out of unison; and using jump cuts instead of continuous motion. In the rest of the film he also uses gray and overlapping figures to alter depth relations; inverts and reverses sections and sequences; alters the speed of figure movements; reverses the colors of figure and ground; briefly introduces diagonals; and finally, superimposes figures (figs. 1.8–1.12). These variations follow no predictable system, suggesting that Richter thought of them spontaneously as he was making the film. Yet a basic pattern remains throughout: rectangles and squares positioned perpendicular to the frame moving across or into and out of the screen. In other words, the film creates an impression of order in spite of the moment-by-moment disorder, thereby conforming to Richter's definition of Dada as a balance between reason and unreason.

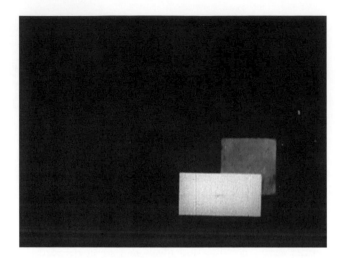

Figure 1.8 Hans Richter, *Rhythm 21*, 1921.

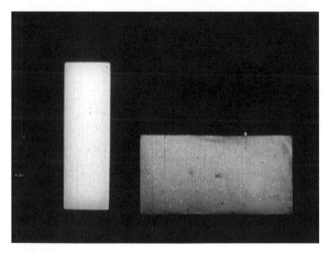

Figure 1.9 Hans Richter, *Rhythm 21*, 1921.

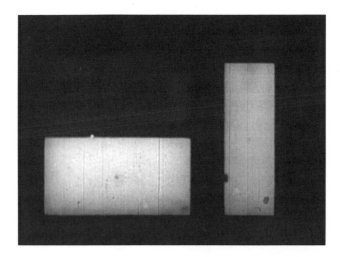

Figure 1.10 Hans Richter, *Rhythm 21*, 1921.

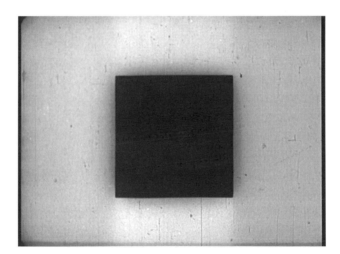

Figure 1.11 Hans Richter, *Rhythm 21*, 1921.

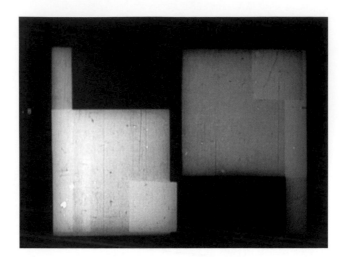

Figure 1.12 Hans Richter, *Rhythm 21*, 1921.

In doing so, the film also expresses the metaphysical vision of reality and human beings informing this definition. Indeed, Richter himself made this argument about his abstract style:

> Month after month, we studied and compared our analytical drawings made on hundreds of little sheets of paper, until eventually we came to look at them as living beings which grew, declined, changed, disappeared—and then were reborn. We finally could operate them like instruments (and that is exactly what we called them). A vertical line was made meaningful by the horizontal, a strong line grew stronger by a weak one, a single unit became important against many, a defined one was clear against an undefined one, and so forth. All of these discoveries became meaningful in the light of our belief that a precise polar interrelationship of opposites was the key to an order, and once we understood this order we knew we could control this new freedom.[26]

Richter is arguing that his abstract work, including the *Rhythm* films, constitutes a manifestation of his vision of "life," of the metaphysics informing his critique of modernity and his functionalist definition of Dada. In it, all sorts of formal "oppositions" are balanced in a harmonious whole, just as, for Richter, being authentically human consists of achieving a balance between opposites of reason and unreason, conscious and unconscious, civilized and primitive, thought and feeling, order and chance.

Admittedly, the argument that the *Rhythm* films conform to Richter's definition of Dada and the metaphysics informing this definition is based on loose analogies to their form. But these analogies are ones that Richter himself makes, and they point to at least some of the reasons why he believed his films to be Dadaist. Such analogies are also found in the metaphysical tradition of abstract painting that emerged in the 1910s and was exemplified by de stijl and the painter Piet Mondrian. Mondrian was convinced that human consciousness in modernity was evolving toward knowledge of the absolute or universal

principles governing reality, and in 1920 he had begun making his first fully neoplastic paintings in which planes consisting of the three primary colors, the "noncolors" black, white, and gray, and black horizontal and vertical lines are brought into different, nonhierarchical relationships. These are predicated on the metaphysical belief that reality at its most general consists of oppositions between male and female, spirit and nature, outwardness and inwardness, and the particular and the universal, which ideally exist in perfect equilibrium. It is this utopian balance between opposites that constitutes the universal or absolute knowledge toward which art aims and human consciousness is evolving in the modern world, Mondrian thought, and it is by bringing into equilibrium the plastic elements of painting that the universal can be expressed and the "repose" necessary for contemplation of the absolute can be attained: "In art we have *direct plastic expression of the universal* (the equilibrated plastic of relationships), non-corporeal in its manifestation and therefore free of the temporal that obscures the eternal."[27] Like Richter, therefore, Mondrian uses an analogy between the metaphysical and pictorial balance of opposites to claim that the latter expresses or manifests the former.

Richter had developed ties with Theo van Doesburg, editor of *De Stijl* and one of the leaders of the de stijl movement, right before making *Rhythm 21* in 1921. In late 1920, having heard about their work, van Doesburg visited Richter and Eggeling at Richter's parents' estate in Germany for several weeks, and the next year he published an article on their abstract filmmaking in *De Stijl*. Richter also began publishing in the periodical, and *Rhythm 21* clearly has affinities with the type of art promoted and practiced by Mondrian and the de stijl group. As art historian Yve-Alain Bois has argued, de stijl can be defined by a "single generative principle" consisting of two "operations": "elementerization" and "integration." Elementerization is the reduction of an art form to its most fundamental, irreducible elements, and integration is the unification of these elements into a "nonhierarchical whole" in which they exist in interdependent relations.[28] In the 1920s, Mondrian performed both operations by reducing painting to planes of primary colors and noncolors as well as horizontal and vertical lines and then bringing them into equilibrium.

Richter did something similar to his abstract style before making *Rhythm 21*, and it seems likely that this was a result of his exposure to de stijl. Prior to meeting van Doesburg and making the film, Richter had used a scroll of paper to bring a series of drawings into relationships with each other and to create the rhythmic effect he so prized in a work he called *Präludium* (1919; fig. 1.13). However, its vocabulary differs in important ways from that of *Rhythm 21*. While using rectangles and squares colored black, white, and gray like the film, it also employs lines and curves, and it clusters multiple, smaller figures together. The overall impression is of a single configuration growing in complexity and size as the scroll unwinds. In *Rhythm 21*, this vocabulary has undergone a radical reduction, what Bois calls "elementerization." Lines and curves have disappeared, and instead of a single configuration that becomes larger and more intricate like an organism—Richter in fact described the drawings in his scrolls as "living beings which grew, declined, changed, disappeared"—the film instead integrates independent squares and rectangles into various kinds of relationships with each other just as de stijl art works do.

Other debts to de stijl are also evident. Vilmos Huszar, another de stijl artist, had published a black-and-white linocut in *De Stijl* in 1918 in which it is impossible to discern the figure from the ground, thereby integrating the ground into the picture and creating a nonhierarchical relationship between it and the figure, just as happens in parts of *Rhythm 21*.[29] The asymmetrical, geometrical, and orthogonal nature of the abstraction in the film is also reminiscent of de stijl. And, perhaps most important, though Richter had always been interested in the relationships between the different elements in his pictures because of the rhythmical effects that could be produced, with *Rhythm 21* he justifies this interest in terms of the metaphysical balancing of opposites and the search for the universal that one finds in de stijl.

It would be wrong, however, to classify *Rhythm 21* as a de stijl film. In addition to creating a strong impression of illusionistic depth, which Mondrian and others sought to abolish in their pictures, the film is obviously concerned with movement, which Mondrian saw as antithetical to the "repose" and "balance" he sought to achieve. Furthermore, as van Doesburg himself pointed out,

43

Figure 1.13 Hans Richter, page 7 of *Präludium* (Prelude), 1919. Pencil drawing, 84.4 × 51.7 cm (33.2″ × 20.4″). Kupferstichkabinett, Staatliche Museen, Berlin. Photograph © Bildarchiv Preussischer Kulturbesitz/Art Resource, New York. © Richter Estate.

Richter and Eggeling when he visited them "had not yet attained extreme puri-fication of form" typical of de stijl, and the integration of elements in *Rhythm 21* does not reach the degree it does in de stijl works (for example, figure and ground are only indiscernible in parts of the film).[30] Most obviously, Richter briefly includes diagonals, which Mondrian opposed, and, when van Doesburg began using them in 1925, the practice precipitated the former's withdrawal from the movement. *Rhythm 23* uses them much more extensively and, in its formal profusion, seems much less indebted to de stijl, suggesting that the move-ment's stylistic influence on Richter was brief. Philosophically, Richter's cri-tique of modernity is very much the product of his Dadaist background, while modernity was viewed positively by Mondrian because of its progress toward abstraction and knowledge of the absolute. Instead, de stijl offered Richter both a philosophical justification for the more structured abstract art he was pursuing in the late 1910s, one that fit well with his definition of Dada and the metaphys-ics that inform it, as well as some techniques for putting it into practice.

This synthetic approach was very much in tune with Richter's attitude toward modernity. Dada is usually identified with extreme, uncompromising condemnations of the modern world, but Richter neither rejected modernity nor attempted to bring about its demise. Instead, like the other avant-garde filmmakers studied in this book, his relation to the changes inherent in mod-ern life was a complicated one. He realized that rationality is fundamental to human nature, and that even those of his Dada colleagues who decried it the most, such as Tzara, employed it in calculating how to attack the bourgeoisie through (anti-)art. Instead, he sought to correct its worst excesses by balancing it with unreason through the combination of the elemental, structured abstrac-tion found in a movement like de stijl with the chance and spontaneity prized by the Dadaists.

"Cinema pur" and *Ballet mécanique*

While painters such as Hans Richter were making wholly abstract films using animation in the early 1920s, others were pursuing a different kind of cinematic abstraction that employed representational imagery. Their films are considered abstract in the sense that they "take away," or extract, from reality plastic properties that a disparate range of concrete things have in common, such as shape, texture, and rhythm. In France in the 1920s, the term "cinema pur," or pure cinema, was applied to both kinds of abstract filmmaking because there was considerable debate among critics and filmmakers about what pure cinema was or should be. Most of the avant-garde believed that mainstream narrative filmmaking was dominated by theater and literature. Instead of developing the new, visual art of film by exploring its specific features such as editing and camera movement, too many filmmakers, they argued, simply mechanically reproduced plays, novels, screenplays, and other verbal art works. If their films had any artistic merit at all, it lay in the noncinematic realms of acting or writing, not in their use of properly cinematic techniques. However, different ways of purifying film of these arts were proposed.[1]

Some claimed that cinema was a narrative art like literature and theater and located cinematic specificity in its capacity to tell particularly realistic stories, or stories in which the emotional states of characters figured prominently, or

ones that, as the filmmaker René Clair put it, used "purely visual means" such as the editing of shots into rhythmic patterns.[2] Others felt that pure cinema must totally eschew storytelling, which they identified with literature and theater. By 1926, Germaine Dulac, who had previously made narrative films including innovative impressionist ones concerned with representing the subjective states of characters, was employing the musical analogy found in abstract painting to argue that a film should be "music for the eyes," a "visual symphony" in which only the rhythm of forms in motion is used to express emotions and ideas.[3] For Dulac, this did not require abandoning representational imagery, and in a film such as *Thème et variations* (1928), she juxtaposes footage of rotating machines and a twirling ballet dancer to realize her conception of pure cinema. Clair's brother Henri Chomette, meanwhile, seconded Dulac's call for visual symphonies that dispensed with stories, but in addition argued that cinema should leave "behind the logic of events and the reality of objects," thereby seeming to call for a totally abstract, nonrepresentational form of pure cinema like Richter's.[4]

One of the most important participants in these debates, both as a filmmaker and critic, was the painter Fernand Léger. After World War I, he became increasingly interested in film as a result, in part, of his friendship with the poet Blaise Cendrars, who was involved in the making of Abel Gance's *J'accuse* in 1917. Gance was the most prominent and respected French narrative filmmaker of the period, and in response to Gance's next film, *La roue* (1922) (which Cendrars also worked on), Léger articulated a particular position in the debate about pure cinema.[5] In his article on the film, Léger argued that Gance had "elevated the art of film to the plane of the plastic arts" in those sequences in which a train figures prominently (the film's lead character, Sisif, is a railway engineer).[6] Like many other avant-gardists, Léger believed that cinema should not imitate theater by telling stories, claiming that "the dramatic effect of a living person, speaking with emotion, can not be equaled by its direct, silent projection in black and white on a screen. The film is beaten in advance; it will always be bad theater."[7] Instead, film's artistic specificity lay in "*making images seen*, and the cinema must not look elsewhere for its reason for being."[8] In order to explain what he meant by "making images seen," Léger distinguished between noticing

and seeing something. Most of the time we only notice things without seeing them fully, he believed. "The cinematographic revolution," however, "is *to make us see everything that has been merely noticed*."[9] Because of its size, the projected cinematic image allows viewers to fully see the subjects it records.

In addition, Gance used editing and the close-up to fragment the train and draw attention to its parts and their plastic properties—"its wheels, its rods, its signal plates, its geometric pleasures, vertical and horizontal."[10] Léger insisted that such plastic features were just as interesting and moving as any story: "You will see all those fragments magnified a hundred times, making up an absolute whole, tragic, comic, plastic, more moving, more captivating than the character in the theater next door."[11] Rather than reaching for the musical analogy and envisaging film as a "visual symphony" of forms in motion, Léger felt that, like modern painting, it should be a plastic art dedicated to revealing "the intrinsic plastic value of the object," which it is able to exhibit with particular force and clarity owing to the size of the screen and techniques such as editing and the close-up.[12] As we shall see, he attempted to put this conception of pure cinema into practice in the film *Ballet mécanique*, which he made in 1923–1924 with the American filmmaker Dudley Murphy, and which is probably the first and certainly one of the most influential abstract films to use representational imagery.[13] Strangely, his claim that cinema is an art with "limitless plastic possibilities" has been overlooked by many interpreters of the film, who have instead turned to Léger's painting in the 1910s to understand it.[14] Léger's theory of modernity, which underwent a significant change in the early 1920s with crucial ramifications for both his painting and filmmaking, has also been overlooked.

In order to foreground the plastic properties of the subjects it depicts as well as explore their similarities and differences, *Ballet mécanique* makes extensive use of close-ups and other techniques such as a prism, apertures, and neutral backgrounds, isolating these subjects from their everyday contexts and focusing the viewer's attention on their plastic features (fig. 2.1). It also repeats shots of certain subjects and shows them from different angles. Commentators tend to divide the film into seven sections bracketed by a prologue and epilogue, with each section unified by similarities between plastic values and subject matter.[15]

Figure 2.1 Fernand Léger and Dudley Murphy, *Ballet mécanique*, 1924.

Any such segmentation is imprecise and somewhat arbitrary, however, as the filmmakers repeat some shots and subjects throughout, and plastic values from one section often recur in subsequent ones. Léger himself in his notes on the film divided it into seven parts, and indicated that each was "penetrated" by rapidly edited sequences consisting of colored forms in order to create variety. He also argued that the film went "from slow motion to extreme speed," but although the editing does get faster as the film progresses, the rapidly edited sequences that interrupt each section, as well as the use of stop-motion to animate objects, make it difficult to verify this claim precisely.[16] Calculating roughly, whereas in the first section the average shot length (minus the rapidly edited "penetration" sequence) is about seven seconds, by the last section, which focuses on the newspaper headline "On a volé un collier de perles de 5 millions" (A pearl necklace worth 5 million has been stolen), it has dropped to about half a second.

The first section exemplifies a number of these formal principles. After the title sequence in which Léger's jerkily animated "Charlot," his cubist Charlie Chaplin figure (fig. 2.2), takes off his hat and bows his head, we see a medium shot of a woman, Katherine Murphy (wife of the filmmaker Dudley) on a swing in a garden, swinging away from and toward the camera, her head moving up and down in time with the swinging motion; a close-up of the mouth of another woman, Kiki de Montparnasse, visible through a black aperture that hides the rest of her face, her mouth alternating between smiling and not smiling; a straw hat centered on a black background; a panning shot of several painted discs spinning rapidly on a wall; a close-up of a shiny metallic ball circling back and forth toward the camera, with several circular objects visible on the wall behind it; an upside-down, high-angle shot of Katherine Murphy continuing to swing, the camera now mounted on the swing and moving with her; and another, even closer shot of a metallic ball swinging away from and toward the camera, the filmmakers and their apparatus reflected on its shiny surface. The dominant plastic values in this section are the rhythmic, back-and-forth motion created by the balls, the swinging woman, and to a lesser extent Kiki's mouth, as well as the circular shapes of the hat, spinning discs, and the balls. However, there are also some contrasts. Not only is the rhythmic movement counterbalanced by the

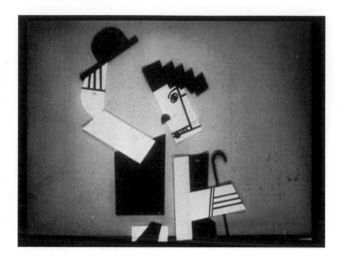

Figure 2.2 Fernand Léger and Dudley Murphy, *Ballet mécanique*, 1924.

stillness of the hat, but prior to the hat's appearance, Léger's first rapidly edited "penetration" sequence occurs. The editing is so fast—there are about fifty-five shots in eight seconds, meaning that each shot is on screen for roughly a sixth of a second—that one only gets a vague impression of their widely varying contents, which include circles and triangles, a black typewriter centered on a white background, and dark wine bottles against a light background. Many of these shots are repeated and varied. For example, the triangle is sometimes upside down, while the circle moves toward and away from the camera; the circle, triangle, and hat alternate between red, green, yellow, and blue; and there are several shots of the bottles in a variety of positions with a different number in each shot.

Other sections are unified by different plastic values and subjects. For instance, section 4, which is particularly important for a consideration of Léger's view of modernity, focuses to a large extent on machines and the similarities of their rhythmic movements to human beings. A man slides down a fairground ride (fig. 2.3). He is filmed from above moving left to right, and jump cuts are employed to create a mechanical pulse as the same shot of the man is repeated five times, his motion interrupted by a cut in exactly the same place each time. The sideways direction of his movement is contrasted with the up-and-down motion of a piston in the following shot, which moves at roughly the same speed as the jump cuts, thereby picking up their rhythmic beat (fig. 2.4). Shots of rotating machine parts from different angles as well as spiraling whisks are intercut with a sequence of close-ups of Kiki's face against a black background (figs. 2.5, 2.6). The face is motionless, but the filmmakers animate it by cutting back and forth between a low-angle shot in which her mouth and chin are visible, and a level shot of the top half of her face in which they are not. These jump cuts again create a rhythmic effect, which is intensified as the editing speeds up. The section ends with a woman climbing some stairs toward the camera carrying a bag of washing on her shoulder. The same, approximately two-second shot is repeated twelve times, and as before, the cut in the middle of her action creates a strong mechanical beat that mimics the regular movements of the machines we have witnessed previously. After a brief return to Kiki's alternately smiling and unsmiling mouth from the first section, the same shot of the washerwoman is

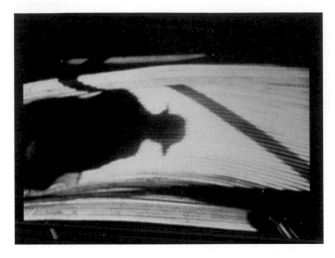

Figure 2.3 Fernand Léger and Dudley Murphy, *Ballet mécanique*, 1924.

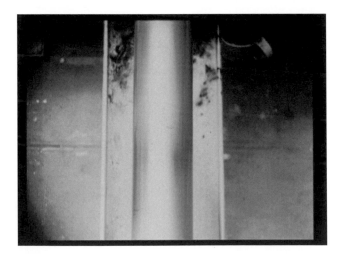

Figure 2.4 Fernand Léger and Dudley Murphy, *Ballet mécanique*, 1924.

Figure 2.5 Fernand Léger and Dudley Murphy, *Ballet mécanique*, 1924.

Figure 2.6 Fernand Léger and Dudley Murphy, *Ballet mécanique*, 1924.

repeated another fourteen times. This section is unified by a regular rhythm that in the case of the machines is created by their movements, but with the humans is manufactured through jump cuts and the repetition of shots.

How are we to understand this innovative film, which assaults the viewer with a bewildering array of often rapidly edited close-ups that force us to focus on the plastic properties of machines, machine-like entities, and a host of other objects?[17] And what vision of modernity does it instantiate? In his seminal book *The Cubist Cinema*, scholar and filmmaker Standish Lawder turns to Léger's painting of the previous decade to answer these questions.

In the early 1910s Léger had developed a cubist style that sought to impart the sensations of both dynamism and contrast, which he justified by appealing to perceptual realism. Perceptual experience, it was argued by many in this period, was being fundamentally transformed by modern forces such as technology, industrialization, and urbanization, all of which were rapidly increasing the pace of everyday life for human beings, especially in urban environments. As a result, reality was no longer perceptually experienced as a smooth, spatiotemporal continuum, but rather as dynamic and fragmented, as constantly changing and susceptible to violent rupture. Arguing in a 1913 lecture that "the *realistic* value of a work of art is completely independent of any imitative character," Léger quoted Cézanne's purported remark that "For an impressionist, to paint after nature is not to paint the object, but to express sensations."[18] Like the impressionists who sought to find pictorial equivalents for the sensations of light and color they experienced in contemplating nature, Léger saw his art of "dynamic divisionism" as realistic in the sense that, although it might not accurately imitate the external appearance of the modern world, it produced the sensations of speed and conflict experienced every day by its inhabitants: "Present-day life, more fragmented and faster moving than life in previous eras, has had to accept as its means of expression an art of dynamic divisionism."[19]

Although there are important changes and developments in Léger's painting in the 1910s, his concern to find a pictorial equivalent for this fragmented, dynamic perceptual experience is still evident in his famous painting from 1919,

The City, which is commonly viewed as a major work in the avant-garde genre of simultanism (fig. 2.7). Simultanism refers to the synthesis of fragments, both perceived and imagined, from different times and places in a single image. Here is how Lawder in *The Cubist Cinema* describes *The City*:

> *The City* is essentially a portrait of modern life in which Léger has used the Cubist visual vocabulary of sharp-edged flattened forms to create a simultaneous image of the many characteristic faces of the city. The constant shift of scale and viewpoint, the rush of images assaulting the eye simultaneously, the confusion of the senses, the disjointed space, the depersonalization of the individual, the vision in motion—all of these sensations that so incisively describe city life are realized by Léger here. The painting has a consciously modern note, for Léger was highly sensitive to the images and rhythms of urban life. He attempted to transpose those sensory impressions directly and immediately onto his canvas.[20]

Although it is not a city film, Lawder argues that *Ballet mécanique* attempts to elicit the same perceptual experience from the spectator as *The City*. As he puts it, "Contrast is both the life-blood and the binding force of *Ballet mécanique*. The film is composed not from separate shots which link to each other as in most films, but from disparate ones which clash and collide."[21] And he connects the putative centrality of speed and conflict in the film to the concerns and strategies of Léger's painting as a whole: "He sought to create in film the same discontinuous, fragmented, kaleidoscopic world that his paintings [describe]. . . . The pulsating energies of modern urban life, its rhythms and its forms . . . all can be felt in *Ballet mécanique*. [This] film is a spectacle in constant movement . . . a hard, intense, and vitally alive man-made environment, like the city, like [Léger's] painting *The City*."[22] Several statements from Léger's writings of the period, both on his film and his art in general, support this interpretation. In 1924, for example, during the period he was completing *Ballet mécanique*, Léger writes in an article for the *Bulletin de l'Effort Moderne* (his dealer Léonce Rosenberg's

Figure 2.7 Fernand Léger, *The City*, 1919. Oil on canvas, 96.8 × 130.5 cm (38 1/8" × 51 3/8"). Florene May Schoenborn Bequest, The Museum of Modern Art, New York. Photograph © The Museum of Modern Art/Licensed by SCALA/Art Resource, New York. © 2010 Artists Rights Society (ARS), New York/ADAGP, Paris.

magazine): "Life rolls by at such a speed that everything becomes mobile. The rhythm is so dynamic that a 'slice of life' seen from a café terrace is a spectacle. The most diverse elements collide and jostle one another there. The interplay of contrasts is so violent that there is always exaggeration in the effect you glimpse."[23] And, as Lawder points out, in his unpublished preparatory notes for *Ballet mécanique*, Léger summarized the design of the first section of his film as follows: "All of this in constant opposition of violent contrasts."[24]

There is, however, another plausible interpretation of the film, one that, to my knowledge, has never been systematically articulated but that nevertheless surfaces occasionally in Lawder's reading and others. It concerns the film's relation to the "machine aesthetic" or "machinism" of the 1920s, which was associated with the purism of Le Corbusier and Amédée Ozenfant in France (to which we will return), but also found elsewhere among the avant-garde in Europe, particularly in the constructivist movement in the Soviet Union. Summarizing briefly: according to machinism, reality should be fundamentally transformed using the machine as a blueprint and tool, so as to produce a utopia of order, harmony, control, and efficiency. Through the literal and figurative mechanization of life, a new, utopian society can be created. And it is this radical transformation of reality, based on an idealized conception of the machine, that *Ballet mécanique* is seen to be concerned with.

Most obviously, the film contains shots of machines and machine parts, mass-produced objects manufactured by machines, and an intermittent mechanical rhythm created by the rhythmic editing of shots as well as repetitive movement within the image, which periodically animates the subjects of the shots with a mechanical beat regardless of whether they are machines or not. This rhythm also functions—along with plastic properties such as shape and texture—to encourage the spectator to notice abstract similarities between the mechanical and nonmechanical objects the shots depict, as we saw in section 4 of the film. The apparent centrality of the machine in the film also dovetails with Léger's postwar painting in general. Although he had used mechanical shapes such as cylinders as plastic elements prior to the war, it is only after the war that machines and machine parts become concrete subjects of his paintings, a change

that has often been attributed to Léger's experiences as a solider on the front line during World War I.

Moreover, although the film does not explicitly or systematically offer the machine as a blueprint for transforming reality, it does nevertheless make a more substantial gesture toward one element of the revolution envisaged by machinism, namely, the mechanization of human beings. It does this through the rhythmical repetition and alteration of the facial expressions of Kiki de Montparnasse, which rob her face of psychological depth and turn it into a pure plastic surface; the employment of an aperture to isolate her facial features, which has a similar effect; the use of editing to rhythmically repeat bodily movement, as in the famous sequence of the washerwoman climbing a staircase, which again robs the human body of psychological depth and turns it into a plastic object animated by a mechanical beat; and the general emphasis throughout the film on abstract similarities between mechanical objects and the human face and body, particularly similarities of shape and rhythm.

Though in much of the discourse of machinism the mechanization of human beings remains a metaphor—the machine functions as an ideal that human beings should emulate in their behavior in order to achieve maximum efficiency and productivity—avant-gardists in the 1920s sometimes seemed to subscribe to a neo-Lamarckian belief in the possibility of the literal and rapid evolution of human beings into machine-like entities. Léger was no exception, remarking, for example, in a letter to Rosenberg in 1922: "The contemporary environment is clearly (dominated by) the manufactured and 'mechanical' object; this is slowly subjugating the breasts and curves of woman, fruit, the soft landscape."[25] Though such remarks by Léger are rare, it is certainly possible to argue that this view of "the contemporary environment" and its transformative impact on the human body is instantiated in his postwar nudes and human subjects, which are highly mechanized and standardized in character, and which lack any kind of psychological dimension. Whether or not we take Léger to be subscribing to the neo-Lamarckian view that human beings will literally evolve into machine-like entities in modernity, it is clear that the human face and body in *Ballet mécanique* are reduced to plastic objects, and that

the spectator is strongly encouraged by the film to notice abstract similarities between their features and machines.

Further evidence for this debt to machinism can be found in Léger's writings on film from this period. In his essay from 1922 on Gance's *La roue*, for example, he points approvingly to the way in which, in the first part of the film, "the machine becomes *the leading character, the leading actor*," and notes that this elevation of the machine "crushes and eliminates the human object, reduces its interest, pulverizes it."[26] This statement clearly echoes the views of other artists and filmmakers allied to the machine aesthetic, including the filmmaker Dziga Vertov, who, as we will see in chapter 5, in exactly the same year—1922—is calling for the "[exclusion of] man as a subject for film" and his replacement by "the poetry of machines." "The machine makes us ashamed of man's inability to control himself," announces Vertov, articulating the contempt for the human body typical of the machine aesthetic in its heroic phase.[27]

Thus, we have a second plausible interpretation of *Ballet mécanique* and its vision of modernity. Again, this reading can be found in Lawder's seminal work, where he points to the mechanization of the human figure in the film.[28] There are also traces of it in the detailed analysis of the film by film scholars David Bordwell and Kristin Thompson, although they are careful not to go beyond the modest claim that the film "cues" the spectator to notice abstract similarities between human beings and machines. As they put it: "[T]he film creates a mechanical dance. Relatively few of the many objects we see in the film are actually machines. . . . But through juxtaposition with machines and through visual and temporal rhythms, we are cued to see even a woman's moving eyes and mouth as being like machine parts."[29]

On an aesthetic level, there is a major, fundamental incompatibility between this reading and the first. The machinist reading argues that the film is designed to encourage the spectator to notice abstract *similarities* between the subjects and plastic properties of machines, rather than to produce the violent *contrasts* between them that Lawder's interpretation postulates as the central perceptual effect of the film.

Both readings correctly identify a concern in *Ballet mécanique* with two distinct types of change in the modern world: the transformation in human perceptual experience brought about by the increased pace of life in modernity, and the significance of the "machine age" for society. But neither accurately pinpoints the nature of this concern. If we look carefully, we find that the film neither fully embraces nor totally repudiates these changes, but instead evinces a more tangled stance toward them.

If we closely examine Léger's writings from around 1923–1924, when he is making *Ballet mécanique*, we find that, although the machine is obviously a central preoccupation for him, he describes it simply as "raw material" that he uses in the creation of something else that is much more important. As he puts it in 1923: "The mechanical element is *only a means and not an end*. I consider it simply plastic 'raw material,' like the elements of a landscape or a still life."[30] During this period, the "something else" that Léger aims to create in his art is what he refers to as "the Beautiful" or, quite simply, "Beauty." One place where he believes that beauty is found often, but certainly not always, is in what he refers to as "modern" or "useful" objects, which include, but are not confined to, machines and objects made by machines. He therefore states that the goal of his painting is to "obtain the equivalent of the 'beautiful object' sometimes produced by modern industry."[31] Indeed, he views artists within modernity as being in competition with, and potentially rendered obsolete by, the beauty of the "modern" or "useful" object: "The situation at the present moment is tragic enough. The artist is 'in competition' with the useful object, which is sometimes beautiful. Or at least fascinating. He [the artist] must create as well or better. . . . If they were always beautiful, there would no longer be any reason for the role of the artist to exist. . . . I repeat, in the face of these objects, the artist's situation is often disturbing."[32]

Léger during this period defines beauty in both reality and his art in, roughly speaking, a classical fashion as "geometrical order," in which the plastic properties of objects are balanced into harmonious relationships. As he puts it: "A picture organized, orchestrated, like a musical score, has geometric necessities

exactly the same as those of every objective human creation (commercial or industrial achievement). There are the weight of masses, the relationship of lines, the balance of colors. All the things that require an absolute order."[33] What Léger finds beautiful about many "modern" or "useful" objects, for which his art tries to find a competitive "equivalent," is precisely their classical qualities: their order, balance, and harmony. "The relationship of volumes, lines, and colors demands absolute orchestration and order. These values are all unquestionably influential," he writes in his text "Notes on Contemporary Plastic Life." "They have extended into modern objects such as airplanes, automobiles, farm machines, etc. Today we are in competition with the 'beautiful object'; it is undeniable."[34] Furthermore, in line with classical conceptions of beauty more generally, Léger argues that the beauty he is trying to produce in his art is not specific to modernity, but is a universal, transhistorical, human constant. Again in 1924, he says that:

> We are not now confronting the phenomenon of a new order, properly speaking; it is simply one architectural manifestation like the others. . . . Greek art made horizontal lines dominant. It influenced the entire French seventeenth century. Romanesque art emphasized vertical lines. . . . One can assert this: a machine or machine-made object can be beautiful when the relationship of lines describing its volumes is balanced in an order equivalent to that of earlier architectures.[35]

We should not conclude from this that he did not think there was something significantly different about modernity from earlier periods, for he argues repeatedly that "*modern man lives more and more in a preponderantly geometric order.*"[36] However, he did not see this "geometric order" itself as anything radically new—only its intensity and its omnipresence were new.

Although this classical notion of beauty is often embodied for Léger in the machine, it also transcends the machine to include a variety of objects in everyday life that exemplify it. As Léger puts it in 1924, "The Beautiful is everywhere;

perhaps more in the arrangement of your saucepans in the white walls of your kitchen than in your eighteenth-century living room or in the official museums."[37] And he is very careful to insist, again in 1924, that beauty and the machine are by no means coextensive:

> the more the car has fulfilled its functional ends, the more beautiful it has become. That is, in the beginning, when vertical lines dominated its form . . . the automobile was ugly. . . . When, because of the necessity for speed, the car was lowered and elongated . . . it [became] beautiful. This evidence of the relationship between the beauty and utility of the car does not mean that perfect utility automatically leads to perfect beauty; I deny it until there is a conclusive demonstration to the contrary.[38]

We can recognize in Léger's embrace of a classical conception of beauty the influence of the "call to order," the poet Jean Cocteau's phrase for the turn toward classicism by much of the French avant-garde after 1914. Because of the destructiveness of the war and the threat of German invasion, many French avant-gardists moved away from the prewar representation of the dynamism and fragmentation of modernity toward styles that emphasized order and construction, which, fueled to varying degrees by nationalism, they sought to root in classical tradition and French national identity.[39] In the late 1910s, Léger was alone in resisting this shift among the cubists associated with Léonce Rosenberg's Galerie de l'Effort Moderne. While he was painting simultanist works such as *The City*, Juan Gris, Jean Metzinger, and others had all adopted classical styles emphasizing pictorial stability and harmony, and Rosenberg himself published a pamphlet in 1920 entitled "Cubism and Tradition" in which he argued that a cubist painting was subject to the "eternal laws of equilibrium."[40] However, in 1920, Léger finally began to embrace the call to order, and this was the result, in large part, of his exposure to one of its major manifestations, the purism of the painter Amédée Ozenfant and the architect Charles-Edouard Jeanneret, whose pseudonym was Le Corbusier.

Ozenfant and Le Corbusier launched purism in Paris in 1918 with their manifesto, *After Cubism* (1918), which they began by declaring: "The War over, everything organizes, everything is clarified and purified; factories rise, already nothing remains as it was before the War." A new spirit of "order and purity illuminate and orient life," they continued, which was manifested in the harmony, organization, efficiency, economy, and clarity found in modern industry, in machines, in the design of modern cities, indeed everywhere in modern life except art.[41] Although cubism, the most modern art movement, had correctly replaced the subject with "pure form," it remained an "ornamental art" that merely titillated the senses, much like good food.[42] What was needed instead was purism, a rational art that appealed to the mind as well as the eye and that, like science, sought through logic and analysis to reveal the invariant, objective, general laws governing reality and our perception of it. Such laws, and the "geometric pattern" they reveal in nature beneath its changing appearances, are best expressed in numbers and equations.[43] A purist work of art should therefore "induce a sensation of a mathematical order" by allowing the viewer to experience and participate in the harmony of the laws of reality.[44] Such an experience of harmony, they argued, is "the source of beauty," and in the canvases they painted after 1918 as well as their periodical *L'esprit nouveau* from 1920 through 1925, they sought to put this classical conception of beauty and the philosophy underpinning it into practice.[45] Rather than depicting machines and industrial subjects, their paintings are still-lifes of quotidian objects such as bottles, glasses, and plates because they believed that the plastic properties of such "type-objects," as they came to call them, better instantiated the beauty of the harmonious, unchanging laws of reality (fig. 2.8).

Rosenberg bought several of Ozenfant's and Le Corbusier's paintings in 1921, and included their work along with Léger's in a group show, The Masters of Cubism, that same year. By this time Léger had already met Le Corbusier, and *L'esprit nouveau* published an essay on his art in its fourth issue as well as stills from *Ballet mécanique* in 1924. At the International Exhibition of Decorative Arts in Paris in 1925, Le Corbusier contributed a small Pavillon de L'Esprit Nouveau that showcased his ideas for modern residential architecture

Figure 2.8 Amédée Ozenfant, *Purist Still Life*, 1921. Oil on canvas, 60 × 73 cm (23.6" × 28.7"). Musée D'Art Moderne, Saint-Etienne, France. Photograph © Michèle Bellot/ Réunion des Musées Nationaux/Art Resource, New York. © 2010 Artists Rights Society (ARS), New York/ADAGP, Paris.

(the pavilion consisted of a standardized, functionalist apartment in a proposed 660-unit building), and among the purist still-lifes hanging on its walls was Léger's painting *The Baluster* (1925). Clearly, many elements of Léger's theory from this period—his classical notion of beauty, his focus on "modern" and "useful" objects, his belief that "The Beautiful is everywhere; perhaps more in the arrangement of your saucepans in the white walls of your kitchen than in your eighteenth-century living room or in the official museums," his notion of a transhistorical "geometric order" that is intensifying in modernity—bear a strong resemblance to purist arguments. Just as important, his practice changed. In place of the dynamism and fragmentation of paintings before 1920 such as *The City*, his paintings from *The Mechanic* (1920) onward, such as *Three Women* (1921), evince a much greater degree of classical qualities such as stability, clarity, harmony, and the balance of horizontal and vertical planes, something that Lawder and others overlook (fig. 2.9). As Léger scholar Christopher Green has put it, owing to the influence of purism, Léger's "view of what was essential to reality in modern life gave a central importance to the qualities of precision, economy and equilibrium."[46]

There is also ample evidence that purism informed Léger's film practice. If we look carefully at what Léger liked so much about Gance's *La roue* in his essay of 1922, it is not the centrality of the machine per se that he celebrates, but its instantiation of a classical conception of beauty:

> You will see [in *La roue*] moving images presented like a picture, *centered* on the screen with a judicious range in the *balance* of still and moving parts (the contrast of effects); a still figure on a machine that is moving, a modulated hand in contrast to a geometric mass, circular forms, abstract forms, the *interplay* of curves and straight lines (contrasts of lines), dazzling, wonderful, a moving *geometry* that astonishes you.[47]

Furthermore, *Ballet mécanique* contains many "modern" and "useful" objects, of which only some are machines or machine parts. It depicts a hat, numerous

Figure 2.9 Fernand Léger, *Three Women (Le grand dejeuner)*, 1921. Oil on canvas, 183.5 × 251.5 cm (6' 1/4" × 8' 3"). Mrs. Simon Guggenheim Fund, The Museum of Modern Art, New York. Photograph © The Museum of Modern Art/Licensed by SCALA/Art Resource, New York. © 2010 Artists Rights Society (ARS), New York/ADAGP, Paris.

kitchen utensils (fig. 2.10), plates, mannequin legs (fig. 2.11), a shoe, bottles, a horse's collar, words, and geometric shapes such as triangles and circles. Many of these are the kind of quotidian "type-objects" that were the subject of purist paintings, and they are often filmed in such a way as to foreground their geometrical properties. They are shown in their entirety centered against a neutral background, for example, or are organized into symmetrical patterns. The focus on numbers, especially in the film's final section, dovetails with the purists' interest in mathematics, and the repeated use of triangles and circles in the rapidly edited penetration sequences, as well as the presence of the triangular motif created by the prism and the circular one throughout much of the rest of the film, accords with the purists' belief in the primacy of these forms. The shots of Katherine Murphy in a garden on a swing and smelling flowers evoke the classical, transhistorical concept of beauty promoted by both the purists and Léger, as do the plastic similarities between her swinging motions and the moving objects seen subsequently, which suggest that they exemplify this notion. And some of the colors used in the penetration sequences, particularly yellow, red, and blue, are ones that Le Corbusier and Ozenfant advocated as "constructive" and used in their paintings.

Moreover, the fact that the film consistently foregrounds the abstract similarities between its subjects can be understood not merely as an attempt to point to the resemblances nonmechanical objects such as the human face and body bear to machines, as the machinist reading argues, but as an effort to emphasize what many of them have in common, namely, the classical conception of beauty to which Léger subscribed at the time. Further evidence for this emerges if we address Léger's initially perplexing claim that *Ballet mécanique* is not an abstract film at all. Scholars such as Bordwell and Thompson view the film as a paradigmatic example of an abstract film, and yet Léger emphatically stated that "Figures, fragments of figures, mechanical fragments, metals, manufactured objects . . . [are] objective, realistic and in no way abstract."[48]

In part, Léger probably meant by this statement that his film is not a purely abstract film like Richter's. However, there is another sense in which the film can be understood as "in no way abstract" that is hinted at in the manner

Figure 2.10 Fernand Léger and Dudley Murphy, *Ballet mécanique*, 1924.

Figure 2.11 Fernand Léger and Dudley Murphy, *Ballet mécanique*, 1924.

in which the remark above lists some of the concrete objects depicted in *Ballet mécanique* as opposed to their abstract similarities to each other. As we saw at the beginning of this chapter, Léger articulated a particular position in the pure cinema debate, arguing that cinema should be a plastic art dedicated to revealing "the intrinsic plastic value of the object," and that such plastic features are "more captivating than the character in the theater next door." Furthermore, in his writings on film, Léger privileged and emphasized the close-up and its transformative power above all other cinematic techniques. For example, in his retrospective notes on *Ballet mécanique*, he remarked: "I used the close-up, which is the only cinematographic invention."[49] In his March 1923 reply to René Clair's survey in the journal *Film*, he observed: "[The cinema] will be everything . . . when film-makers develop the consequences of the close-up, which is the cinematic architecture of the future."[50] He goes on to say of the power of the close-up: "A detail of an object transformed into an absolute whole is personified when projected in large dimensions; a portion of a human being is personified when projected in large dimensions."[51] In his remarks on *Ballet mécanique*, he continues: "Fragments of objects were also useful; by isolating a thing you give it a personality."[52]

The common notion here is personality, and in Léger's repeated linking of it to the close-up we can detect the influence of one of the best-known film theorists and filmmakers of the period, Jean Epstein.[53] Epstein, by 1923, was an acquaintance of Léger, and in March 1923 Léger named him, along with Gance and Cendrars, as one of the most important figures in the French cinema. Epstein's basic argument about the close-up in the early 1920s was that it, along with movement, endowed objects with a "personality," a "soul," a "life," thereby dramatically intensifying the perceptual and emotional impact they have on the spectator. In 1924, for example, Epstein wrote: "a close-up of a revolver is no longer a revolver, it is the revolver-character, in other words the impulse toward or remorse for crime, failure, suicide. It is as dark as the temptations of the night, bright as the gleam of gold lusted after, taciturn as passion, squat, brutal, heavy, cold, wary, menacing. It has a temperament, habits, memories, a will, a soul."[54]

It is impossible to know how far Léger subscribed to Epstein's theory, as he does not explain his use of the word "personality." However, given his acquaintance with the views of Epstein and other French film theorists who held similar ones (such as Clair), it is plausible to conjecture that he believed that by using the close-up in *Ballet mécanique* and by endowing the objects he depicted in each shot with movement, he would thereby grant these objects an anthropomorphic "personality," thus intensifying the perceptual and emotional impact on the spectator of the classical beauty he believed them to possess. Whether or not the close-up in combination with movement actually achieves such an effect, their consistent use in the film points to Léger's concern to interest the spectator in a number of *concrete* objects and their plastic beauty, not just machines and their abstract similarities to nonmechanical entities.

Ballet mécanique's relation to the changes envisaged by machinism was therefore more complex than the extreme and uncompromising commitment usually attributed to avant-gardists. Rather than unconditionally embracing the machine as a blueprint for a future utopia, Léger's primary artistic ambition during the period he made *Ballet mécanique* was the representation of a classical notion of beauty that he found all around him *in the present*. While he believed that such beauty was more intense and prevalent in modernity than in previous epochs, he did not think that it was anything radically new, and instead saw it as fundamentally continuous with previous periods. He certainly thought that the machine often exemplified beauty, but he viewed it as just one type of object among many others to do so. Thus, he employed many "modern" or "useful" objects in his film, not just machines, many of which were thought by purists to exemplify their classical conception of beauty. And, under the influence of Epstein's film theory, he attempted to foreground this beauty by intensifying the perceptual and emotional impact of their concrete plastic properties on the spectator through the repeated use of the close-up and movement.

I turn now to Lawder's interpretation of *Ballet mécanique*, which argues that the film instantiates the dynamic and fragmented perceptual experience of reality brought about by the increased pace of modern life. Already it should be

apparent that this reading contrasts with Léger's pursuit of beauty in the period in which he made *Ballet mécanique*. In contradistinction to the fast, conflicting perceptual experience emphasized by Lawder, Léger from 1920 onward pursued "the qualities of precision, economy, and equilibrium" he associated with purism and its classical, transhistorical conception of beauty, as is evident in his writings and paintings. Furthermore, in a text from 1924 (the year he finished *Ballet mécanique*) entitled "The Spectacle: Light, Color, Moving Image, Object-Spectacle," we find him repeatedly criticizing the dynamic, fragmented perceptual experience of reality characteristic of modernity as harmful to human beings. For example, he claims:

> The hypertension of contemporary life, its daily assault on the nerves, is due at least 40 percent to the overdynamic exterior environment in which we are obliged to live.
>
> The visual world of a large modern city, that vast spectacle that I spoke of in the beginning, is badly orchestrated; in fact, not orchestrated at all. The intensity of the street shatters our nerves and drives us crazy.[55]

In 1924, therefore, the perceptual experience associated by so many avant-gardists with modern life has become an object of criticism in Léger's writings. And, perhaps unsurprisingly, he views the classical notion of beauty, with its qualities of harmony and order, as the perfect antidote or cure for it. "If the spectacle offers intensity, a street, a city, a factory ought to offer an obvious plastic serenity," he claims. "Let's organize exterior life in its domain: form, color, light. . . . A society without frenzy, calm, ordered, knowing how to live naturally within the Beautiful without exclamation or romanticism."[56]

Obviously, remarks such as these, coming in the same year as Léger is completing *Ballet mécanique*, give us good reason to question Lawder's interpretation of the film, which claims that Léger is trying to instantiate in *Ballet mécanique* the very perceptual experience that, in the extracts I have just cited, he is criticizing as having a deleterious effect on human beings. But there is also evidence

in Léger's unpublished notes on the film to make us suspicious of this reading, evidence that Lawder tends to ignore. Sometimes, far from emphasizing dissonance and conflict, Léger champions the qualities of unity and similarity and writes of his intention to avoid fragmentation in his film. For example: "Each of the parts [of the film] has its own unity due to the similarity of clusters of object-images which are visually alike or of the same material. That was the goal of construction and it prevents the fragmentation of the film."[57] We also have Bordwell and Thompson's detailed analysis, which convincingly shows that the film encourages the spectator to notice abstract similarities between objects in the shots of the film, once again pointing to its pull toward similarity rather than difference and conflict.

Nevertheless, there are clearly places in *Ballet mécanique* that conform to Lawder's interpretation because they are fast and fragmentary, such as the first "penetration" sequence, in which roughly fifty-five shots depicting a wide variety of subjects occur in eight seconds. Moreover, there are other places in Léger's unpublished preparatory notes where he points to his desire to create perceptual conflict, such as when he talks of a "constant opposition of violent contrasts" in the film and his desire to "'persist' up to the point where the eye and the mind of the spectator 'can't take it any more.'"[58] Léger thought of himself as a perceptual realist, as someone who created pictorial equivalents of the perceptual experience of the modern world. Even though he fell under the influence of purism and its classical values in the early 1920s, he did not restrict his pictures to purist type-objects, or adopt wholesale purist color schemes and other compositional principles. Although he came to accept the classical conception of beauty promoted by the purists as a part of modern life, he did not turn his back on the conflictual, dynamic quality of the perceptual experience of modernity with which he had always been preoccupied. As Green notes, "his work might be more structured and lucid in the 1920s than it was in 1913–14 [owing to purism and the 'call to order'], but its use of contrasts to give pictorial intensity through dissonance continues unabated."[59] Conflict, in other words, remained an abiding concern of Léger's, both in his paintings and in *Ballet mécanique*.

In one of his published statements on the film, Léger writes: "Contrasting objects, slow and rapid passages, rest and intensity—the film was constructed on *that*,"[60] which suggests that there is a deliberate push and pull between "rest" and "intensity" in the film; that it is ultimately a mixture of what Léger calls the "intensity of the street [that] shatters our nerves and drives us crazy," which he sees as characteristic of modern perceptual experience, and the "calm" order of "the Beautiful," the classical ideal, which in 1924 he views as the antidote or cure for this intensity. *Ballet mécanique*'s stance toward the transformation of perception in modern life is therefore just as complicated as its attitude to machinism. Although, as Lawder argues, the film does at least partially instantiate the fragmented, dynamic perceptual experience of reality associated by avant-gardists with modernity, it does not do so in order to embrace this change unequivocally. Rather, it offers an antidote, a cure for this modern perceptual experience in the form of a transhistorical, classical ideal of beauty that is manifested in machines, various other objects, and the human face and figure, their impact intensified by drawing attention to their concrete plastic qualities using the close-up and movement. Just as Richter neither accepts nor rejects the rationalism of modernity, instead attempting to correct its excesses by balancing it with unreason, so Léger neither repudiates nor embraces the fragmentation of perception in modernity, offering instead a classical notion of beauty as its counterweight.

DADA, *ENTR'ACTE*, AND *PARIS QUI DORT*

Of all the avant-garde movements examined in this book, Dada is the one most often identified with extreme, uncompromising condemnations of bourgeois modernity, and for good reason. As is well known, the name Dada was first used by a group of painters and poets in 1916 in Zurich, where artists and intellectuals from many countries congregated to take advantage of Switzerland's neutrality during World War I. The members of the group were disgusted by the unprecedented destruction caused by the modern weaponry used in the war. Rather than improving human life, the tremendous advances in science, technology, and industry in the nineteenth and early twentieth centuries enabled the mass production of armaments that caused suffering and death on a previously unimaginable scale; it is widely believed that fifteen million people eventually perished and twenty million were wounded in World War I, many of them civilians. Hence, in self-conscious opposition to the nationalism that had helped give rise to the conflict, the Dadaists embraced internationalism, both in the composition of their movement, which was made up of artists from several countries, and in their multilingual performances at the Cabaret Voltaire in the spring of 1916. In fact, Dada was supposedly adopted as the name of the movement because, as one of its founders, the poet Hugo Ball, wrote in his diary on April 18 of that year, "*Dada* is 'yes, yes' in Rumanian, 'rocking horse' and

'hobbyhorse' in French. For Germans it is a sign of foolish naïveté, joy in pro-creation, and preoccupation with the baby carriage."[1]

For most Dadaists, however, the war was but a symptom of a profound moral crisis in modern life. To them, it seemed that the forces of modernization were responsible for a general collapse of values that had led to the war. In a lecture about the painter Wassily Kandinsky given at the Galerie Dada in Zurich in April 1917, for example, Ball identified three such "destructive" forces. The decline of religion had caused the world to "disintegrate" by robbing it of "meaning" and "purpose"; "Man [had] lost the special position" granted to him by religion, and had been reduced to being a part of nature, no better or different than a stone or animal. The discoveries of modern science, par-ticularly "the dissolution of the atom," had revealed nature to be "random" and had undermined "every relation, established by reason and convention." Finally, the "mass culture of the modern megalopolis" had annihilated individuality.[2] Bourgeois modernity, in other words, had rendered life meaningless, chaotic, and inhuman. As a result, artists like Kandinsky "stand in opposition to society," Ball declared, "dissociat[ing] themselves from the empirical world, in which they perceive chance, disorder, disharmony" and instead try to resurrect the spiritual values of harmony and order through abstract art.[3]

Other Dadaists blamed different modernizing forces, but they all tended to think that the war had revealed bourgeois modernity as morally corrupt, and that art, if it were to have any relevance, had to root out this corruption. In a retrospective essay about the movement, the poet Tristan Tzara, another found-ing member, wrote: "Dada took the offensive and attacked the social system in its entirety, for it regarded this system as inextricably bound up with human stupidity, the stupidity which culminated in the destruction of man by man, and in the destruction of his material and spiritual possessions."[4] Today, Dada is most often identified with Tzara's brand of anarchistic, some would say nihilistic, assault on bourgeois society. For Tzara and like-minded Dadaists, the war had demonstrated that *all* of bourgeois society's values and institutions—"Honor, Country, Morality, Family, Art, Religion, Liberty, Fraternity"—were bankrupt and obsolete, for none had been able to stop it.[5] Indeed, Tzara felt these values

were complicit in the war because they were used to hypocritically mask the baser instincts that had caused it—principally the materialistic self-interest of the bourgeoisie—beneath the veneer of civilization. This was true of literature and art as well, which "had become institutions located on the margin of life, that instead of serving man . . . had become the instruments of an outmoded society. They served the war and, all the while expressing fine sentiments, they lent their prestige to atrocious inequality, sentimental misery, injustice and degradation of the instincts."[6] Art along with society as a whole therefore needed to be attacked—"there is a great negative work of destruction to be accomplished. We must sweep and clean."[7] Tzara developed a repertoire of strategies in his writings and performances to do so, such as the use of nonsense and contradiction to counter the rationalism increasingly valued in modern culture since the Enlightenment. Even Dada did not escape his onslaught. "DADA MEANS NOTHING," he declared; it "doubts all," including Dada itself, for "the true dadas are against Dada."[8] It is the wholesale nature of this assault on bourgeois society that has led some to conclude that the offensive of Tzara and Dadaists like him "is in fact launched against the whole of Western civilization which culminates in Enlightenment-style modernity."[9]

Entr'acte (1924) is considered by many to be the quintessential Dadaist film because it, too, seems to be engaged in a sweeping attack on bourgeois society and to exemplify the anarchy and nihilism typically associated with Dada today. Certainly, it is the film most often privileged in commentaries on Dada cinema. The script, if it can be called that, was written by the poet and painter Francis Picabia while at work with the composer Erik Satie on the ballet *Relâche* (Relax/performance suspended) for the Swedish ballet based in Paris. Picabia envisaged a film with two parts, one to introduce *Relâche,* the other to be shown during the intermission, and he purportedly wrote the outline spontaneously on a napkin at the restaurant Maxim's.[10] He commissioned the young French filmmaker René Clair to make it, and Satie wrote the score.[11] The result was *Entr'acte*, which means "intermission."

Picabia was for a time close to Tzara, whom he met in Zurich after the end of the war in early 1919. Together they composed texts for the February

1919 issue of Picabia's journal *391* and collaborated on the May installment of Tzara's periodical *Dada*. When Tzara relocated to Paris a year later, by which time Picabia had eagerly embraced the Dada moniker, they enthusiastically participated together in the various performances, soirees, exhibitions, publications, and provocations that constituted the Dada season of 1920. In 1921, as Paris Dada began to disintegrate as a result of personal rivalries and philosophical differences, Picabia publicly broke with Tzara and Dada; by the time he was working on *Relâche* and *Entr'acte* in 1924, most Dadaists had moved on to something new, many to surrealism, which was officially launched that year with the publication of André Breton's first manifesto of surrealism. Indeed, in the final issue of *391*, Picabia referred to *Relâche* as an "Instantanist ballet" rather than a Dadaist one, although he did not develop the notion of Instantanism much beyond the claim that it involves a rejection of the past and the future in favor of living completely in the present moment and doing whatever one feels like doing at that moment, a way of being he referred to as "perpetual motion."[12]

Nevertheless, Picabia shared much with Tzara artistically, philosophically, and temperamentally during this period, including his apparent nihilism. In his "Dada Cannibal Manifesto" of March 1920, he famously proclaimed:

DADA smells like nothing, it is nothing, nothing, nothing
It is like your hopes: nothing
like your paradises: nothing
like your idols: nothing
like your politicians: nothing
like your heroes: nothing
like your artists: nothing
like your religions: nothing[13]

And Picabia and Clair's *Entr'acte* can appear to be the great work of negative destruction called for by Tzara, engaged in a nihilistic attack on the values of bourgeois modernity in general. "*Entr'acte*," writes philosopher Noël Carroll, "is a film born in the spirit of negation."[14] To begin with, there are the perceptual

assaults on the viewer.[15] The backdrop for the ballet *Relâche* consisted of hundreds of metal, reflective disks that, when illuminated at their brightest, blinded the audience, and *Entr'acte* contains similarly visually aggressive techniques.[16] During the film's prologue, projected before the ballet began and the blinding set was unveiled, a cannon is shown moving of its own accord through stop-motion on the roof of the Theater des Champs-Elysées, home to the Swedish ballet and the venue where *Relâche* was performed and *Entr'acte* projected. In slow motion, Picabia and Satie leap into the frame and continue to jump up and down. They then proceed to have a conversation, now depicted at normal speed, apparently about what to do with the cannon (fig. 3.1). Satie gestures several times toward the camera and by extension the film's audience. Finally, they load a missile into its barrel and exit the frame, this time in a fast-motion shot that reverses the one in which they entered. A close up of the cannon's mouth pointed directly at the camera reveals the missile traveling toward the viewer, and the prologue ends (fig. 3.2). At this point, the ballet would have begun, implying that *Relâche*, like the missile, is a weapon targeted directly at the audience watching it.

This is not the only time such aggression toward the viewer occurs. In the longer part of the film shown during the ballet's intermission, sparring white boxing gloves are superimposed over a shot, initially out of focus, of a busy Parisian intersection. As it comes into focus, the film cuts to a single white boxing glove against a black background, punching at the camera and again, by implication, the audience (fig. 3.3). As a metaphor for the loss of consciousness someone might suffer after being hit in the face, the shot of the busy intersection then returns, now out of focus, and quickly fades. A little later, the mouth of another weapon, this time a rifle, confronts the audience in close-up (fig. 3.4), as a hunter takes aim at an egg floating on a jet of water. The filmmakers also employ a number of disorienting techniques to perceptually attack the viewer. In addition to the numerous upside-down shots, there is a sequence in which a paper boat is superimposed over city rooftops while the camera careens wildly from side to side as if imitating the lurching of a ship. There are abrupt shifts in shot scale and angle. Long shots are often followed by close-ups, or they are combined through superimposition, and extreme high angles alternate

Figure 3.1 René Clair and Francis Picabia, *Entr'acte*, 1924.

Figure 3.2 René Clair and Francis Picabia, *Entr'acte*, 1924.

Figure 3.3 René Clair and Francis Picabia, *Entr'acte*, 1924.

Figure 3.4 René Clair and Francis Picabia, *Entr'acte*, 1924.

with low ones. Finally, the repeated use of superimposition makes the content of some shots indistinct.

The film not only assaults the viewer perceptually; it disorients him cognitively. Commentators often divide its longer section into two halves, the second commencing with a funeral procession that becomes a chase. The goal-oriented structure of the procession and the chase, along with the causal connections between its shots, gives it a degree of coherence largely absent from the first half, whose sequences, as Siegfried Kracauer noted, "are loosely connected in the manner of free associations, drawing on analogies, contrasts, or no recognizable principle at all."[17] As a result, Kracauer suggests, the first half of the film has the quality of a dream—although he is wrong about this. However incomprehensible, films modeled on dreams or dream mechanisms are typically narratives, as we shall see in chapter 4. That is, they have agents who pursue goals, even though those goals might change suddenly, or the identity of the agents pursuing them might be ambiguous, or their meaning might be obscured through symbolism. And their scenes and sequences are often causally connected, even though this causal continuity is combined with forms of discontinuity. This is not surprising, given that dreams themselves are widely perceived as having narrative features like causality, agents, and symbolism connecting their parts. But it is precisely narrative that is largely avoided in the first half of *Entr'acte*, which consists of a variety of short sequences that seem to have been chosen because they cannot be connected causally or by agents with goals, such as a paper boat superimposed over wildly careening shots of rooftops; a ballet dancer shot from below through a transparent surface, twirling and jumping up and down, often in slow motion; and the artists Marcel Duchamp and Man Ray playing chess. Clair often intercuts these sequences. For example, a shot of the ballet dancer from below is included in the sequence of the paper boat superimposed over rooftops; and a shot of a body of water over which upside-down faces and rustling fabric are later superimposed is inserted between shots of the dancer's legs and arms.

Several of these sequences contain agents pursuing goals—Ray and Duchamp playing chess, the dancer dancing—and some of their shots are linked causally, such as when Duchamp in a close-up reacts in surprise to the Place de

la Concorde's appearance on his chess board in the previous shot. But these brief moments of narrative are quickly aborted, and the sequences themselves have no causal connection with each other, nor do they answer questions raised by earlier sequences. As Carroll has suggested,

> the rejection of a consistent narrative structure is also deeply connected with an assault on rationality. . . . Traditionally, narrativity and rationality stand in close relation. Narration is a form of explanation. It is a means of selecting and ordering experience so that later events are accounted for in terms of earlier ones. To narrate is to reason, to offer one kind of explanation. Indeed, narrative explanations are probably the most commonly used forms of explanation.[18]

By eschewing causal and more broadly rational connections between sequences in the first part of the film, Clair and Picabia can be seen to be attacking rationality itself. This does not mean there are no relations among the sequences, for as Kracauer noted, one can find some visual resemblances between them. The dancer jumping up and down in slow motion echoes Picabia and Satie's slow-motion leaps into and out of the frame during the prologue, for instance. Yet it is easy to overstate such connections, as does philosopher Gilles Deleuze, who argues that the film's sequences seem to blend and metamorphose into each other in a process of constant becoming because of their similarities: "The dancer's tutu seen from beneath 'spreads out like a flower,' and the flower 'opens and closes its corolla, enlarges its petals and lengthens it stamens,' to turn back into the opening legs of a dancer; the city lights become a 'pile of lighted cigarettes' in the hair of a man playing chess, cigarettes which in turn become 'the columns of a Greek temple, then of a silo, whilst the chessboard becomes transparent to give a view of the Place de la Concorde.'"[19] This is an inaccurate description of some of the shots in the film and their order. For example, matches, not cigarettes, are superimposed on the man's hair; and they do not "become" the columns of a Greek temple, for before the shots of the columns begin (and it is not clear they are in a Greek temple), the man scratches his head and the matches disappear as he

looks up at the camera. Deleuze also overlooks Clair's use of intercutting. One subject does not "become" another; when showing one subject, Clair will often cut to another that we have already seen or show us one we will see more of.

Perhaps more important, everything resembles everything else on some level. Similarities, however vague and tenuous, can nearly always be found between one thing and another—in shape, color, texture, rhythm, speed and direction of movement, or position in space. The matches superimposed on the man's head can be said to resemble the columns because they are rectangular in shape, even though they are irregularly scattered in contrast to the ordered arrangement of the columns, are much smaller, and have straight edges instead of curved ones. The question is whether this part of the film is designed to foreground *perceptually salient* similarities between its sequences, ones the viewer might notice, and I would argue that it is not. It is edited quickly, each shot lasting on average just over three seconds, and some are much shorter.[20] When combined with the disorienting techniques already mentioned—sudden shifts in shot scale and angle, superimposition, upside-down shots, lurching camera movement—the fast editing makes it hard for the viewer to notice resemblances. As Kracauer himself notes, many of the sequences seem to be related "by no recognizable principle at all." Instead, I would suggest, the perceptual experience of the first half of the film is one of the few genuine examples in film history of what Walter Benjamin called distraction, in which "No sooner has [the viewer's] eye grasped a *scene* than it is already changed." Unlike the vast majority of films, it consists of quickly edited shots that are almost entirely unconnected by time, space, agents, and subject matter. Hence, "The spectator's process of association in view of these images is indeed interrupted by their constant, sudden change," a subject I shall return to in chapter 6.[21]

In addition to assaulting rationality through the rejection of narrative, the film also attacks morality. In the transition from the first to the second half, sequences get longer and causal connections begin to emerge between them. Picabia appears on a roof with a rifle and coolly takes aim at the hunter, who is played by Jean Borlin, choreographer and principal dancer for *Relâche* and the Swedish ballet. A target superimposed over the hunter's face with the bull's-eye

positioned on his mouth suggests that Picabia is deliberately aiming at his head. Picabia fires, the hunter falls off the roof, and we cut to what is presumably the hunter's funeral—although not without the confusing insertions of a shot of his hearse (which we later see has Picabia's and Satie's initials on it) *before* Picabia fires, a shot of the egg once again suspended over the jet of water after the funeral has begun, and a fade-out followed by a fade-in of the sun. Borlin is subjected to violence once more at the end of the film, when he is kicked in the head. Yet, as with his "murder," there are no moral repercussions, nor are there repercussions when the man's head is burned by matches or the dancer is filmed from beneath. This flouting of moral norms continues into the funeral itself, which becomes an occasion for absurdity rather than respectful mourning. It appears to take place at a fairground; the hearse is pulled by a camel; and an air vent blows up the skirts of female mourners. Others are wearing chains of flowers around their necks and eating bread that hangs from the side of the hearse. As the procession begins, slow-motion shots of the mourners leaping into the air in a manner that recalls Picabia's, Satie's, and the dancer's earlier leaps—Clair even inserts another low-angle shot of the dancer to suggest such a connection—only add to the sense of ridiculousness.

The film also attacks art. Ballet is pilloried by filming the figure of a classical dancer, usually associated with grace and beauty, from below, her groin and bottom clearly visible, and by giving her a beard and spectacles at one moment. And when the hearse comes unhinged from the camel and rolls away down the road, the funeral procession turns into a chase reminiscent of the one- and two-reel comic films of the 1900s and 1910s, in which, under the slightest pretext, a group of people chase after something and cause havoc along the way. Thus, in addition to deliberately choosing subjects that have little connection and filming them in a disorienting manner in the first half of the film—thereby violating the expectation that a work of art should be well crafted and communicate something meaningful—the film's second half, rather than aspiring to high art, deliberately models itself on what is often thought of as one of the cinema's lowest, least sophisticated, most primitive forms: slapstick comedy. The final sequence continues in the same vein by breaking with the widespread

artistic convention of an unambiguous ending: just as the film seems to finish with the appearance of the title "Fin" ("The End"), Borlin jumps through it, is kicked in the head, and in reverse motion is propelled back through the title.

By assaulting the viewer perceptually and cognitively, as well as violating moral norms and artistic conventions, the film can be seen as an attack on the bourgeoisie itself. Not only would members of the bourgeoisie have been expected to attend performances of *Relâche*, but the sort of rational, moral, and artistic values *Entr'acte* assails are ones that were deemed obsolete and hypocritical by Dadaists in the aftermath of World War I, for reasons explored at the beginning of this chapter. In addition, Carroll has suggested that the film's chase is a metaphor for the self-destructiveness of bourgeois society. As the chase begins to speed up, Clair intercuts shots of cars, cyclists, boats, and even a plane, along with point-of-view shots from rapidly moving vehicles (including a roller coaster), "to suggest that the whole of Paris is involved in the chase after the hearse."[22] The shots become shorter as the hearse, mourners, and intercut vehicles move faster; the point-of-view shots become more rapid and unwieldy; and Clair once again resorts to superimposition, often of vehicles moving in opposite directions, as well as upside-down shots, in order to convey the disorientation of fast movement. The sequence climaxes in a burst of brief, rapidly moving shots with contrasting and clashing directions of motion that are so fast they become almost abstract, and the coffin falls off the hearse and rolls onto nearby grass. Carroll, pointing out that the chase owes much to Mack Sennett, one of the great practitioners of the chase genre, writes:

> Part of the significance of Sennett chases involves the literalization of fears about the pace of modern life. That is, Sennett literalizes the belief that the accelerated pace of life, especially in light of the slow-paced, rural background of most of the proletarian audience, is inherently destructive. . . . Clair selects this aspect of Sennett's iconography for *Entr'acte*. Though Clair does not emphasize characters actually falling down, the cumulative effect of the race is the dispersal of the procession, the emblem of bourgeois society. . . . The chase

is also a reckless one, changing direction continuously. Most of the mourners have disappeared by the end of the chase; the speed of the moribund race has broken up society. The race is a self-destructive one, hurtling headlong and recklessly at a pace that breaks society apart.[23]

In general, Carroll concludes, the film is "hostile" toward the bourgeoisie and "destructive" of bourgeois values.

Yet it is wrong to identify Dada or *Entr'acte* exclusively with negation and destruction, or to conflate the assault on society of some of its members with a condemnation of bourgeois modernity as a whole. To start with, some Dadaists, as we have already seen in the cases of Hugo Ball and Hans Richter in chapter 1, were far less concerned with attacking society than with finding spiritually satisfying alternatives to the perceived meaninglessness of modern life (Ball) or correcting its excesses (Richter). Furthermore, Dadaists such as Picabia and Tzara did not nihilistically reject all bourgeois values. As Georges Ribemont-Dessaignes, another major participant in the movement, noted in his 1931 "History of Dada," "The activity of Dada was a permanent revolt of the individual against art, against morality, against society. . . . It aimed at the liberation of the individual from dogmas, formulas and laws, at the affirmation of the individual on the plane of the spiritual."[24] In opposing constraints on the individual of any kind, both Picabia and Tzara, in their different ways, valorized personal freedom, and they did so to the extent of advocating the individual's liberation not only from external restrictions but from himself, from his own rationalistic self-control, by giving in to his immediate, nonrational needs and instincts. Tzara himself suggested as much: "Dada was born of a revolt common to youth in all times and places, a revolt demanding complete devolition [*sic*] of the individual to the profound needs of his nature, without concern for history or the prevailing logic or morality."[25] So did Breton: "DADA, recognizing only instinct, condemns explanation *a priori* According to DADA, we must retain no

control over ourselves. We must cease to consider these dogmas: morality and taste."[26] Picabia's short-lived Instantanism is another version of this idea.

Charles Taylor has suggested that there is a turn to interiority in modern art born of a desire to escape the instrumental rationality of bourgeois modernity, which is perceived as imprisoning and deadening. Modern artists draw on nonrational or irrational aspects of subjective experience such as sensations, emotions, instincts, drives, the unconscious, dreams, free association, and spirituality in the hope that they cannot be assimilated by utilitarian rationalism and because they restore the vitality and vibrancy to life that utilitarian rationalism putatively denudes. Because the mind is, in part, rational, this subjectivism is simultaneously antisubjectivist, involving a decentering of the rational self in order to liberate its nonrational or irrational dimensions. "The liberation of experience," Taylor remarks, "can seem to require that we step outside the circle of the single, unitary identity, and that we open ourselves to the flux which moves beyond the scope of control or integration."[27] Certainly, the Dadaism of Tzara and Picabia constitutes one version of this general trend in its call for abandoning rational self-control and giving free rein to momentary impulses in all their chaos and anarchy. Surrealism, which we will encounter in chapter 4, is another. Yet this extreme, radical form of individualism is hardly antimodern. Instead, to use Marshall Berman's words, it is a way of "denouncing modern life in the name of values that modernity itself has created."[28] This is the value of personal freedom, the liberalism that is both a cause and consequence of bourgeois modernity. Without the unleashing by industrial capitalism of the productive powers of the bourgeoisie in their utilitarian pursuit of their own material well-being, all that is solid would not have melted into air; traditional, premodern restrictions on individual freedom of religious, feudal, and other varieties would not have dissolved; and Dada would have been unthinkable. In fact, Tzara's and Picabia's idealization of personal freedom in the form of acting on impulse bears an uncanny resemblance to the avant-garde caricature of the middle classes as selfishly concerned with nothing but fulfilling their own desires. It confirms the wisdom of Renato Poggioli's remark that "Avant-garde art then cannot help paying involuntary homage to democratic and liberal-bourgeois society in the

very act of proclaiming itself antidemocratic and antibourgeois; nor does it real-
ize that it expresses the evolutionary and progressive principle of that social order
in the very act of abandoning itself to the opposite chimeras of involution and
revolution."[29] Only in a society that allows its members considerable personal
freedom, and that tolerates nonconformity and dissent, could a movement like
Dada arise, and in clamoring for this freedom in a radical form, it can only help
perpetuate that society. Even Dada, it turns out, was not totally antibourgeois.

It would be equally wrong, however, to simply equate Tzara's and Pica-
bia's brand of individualism with the liberalism of bourgeois modernity. For
while embracing the bourgeois value of personal freedom, Dada simultaneously
opposes, in the name of that value, limits placed on freedom by the bourgeoisie,
principally the internal constraint of rationalistic self-control. It advocates, in
other words, a more expansive conception of a bourgeois value than the bour-
geoisie itself is prepared to countenance. It is a good example of how, as I noted
in the introduction, avant-garde artists were rarely either anti- or promoderniza-
tion in general, but instead criticized one or more features of modernity while
embracing others, or embraced and criticized the same features simultaneously.
Modernity itself is contradictory, and the changes it brings about can be experi-
enced as libratory and oppressive at one and the same time. In the case of Dada,
the personal freedom of modern life is celebrated in a radical form while the
instrumental rationality that has enabled it is rejected as a stultifying, deadening
constraint on that freedom.

As for *Entr'acte*, in its seeming rejection of rational, moral, and artistic
restraints of any kind, it can be seen as an expression, even an instantiation, of
the personal freedom valorized by Tzara and Picabia, who in fact referred to
the film as "the image in freedom."[30] Freedom is not the only value the film
affirms, however. It is important to remember that it was made by René Clair,
who, though for a time sympathetic to Dadaism, was not himself a member of
the movement. In fact, his concerns during the period he made *Entr'acte* were
quite different from those of Dadaists like Picabia and Tzara. While they were
attacking art, he was first and foremost dedicated to developing the young art
of film, and he was deeply concerned that its growth was being impaired by the

influence of the older verbal arts, primarily literature and theater. "It is time to have done with words," he wrote in 1923. "Nothing is being improved because we are not wiping the slate clean. Real cinema cannot be put in words."[31] Like other French filmmakers of his generation, Clair passionately believed that cinema was primarily a visual art of movement, which, he felt, earlier filmmakers such as the Lumière brothers and Mack Sennett had realized. However, this notion of cinema had been forgotten by those who, in an attempt to prove cinema's status as an art, had aped the verbal arts by making films of dialogue-heavy literary classics and stage plays. In 1924, the year Clair shot *Entr'acte*, he declared that "It can scarcely be denied that the cinema was created to record motion, and yet this is what seems to be forgotten all too often. The principal task of the present generation should be to restore the cinema to what it was at the outset and, in order to do that, to rid it of all the false art that is smothering it."[32] As film scholar Steven Kovacs has pointed out, this is precisely what Clair does in *Entr'acte*'s more coherent second half, in which the funeral procession becomes a chase reminiscent of the one- and two-reel comic chase films of the 1900s and 1910s.[33] In his writings, Clair praised such chase films because they consist of the movement he saw as the basis of film art. His use of the chase in *Entr'acte* is, therefore, not simply the result of a desire to attack high art using a "primitive" form, but an attempt to develop the art of film in a direction he believed in.[34]

Moreover, as film historian Richard Abel has suggested, one senses in *Entr'acte*'s chase scene Clair's attempt to both emulate and go beyond what was widely perceived at the time to be one of the highest achievements of French film art: the famous sequence in Abel Gance's *La roue* (1922) in which the railway engineer, Sisif, is driving the train carrying Norma, the woman he loves, to Paris to be married to another man.[35] In his anguish, Sisif accelerates the train in an attempt to crash it and kill himself, Norma, and everyone else on board. Gance conveys both the train's increasing speed and Sisif's emotions through faster and faster editing, intercutting between ever shorter shots of Sisif, Norma, the train's speedometer, its wheels and tracks, and the top of the train as it hurtles through the countryside (figs. 3.5–3.8). At its fastest, the editing creates a flicker effect owing to the short shot length of under one second, a technique that

Figure 3.5 Abel Gance, *La roue*, 1922.

Figure 3.6 Abel Gance, *La roue*, 1922.

Figure 3.7 Abel Gance, *La roue*, 1922.

Figure 3.8 Abel Gance, *La roue*, 1922.

Soviet montage filmmakers would employ later in the decade. As a result of his animus against the influence on film of the verbal arts, Clair criticized what he saw as *La roue*'s overly Romantic and literary narrative. However, he praised its "extraordinary lyrical passages and inspired movement," focusing in particular on the scene of the speeding train.[36] In his writings of the 1920s, Clair argued that "pure cinema" occurred "as soon as a sensation is aroused in the viewer by purely visual means," and it was precisely the use of visual techniques such as the rapidly moving camera atop the train as well as the sensation they aroused in the viewer that he admired so much about the train scene in *La roue*.[37] "We had already seen trains moving along tracks at a velocity heightened by the obliging movie camera," he remarked about this scene, "but we had not yet felt ourselves absorbed—orchestra, seats, auditorium and everything around us—by the screen as by a whirlpool."[38] As this comment suggests, Clair valued not just the cinema's capacity to represent movement but its ability to impart the sensation of motion to the viewer, to make the viewer *feel* movement, which he often referred to as lyricism, and in the chase scene in *Entr'acte* he employs Gance's techniques to achieve just such a sensation. As the mourners are left behind, he accelerates the cutting between the hearse's wheels, shots taken from the top of the hearse as it careens through the surrounding landscape, and the tracks of the roller coaster, and at the scene's climax the editing is so fast as to make the shots almost illegible. However, he does not simply copy Gance, as he adds techniques used elsewhere in his film, particularly superimposition and upside-down shots as well as graphic contrasts between the rapidly moving shots at the end of the sequence (something else the Soviets would do later in the decade). The result, arguably, is an even stronger sensation of vertiginous movement than is produced by Gance's scene (figs. 3.9–3.14).

In his original scenario, Picabia does not mention the chase, simply describing the scene as a "funeral procession" that should last six minutes. It is likely, therefore, that the chase was Clair's idea, especially as it gave him the opportunity to revitalize what he saw as the overly verbal art of film by returning to one of its earliest traditions and its use of motion. Nevertheless, although for different reasons, Picabia, too, valued the cinema for its capacity to both represent and

Figure 3.9 René Clair and Francis Picabia, *Entr'acte*, 1924.

Figure 3.10 René Clair and Francis Picabia, *Entr'acte*, 1924.

Figure 3.11 René Clair and Francis Picabia, *Entr'acte*, 1924.

Figure 3.12 René Clair and Francis Picabia, *Entr'acte*, 1924.

Figure 3.13 René Clair and Francis Picabia, *Entr'acte*, 1924.

Figure 3.14 René Clair and Francis Picabia, *Entr'acte*, 1924.

create the sensation of movement. In an interview about *Entr'acte* in October 1924, he stated: "What I love are races across the desert, savannas, horses bathed in sweat. The cowboy entering through the windows of a bar-saloon, breaking windowpanes, the glass of whiskey emptied at a right angle into a hearty gullet, and the two brownings aimed at the villain: all of that punctuated like a gallop, accompanied by whip crackings, curses, and gunshots."[39] And in a slightly later text on Instantanism, he adds:

> The cinema should also give us fever, should be a sort of artificial paradise, a promoter of intense sensations exceeding the airplane's "looping the loop" and the pleasure of opium. . . .
>
> The cinema must not be an imitation but an evocative invitation as rapid as the thought in our brain, which has the faculty of transporting us from Cuba to Bécon-les-Bruyères, of making us leap onto a bolting horse or from the top of the Eiffel Tower . . . while eating radishes![40]

These remarks suggest that, whereas for Clair movement in film is to be valued because it is the essence of film art, for Picabia it is its liberating quality that is important. The sensation of motion that can be created by the cinema is much like the movement of thought unconstrained by reason ("as rapid as the thought in our brain"), he suggests, at a moment in his career when he advocated "Instantanism," which "believes only in perpetual motion." But despite their different reasons, both Clair and Picabia valorized movement in film, which suggests that the chase in *Entr'acte* cannot be seen simply as an act of negation and destruction, as part of the Dadaist assault on bourgeois art and society. While it certainly mocks funerals and implies that bourgeois civilization is self-destructive, as Carroll argues, it also affirms, even celebrates film as an art of motion through a controlled, skillful use of accelerating rhythm in editing and camera movement as well as graphic contrasts.[41]

Clair continued to promote his conception of film art in his writings and the string of comedies and fantasy films he subsequently shot in the 1920s and early

1930s, all of which, while often daring in certain ways, are narrative works made within the French film industry rather than avant-garde films. Given his concern with the development of film art, why might he have been willing to join forces with a (former) member of an avant-garde movement known for its hostility toward art? Aside from the obvious benefits for his nascent film career of being given the opportunity to make a film by a well-known artist like Picabia, he was willing, I suspect, because of his desire to counter the influence on film of the older verbal arts of fiction and theater. He sympathized not so much with the Dadaists' attack on art and society in general but rather with their assault on these verbal arts in particular, as suggested by the following retrospective comment: "In an era when for some among us fiction and drama seemed to belong to a worm-eaten age whose rubbish was being hauled away by the Dada moving men . . . the cinema was seen as the medium of expression that was newest and the least compromised by its past—in a word, the most revolutionary."[42]

Nor is it clear that Clair sympathized fully with Tzara's and Picabia's ethos of unconstrained individual freedom, or their critique of bourgeois modernity. The year before he shot *Entr'acte*, he made his first feature, *Paris qui dort* (*The Crazy Ray*) (1923), a comic science-fiction film in which an inventor, Dr. Crase, builds a machine that, like the cinema, can arrest, speed up, and slow down movement and time. This remarkable film begins with the caretaker of the Eiffel Tower descending one day from his residence on the top level to discover that Paris has come to a halt, its activity completely suspended. He encounters, for example, a man about to commit suicide by jumping into the Seine, and a policeman chasing a thief, both frozen in mid-action along with the city's clocks, which have stopped at 3:25 AM. He finds only five other people who have escaped this condition, an airplane pilot and his passengers who flew into Paris earlier that day. As scholar of the avant-garde Annette Michelson describes it, "they explore the city together and discover in that silence and stasis the conditions of *freedom*."[43] Free from any restraint, they make Paris their playground, stealing clothes, jewelry, money, fine food and drink, and repairing to the Eiffel Tower to indulge themselves (fig. 3.15). Within a matter of days, however, boredom overcomes them, and the four men begin to compete for the affections of the one woman. Suddenly,

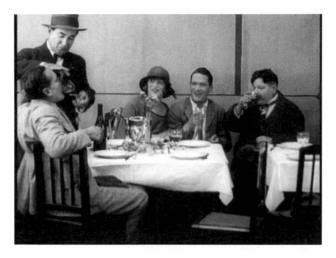

Figure 3.15 René Clair, *Paris qui dort (The Crazy Ray)*, 1923.

just as violence ensues, a call for help issues from the radio and they journey back down into the city to discover its source, a Miss Crase, whose uncle, a professor, has invented a machine responsible for bringing the city to a halt. They are told that they escaped its effects because they were above the reach of the powerful ray it emits—the caretaker on the top level of the Eiffel Tower, the travelers in their plane—and they beg the professor to restore Paris to normal, which he does. They promptly reenter city life with all its hustle and bustle, its inhabitants oblivious to the condition they have been suffering from, and go their separate ways.

The caretaker, however, is attracted to Miss Crase, and realizing he has no money with which to court her, decides to use the professor's machine to bring the city to a halt once more so that he can procure funds. The professor resists, and they struggle over control of the machine's lever. As it swings back and forth erratically, the city alternates between stasis and rapid movement, which Clair conveys using freeze-frames followed by fast-motion shots of traffic, crowds, and boats on the Seine, until finally the machine explodes and normality is restored. When the caretaker and the airplane travelers tell the authorities their story, they are dismissed as lunatics, and they wonder if it has all been a dream. But back at the Eiffel Tower, the caretaker finds a single gleaming remnant of the days spent in idle freedom, a ring.

Michelson describes the film as follows:

> Dr. Crase, then, is the filmmaker. With his little engine he stills and quickens, projects life in and out of motion, speeds and slows the course of things. Setting a city careening headlong into the dizzying pace of modernity, he can at will arrest the flow of life in the ecstatic suspension of time itself.
>
> René Clair's celebration of modernity therefore turns upon that threshold in our history which was the invention of the motion picture. And in the sequences of arrest and release, of retard and acceleration, we experience the shock and thrill, the terror and delight which express the intoxicating sense generally shared in the first

decades of the century, the fulfillment of *une promesse de bonheur* [a promise of happiness] deeply inscribed within the hopes and fantasies of our culture: the control of temporality itself.[44]

Michelson's point is that Dr. Crase's machine is a metaphor for cinema and the control over time and movement it enables, and that this control is deeply desired in our culture and promised by the technological advancements of modernity, which, as many have noted, tend to shrink time and space by enabling human beings to communicate and move across large distances increasingly quickly. Far from a critique, Dadaist or otherwise, of such technological progress, *Paris qui dort* is a "celebration" of it, she suggests, although she qualifies this by pointing out that the possibility of controlling time occasions "both terror and delight."

The ambivalence toward the technological power over time hinted at here by Michelson is also evident in the film's treatment of the personal freedom granted by this power. Liberated by the suspension of temporality from the necessity of working and producing, from rational, legal, and moral constraints, and with everything they could possibly want within reach, its six beneficiaries are able to indulge every momentary instinct for sensual pleasure and material comfort, every chaotic impulse to play and have fun. They are, in other words, free in the sense idealized and sought after by Dadaists like Picabia and Tzara, free to relinquish rational self-control and act on every whim and fancy, to live in the moment. They have become, to use Picabia's term, Instantanists. Yet rather than discovering paradise, they quickly become bored and begin to fight, and when the opportunity arrives, they implore the professor to restore capitalist modernity with all its forward movement, energy, and vibrancy. But that is not all. For once plunged back into modern life and required to work and produce again, the caretaker wishes to be liberated from it once more, and for him and his companions their experience of freedom takes on the aura of a dream.

This is a much more ironic, dialectical vision of freedom than that of Dada. In this film, the very bourgeois modernity that gives rise to technologies that control time and movement, thereby allowing human beings to liberate themselves from that selfsame bourgeois modernity, is desired by those human beings

once they have escaped it. Yet when part of it again, they only wish to be free of it once more. The fact that the same filmmaker could make *Paris qui dort* and *Entr'acte* within a year or two of each other, the former casting doubt on the type of personal freedom from the instrumental rationality of bourgeois modernity that the latter affirms, is yet another example of the deeply ambivalent stance of avant-garde and modern artists in general toward the forces of change at work in modern life. It shows how artists could be both attracted to and repulsed by the same feature of bourgeois modernity: the energy, speed, and vitality of productive forces as they generate material goods and services, brilliantly represented by Clair in *Paris qui dort* through the freezing and then speeding up of images of city life.

SURREALISM AND *UN CHIEN ANDALOU*

"To encompass both [André] Breton and Le Corbusier—that would mean drawing the spirit of present-day France like a bow and shooting knowledge to the heart of the moment," wrote Walter Benjamin in his unfinished Arcades project. Benjamin was referring to the major opposing artistic trends of his day, surrealism and machinism, using the names of their principal exponents in France.[1] Whereas Le Corbusier advocated rationalism, science, objectivity, and technological progress, surrealism, which emerged in the early 1920s shortly after purism, pursued irrationality, prescientific modes of knowledge such as the occult, the subjective, and what Benjamin called "the outmoded": "the first iron constructions, the first factory buildings, the earliest photos, the objects that have begun to be extinct, grand pianos, the dresses of five years ago, fashionable restaurants when the vogue has begun to ebb from them."[2] Benjamin praised the surrealists for being the first to discover the "revolutionary energies" in such outmoded forms, which contained, he argued, the "residues" of the "dream world" of nineteenth-century bourgeois modernity, "the wish symbols of the previous century . . . reduced . . . to rubble" owing to "the development of the forces of production."[3]

Benjamin (characteristically) never explains precisely why such remnants of outmoded dreams might be revolutionary. Others have conjectured that

what he had in mind, as art historian Hal Foster puts it, was that "the capital-
ist outmoded challenges [capitalist commodity] culture with its own forfeited
dreams, tests it against its own compromised values of political emancipation,
technological progress, cultural access, and the like," and surrealism has often
been seen as rebelling against the forces of mechanization and mass production
of commodities unleashed in bourgeois modernity and celebrated by the likes of
Le Corbusier.[4] Foster, for example, argues that the figures of the mannequin and
automaton, which recur frequently in surrealist art, mock and parody what he
calls the "mechanical-commodified," the machinist affirmation of the mecha-
nized human body and the "beautiful," industrially manufactured object found
in purism and *Ballet mécanique*.[5]

> Whereas Léger and company insist on the rational beauty of the
> capitalist object, surrealism stresses the uncanny repressed of this
> modern rationality: desire and fantasy. . . . It does so in order to save
> the object from strict functionality and total objectivity, or at least to
> ensure that the traces of the body are not entirely effaced. In short,
> in the (ir)rationalization of the object the Surrealists seek "subjectiv-
> ity itself, 'liberated' in the phantasm."[6]

Foster concludes that surrealism contested "the modern cult of the machine"
promulgated by movements such as futurism, constructivism, and purism, and
in general surrealism has been viewed as a liberation of the irrational mind from
the rationalism of modern life welcomed by machinism.[7]

In Europe of the 1920s, however, the opposition between machinism and
surrealism was not nearly so clear cut.[8] One person who attempted to synthe-
size the two was Salvador Dalí, who, along with Luis Buñuel, made *Un chien
Andalou* (1929), widely seen as one of the greatest surrealist films. When first
officially launched in Paris in October 1924 with the publication of the first
manifesto of surrealism and the opening of the short-lived Bureau of Surreal-
ist Research, Bretonian surrealism was primarily a movement of writers. The
photographer Jacques-André Boiffard and the painter George Malkine were the

only visual artists on Breton's list of those who had "performed acts of Absolute Surrealism" in the first manifesto.[9] In the following years, however, the surrealists made a concerted effort to attract painters, photographers, and filmmakers (despite doubts among some surrealists about whether painting could achieve surrealism, because of the conscious control it seemed to require), and Max Ernst, Man Ray, Giorgio de Chirico, André Masson, Joan Miró, Yves Tanguy, René Magritte, and other visual artists became associated with it to varying degrees. Among the older painters surrealism appealed to in the mid-1920s was Picasso, and although Picasso never became a surrealist, for a time (1925–1935) he moved closer to its concerns.

It was in part through the work of these visual artists that Dalí was exposed to the movement. When he had his first one-man show in Barcelona in 1925, he was alternating between cubist still-lifes influenced by the purism of *L'esprit nouveau* (which he read), naturalist portraits, and neoclassical figures. But in April 1926, while in Paris, Dalí visited Picasso in his studio and saw Picasso's new, surrealist-inflected cubist paintings with their more elastic forms, which he began employing in his own paintings along with de Chirico's severed heads.[10] Although Dalí denied that he was a surrealist at the time, the influence of the movement on his work became increasingly obvious. Paintings of 1927 such as *Apparatus and Hand* (fig. 4.1) and *Honey Is Sweeter than Blood* depict rotting donkeys, severed hands, heads and breasts, naked female torsos with body hair, veins, mannequins, and unidentifiable organic forms standing on or floating in receding landscapes. Yet they also contain bizarre mechanical forms or "apparatuses" that point to the continuing influence of machinism and purism on Dalí.

His writings of the period are similarly split. In the "Anti-Artistic Manifesto" of 1928, which Dalí cowrote with fellow Spanish intellectuals Sebastiá Gasch and Luís Montanyá while still living in Barcelona, Le Corbusier was named along with Breton as a "great artist."[11] The authors proclaimed that "mechanization has revolutionized the world" and that a "post-machinist state of mind" was being formed. In good purist fashion, they listed approvingly a number of "new phenomena full of an intense joy and joviality" that exemplified the modern, mechanized world, including "the cinema," "the stadium,

Figure 4.1 Salvador Dalí, *Apparatus and Hand*, 1927. Oil on wood, 62 × 47.5 cm (24.4" × 18.7"). Photograph © Salvador Dalí Museum, St. Petersburg, Florida, USA/The Bridgeman Art Library. © Salvador Dalí, Gala-Salvador Dalí Foundation/Artists Rights Society (ARS), New York.

boxing, tennis, and other sports," "the popular music of today: jazz and modern dance," "motor and aeronautics shows," and "beach games."[12] Later that year, Dalí dedicated a lecture he gave to Le Corbusier, whom he called "one of the purest defenders of the lyricism of our time, as well as one of the most hygienic minds of our day"; yet, at the same time, he was publishing texts and creating works that reflected his growing allegiance to surrealism.[13] How is it that he was able to unite two visions of modernity that, on the surface at least, seem to be so antithetical, and what effect did this have on *Un chien Andalou*?

The answer, as Dalí scholar Fèlix Fanés in particular has shown, lies in Dalí's philosophy of anti-art.[14] In his texts of the period, Dalí consistently argues against art and for anti-art—although his conception of anti-art is totally different from that of the Dadaists. In an article on an exhibition of his paintings in 1927, he states: "So-called *artistic* painting does nothing for me at all, neither does it move healthy people, people disinfected from art. Only intelligent and learned people are capable of understanding it."[15] This is in contrast to his own paintings, which he describes as "anti-artistic and direct; they move people and are immediately comprehensible, without the slightest technical training. (It is artistic training which prevents people from understanding them.) There is no need, as in the other kind of painting, for preliminary explanations, *preliminary ideas, prejudices*. They have only to be looked at with pure eyes."[16] Dalí associates art with a conventional, formulaic, clichéd way of looking at reality that has to be learned and that prevents people from seeing the world objectively in all its poetic strangeness. Anti-art, however, avoids such artistic stereotypes and can therefore be appreciated without aesthetic training. Free of preconceived notions, it reveals the extraordinary nature of the ordinary world around us. "To know how to look at an object, an animal, in a spiritual manner, is to see it in its greatest objective reality. But people only see stereotyped images of things, pure shadows emptied of all expression, pure ghosts of things, and they find vulgar and normal everything they are accustomed to seeing every day, as marvelous and miraculous as these things might be."[17] Dalí here uses Breton's word "marvelous" to refer to reality seen without artistic and other subjective prejudices,

but he still at this point (in 1927) distanced himself from surrealism, which he associated with artworks that express their makers' unconscious preoccupations. Though he did not deny the role of instinct and the subconscious in his own work, he insisted that it was rooted in objective facts about the external world. Reality is marvelous, creative, and imaginative enough on its own, he thought, and it is the "unlimited fantasy that is born of the things themselves" that should be the subject of art: "I will not insist on what appears to me today to be absolutely inadmissible, not just the poem, but any sort of literary production which does not comply with the anti-artistic, faithful and objective annotation of the world of facts, the revelation of whose occult meaning we still demand and await."[18]

For Dalí, therefore, anti-art primarily meant objectivity in the sense of an art free of artistic and other subjective distortions, rather than the assault on art advocated by the Dadaists, and he saw photography as the most objective art because, as it is mechanical, the human hand "no longer intervenes" in representing reality: "Pure objectivity of the little camera. Crystal lens. Lens of authentic poetry."[19] He celebrated machines and mass production for the same reason. The standardization and anonymity enabled by machines means that their products are free of human subjectivity and therefore objective, Dalí maintained. Much like nature, they therefore possess an alien beauty. In a text from 1928 entitled "Poetry of Standardized Utility," he declared:

> Le Corbusier, under the heading *Eyes Which Do Not See*, endeavored a thousand times, starting with *L'Esprit nouveau*'s logic—full of sensitivity and finesse—to make us see the simple and moving beauty in the miraculous newborn mechanical and industrial world, as perfect and pure as a flower. The majority of people, however, especially artists and, above all, those with so-called artistic taste, continue to chase away from their illogical and very complicated interiors, the joyful, precise clarity of the unique objects of an unquestionable era of eurythmics and perfection.[20]

Dalí saw cinema, like photography, as another product of mechanization and mass production capable of representing the world objectively, and in a text he dedicated to Buñuel, his collaborator on *Un chien Andalou*, he applied his distinction between art and anti-art to film, arguing that the "anti-artistic filmmaker limits himself to psychological, primary, constant, standardized emotions, aiming thereby to suppress anecdote."[21] The notion of standardization was central to Dalí's conception of the cinema at this moment, and he praised popular films that cater to the masses with generic emotions and uniform character types, particularly comedian comedy, contrasting their anonymity and freedom from human subjectivity with the artistic pretensions of a director like Fritz Lang, which he decried as "artistic putrefaction."[22] Once again, he made the crucial argument that, compared to the "crude" imaginings of an artist such as Lang in his film *Metropolis* (1927), reality is far more extraordinary and poetic.

It was this philosophy of anti-art that helped Dalí to reconcile his love of mechanization with surrealism as he fell increasingly under its spell. Dalí astutely perceived a resemblance between the automatic methods of artistic creation advocated by Breton, which were designed to circumvent the subjectivity of the artist in order to mechanically and objectively transcribe thought in all its irrationality, and his own desire to escape subjective artistic preconceptions and represent reality objectively in all its poetic strangeness. All that was required for him to align his version of machinism with surrealism was to extend his conception of reality beyond the external, physical world to include internal mental processes. This he accomplished when declaring his intention to do nothing more than document facts, in a series of articles he was commissioned to write for *La publicitat* in 1929 while in Paris during the filming of *Un chien Andalou*:

> In effect, documentary and the Surrealist text coincide from the outset in their essentially anti-artistic and more particularly anti-literary process, since not the slightest of intentions, be they aesthetic, emotional, sentimental, etc.,—essential characteristics of the artistic phenomenon—enter into this process. The documentary notes things said of the objective world anti-literarily. In parallel fashion, the

Surrealist text transcribes with the same rigor and as anti-literarily as documentary, the REAL free functioning of thought, of events which occur in reality in our mind, thanks to psychic automatism and to other passive states.[23]

As his use of the word "passive" here indicates, Dalí was picking up a line of argument in Breton's first "Manifesto of Surrealism" that characterizes surrealists as "modest *recording instruments*" who make "no effort whatsoever to filter" their thoughts but are instead "simple receptacle[s]" for them.[24] Like Dalí, Breton viewed artistic creativity as it was traditionally conceived as an impediment to the objective transcription of reality, which he defined in the manifesto as "the actual functioning of thought . . . in the absence of any control exercised by reason, exempt from any aesthetic or moral concern."[25] Somewhat paradoxically, Breton argued that the poet must actively and rigorously circumvent the conscious shaping of the thought process, which he should instead simply listen to and record: "I would like to sleep . . . in order to stop imposing . . . the conscious rhythm of my thought."[26] Hence, Breton disagreed with the poet Pierre Reverdy's theory of poetic imagery. He accepted Reverdy's claim that such imagery must consist of a "juxtaposition of two more or less distant realities"—as in Lautréamont's famous phrase, "beautiful as the chance meeting on a dissecting table of a sewing machine and an umbrella"—for such juxtapositions dispense with rationality and elicit the marvelous by bringing together incongruous objects and concepts. However, Breton rejected Reverdy's assertion that such images are "a pure creation of the mind."[27] Instead, quoting Baudelaire, he insisted that they "come to [the poet] spontaneously, despotically. He cannot chase them away; for the will is powerless now and no longer controls the faculties." The poet's role is "limited to taking note of, and appreciating" such juxtapositions, which occur to him in an instant like a "spark"—he does not invent or control them.[28] Once again we encounter here a version of the antisubjectivist subjectivism I pointed to in Dada. The surrealists were another group in a long line of modern artists who sought to liberate the nonrational or irrational dimensions of the mind in order to restore the vibrancy ("the marvelous") to

life that is supposedly eradicated by instrumental rationality. This subjectivism is simultaneously antisubjectivist because the rational part of the mind must be bypassed in order to access its irrational regions, and the surrealists practiced automatism, in which the writer tries to directly transcribe his thoughts on paper without any conscious mediation, in order to achieve this goal.

Dalí was able to find common ground between his conception of machinism and surrealism because he saw in Breton's advocacy of automatically and objectively recording internal mental phenomena a version of his own desire to represent the external world free of artistic and other subjective human distortions. He also found in surrealism something similar to his conception of external reality. Dalí railed against art in part because he found the world around him much more creative than anything an artist could imagine. In a text about *Un chien Andalou* published in October 1929, he claimed that there are "*facts*, simple *facts* independent of convention; there are hideous crimes; there are irrational and unqualifiable acts of violence which with their comforting and exemplary brilliance shed light upon the distressing moral panorama. There is the anteater, there is, quite simply, the forest bear, there is, etc."[29] Although he acknowledged that much can be explained about human violence, anteaters, and bears by science, he insisted that they would nevertheless always remain "enigmatic and irrational." Dalí's point is that nature, including human nature, is itself irrational, surreal, and therefore "marvelous," as is evident in inexplicable acts of human violence and bizarre creatures such as the anteater. It does not need the creative intervention of the artist to make it so. Quite the contrary: what is required is an objective gaze free of artistic and other subjective distortions to perceive it in all its strangeness.

Something similar is at stake in surrealist arguments about "objective chance," which Breton defined as "the form making manifest the exterior necessity which traces its path in the human unconscious."[30] He meant that certain coincidences in the external world seem at once both "fortuitous" and "preordained,"[31] "as expressive of both the randomness and the hidden order that surrounds us," as scholar of surrealism Maurice Nadeau puts it.[32] For example, in *Nadja* (1928), Breton describes an incident at the opening of one of Apollinaire's plays in which a

young man he does not know mistakes him for a friend killed in the war. A few days later, he begins corresponding with the poet Paul Éluard, and when they subsequently meet for the first time, he recognizes him to be the young man who mistook him for his dead friend at the play. Such a random occurrence reveals a mysterious causality at work in reality—that Éluard and Breton were preordained to meet—one that cannot exist according to a rational conception of the universe, which is therefore revealed to be an illusion. Putting aside one's rational prejudices and self-control allows one to experience objective chance and other equally irrational events in the external world, just as circumventing rational control of the mind enables one to record thought and other irrational phenomena in the internal one. *Nadja* is a compendium of similar events that supposedly *happened to* Breton (in the same way as the juxtaposition of distant realities in the surrealist image "comes to" the poet), all of which, he claims, are "facts" belonging to the "order of pure observation" rather than his creative inventions, and he therefore illustrated his book with documentary photographs of the places where some of the events occurred.[33] Inspired by the similarities between their surreal conceptions of external reality—by 1928 Dalí was refer-ring approvingly to Breton's notion that surreality is contained within reality[34]—Dalí soon began pointing to examples of objective chance in his own life,[35] and in an interview with the artist shortly after they wrote the screenplay for *Un chien Andalou* in early 1929, Buñuel remarked on Dalí's "love" for Breton's *Nadja*.[36]

As a result of this synthesis of surrealism and machinism, Dalí was able to describe *Un chien Andalou* as if it were a documentary, arguing that it "is about simple notation, the observation of facts."[37] Unlike other factual films, however, the facts it deals with, he argued, are "real facts, which are irrational, incoherent, unexplainable." As a result of human prejudices, most facts are distorted by being "endowed with a clear signification, a normal, coherent and adequate meaning." "That the facts of life appear coherent is a result of a process of accommoda-tion much like the one which makes thought appear coherent."[38] But in truth, thought, like reality in general, is "incoherence itself," which *Un chien Andalou* depicts as neutrally, objectively, and mechanically as possible. Hence the film, Dalí claimed, was "created without any aesthetic intention whatsoever," and he

contrasted it in particular with the artistic aspirations of the kind of pure cinema we encountered earlier in this book.[39] For Dalí, *Un chien Andalou* in all its surrealism was just as much the product of his distinctive version of machinism, an artistic worldview that celebrated the capacity of modern machines like photography and cinema to bypass the prejudices and distortions of human subjectivity and reveal reality objectively in all its inexplicable, surreal strangeness.

In the interview with Dalí, Buñuel articulated a similar anti-artistic philosophy. Asked by his interlocutor about the relative merits of the "anti-artistic industrial film" and the "art film," he averred that art did not interest him, and that "traditional ideas about art applied to industry seem monstrous to me. Whether we're talking about a film or a car. The artist responsible for polluting the purest objects of our time is also the one who understands them the least."[40] In the same interview he expressed admiration for the American film industry and the comedians Buster Keaton and Harry Langdon, noting that surrealism was the movement closest to his philosophy of life at that moment. Buñuel, who had known Dalí since his student days, had been advancing anti-artistic views for several years in his film criticism for *Gaceta literaria* and *Cahiers d'art*, views that accorded strongly with Dalí's. Like Dalí, he criticized Lang's *Metropolis* in a review of the film, impugning its "stale romanticism" and "theatrical acting";[41] and in another review he praised Keaton's *College* (1927) for its lack of sentimentality and the comedian's "monotonous expression."[42] In general his film criticism of 1927–1928 contrasts what he saw as the overly melodramatic, literary, and traditional European art film with the vitality and modernity of popular American film.

Of course, as scholar Haim Finkelstein has shown in his careful study of Dalí's and Buñuel's writings, there were important differences between the two.[43] Buñuel was a professional filmmaker who had worked in the French film industry for Jean Epstein, among others, since moving to Paris in 1925, and in his writing of the period he is much more concerned than Dalí with those cinematic features that set film apart from other arts, such as editing, the close-up, movement, and rhythm. For this reason, he was not as avowedly anti-art as Dalí when it came to cinema, and in fact many of his views echo those of René Clair and others

115

who sought to develop the young art of film by liberating it from the influence of theater and literature. In his review of *Metropolis*, he praised those moments of pure cinema in which the movement of machines comes to the fore in place of the melodramatic narrative, much as Clair had celebrated the sequences of the train in Abel Gance's *La roue* (1922) while criticizing its romantic story. He also positively reviewed Carl Dreyer's film *La passion de Jeanne d'Arc* (1928), expressing particular admiration for the "care and artistry" with which its close-ups were composed.[44] Dalí associated pure cinema and artistry with subjective artistic distortions that impeded objectivity, and he therefore dismissed them without qualification. Nevertheless, as Buñuel himself remarked in a letter he wrote in February 1929, just after he and Dalí had completed the screenplay for *Un chien Andalou*, the two were "more united than ever," and it is not hard to see why.[45] Both abhorred the way human prejudices prevented a clear, undistorted view of reality. Just as Dalí pointed to inexplicable acts of human violence and bizarre creatures such as the anteater as examples of "facts" that tend to be masked by human conventions, Buñuel praised the "extreme naturalism" of Erich von Stroheim's *Greed* (1924), a film he greatly admired for its presentation of "abject types, repulsive scenes in which primal and base passions find their most completely realized forms."[46] Both, in other words, shared a desire to transcend the subjective human biases that prevent reality from being viewed objectively in all its irrational strangeness, and both found in the anonymity and standardization of machines and mass culture, particularly cinema and comedian comedy, an ideal of the objectivity they sought. How, then, did they attempt to put this fusion of machinism and surrealism into practice in *Un chien Andalou*?

One way was by adopting what they considered to be an automatic method of writing the script. As Buñuel explained, "the plot is the result of a CONSCIOUS psychic automatism, and, to that extent, it does not attempt to recount a dream, although it profits by a mechanism analogous to that of dreams."[47] This method, however, did not consist of the automatic writing employed by surrealist poets. Instead, their approach was much more conscious. Referring to himself and Dalí in the third person, he wrote:

Both took their point of view from a dream image, which, in its turn, probed others by the same process until the whole took form as a continuity. It should be noted that when an image or idea appeared the collaborators discarded it immediately if it was derived from remembrance, or from their cultural pattern or if, simply, it had a conscious association with another earlier idea. They accepted only those representations as valid which, though they moved them profoundly, had no possible explanation. Naturally, they dispensed with the restraints of customary morality and of reason. The motivation of the images was, or meant to be, purely irrational! They are as mysterious and inexplicable to the two collaborators as to the spectator. NOTHING, in the film, SYMBOLIZES ANYTHING. The only method of investigation of the symbols would be, perhaps, psychoanalysis.[48]

Dalí and Buñuel, in other words, used images from their dreams in the film, but in order to circumvent their own subjective prejudices and objectively transcribe the "real functioning of thought," they consciously rejected anything that could be motivated by rational, moral, or aesthetic concerns, hence making the film as enigmatic to them as anyone else. This included symbols and their dreams (rather than individual dream images), which can be interpreted and explained. Instead, their criterion for inclusion of an image was whether it resonated emotionally—without their being able to explain why—and Buñuel therefore suggested that only psychoanalysis might be able to interpret the film, by identifying the unconscious source of this emotional resonance. It is highly unlikely that the entire script was written using this method, for it is clear that certain choices were motivated by aesthetic and even rational concerns, and a number of the film's images occur in the authors' previous work, such as the rotting donkeys and severed hand and ants (Dalí) as well as the slit eye (Buñuel). But the fact that Dalí and Buñuel putatively chose at least some of the material in the film using what they considered to be an automatic method points not only to the influence of surrealism but also to the anti-artistic, mechanical objectivity they

prized so much. It also explains why Dalí could describe the film as if it were a documentary that simply notates facts.

Another, more easily verifiable way in which the filmmakers synthesized their conception of machinism and surrealism was by employing standard conventions of mainstream narrative filmmaking. As commentators routinely point out, the film does not eschew these conventions as do avant-garde films such as *Rhythm 21*, *Ballet mécanique*, and the first half of *Entr'acte*. Instead, they are integral to the film's effects. We have seen that Dalí prized many of the products of mechanized commodity culture because he saw them as free of human subjectivity and therefore objective. It was in part for this reason that he and Buñuel shared a love of popular American film, with its stereotypical characters, generic emotions, and standardized plots. Just as Dalí praised "hockey sweaters manufactured anonymously" as emblems of modernity,[49] so Buñuel declared in his review of *Metropolis* that "a film . . . ought to be anonymous,"[50] and the standardized, ready-made language of mainstream filmmaking offered them yet another way to bypass their own subjective and artistic distortions in order to represent the real functioning of thought.

To start with, the film contains characters whose "romantic" aspirations would not be out of place in prevailing film genres such as melodrama, and as film scholar J. H. Matthews has pointed out, it includes "several disparaging allusions to the conventions of the silent movie drama, ridiculing its pantomime of passion and stylized gesture."[51] For example, eight years (according to an intertitle) after the prologue in which a man slits open a woman's eye, the same woman, her eye now intact, is sitting reading a book. She senses the approach of a different man who is riding a bicycle while dressed in a dark suit with white frills and wearing a black-and-white striped box around his neck. Dropping the book, she goes to the window and sees him arrive and topple over onto the sidewalk below. She then runs down the stairs of what is revealed to be an apartment building and kisses him passionately on the face as music from Wagner's opera *Tristan and Isolde* swells on the soundtrack (fig. 4.2). Such melodramatic moments occur elsewhere in the film. The version of the script that Buñuel published in *La révolution surréaliste* in December 1929 indicates that the cyclist "gestures like

the traitor in a melodrama" as he pursues the woman in her apartment (fig. 4.3) while she "watches her aggressor's little game in horror," and in general the film's plot, with its erotic conflicts and shifting objects of desire, is reminiscent of a melodrama.[52] Having bestowed her affections on the passive cyclist, the woman later rejects his advances as he aggressively pursues her and then abandons him for another man on a beach. Finally, she and the cyclist appear to meet a violent end buried up to their chests in sand.

It would be wrong, however, to conclude that the film parodies all the conventions of mainstream filmmaking. Although melodrama's sentimentality and theatricality would have been despised by Buñuel and Dalí and seen by them as a worthy target for parody, they praised other popular genres such as comedian comedy, and in *Un chien Andalou* they make strategic use of many of the standard continuity techniques employed in entertainment films from the 1910s onward. For example, the scene in which the woman sits reading in her apartment begins with an establishing shot that clarifies her spatial position relative to the setting (fig. 4.4) and is followed by a dissolve to a medium shot that renders her facial expressions perspicuous (fig. 4.5). As she looks up, as if sensing the cyclist's approach, intercutting shows him cycling outside (fig. 4.6). There is a cut on action when she throws down the book and another as she goes to the window. After she looks outside, a point-of-view shot shows the cyclist below and is followed by intercutting between shots of his fall and her reactions (figs. 4.7, 4.8). As she turns to walk to her apartment door, a reestablishing shot clarifies her spatial position anew (fig. 4.9) and is followed by another cut on action to a medium shot as she walks across the room. Meanwhile, continuity of set, light, costume, and music is maintained across the shots. All these continuity techniques, designed to ensure that the viewer can follow a film's story without confusion from one shot to the next, had long been commonplace in mainstream films by the time Dalí and Buñuel made *Un chien Andalou*, and they function similarly here to enable the viewer to understand, at least to some extent, the characters, their goals, and the time and space in which their actions occur—and not as targets of parody.

The anonymous, ready-made nature of these conventions was not the only reason for their use. We have seen that for Dalí, Buñuel, and Breton, in

Figure 4.2 Salvador Dalí and Luis Buñuel, *Un chien Andalou*, 1929.

Figure 4.3 Salvador Dalí and Luis Buñuel, *Un chien Andalou*, 1929.

Figure 4.4 Salvador Dalí and Luis Buñuel, *Un chien Andalou*, 1929.

Figure 4.5 Salvador Dalí and Luis Buñuel, *Un chien Andalou*, 1929.

Figure 4.6 Salvador Dalí and Luis Buñuel, *Un chien Andalou*, 1929.

Figure 4.7 Salvador Dalí and Luis Buñuel, *Un chien Andalou*, 1929.

Figure 4.8 Salvador Dalí and Luis Buñuel, *Un chien Andalou*, 1929.

Figure 4.9 Salvador Dalí and Luis Buñuel, *Un chien Andalou*, 1929.

their different ways, surreality was not independent from reality, but instead was contained within it in the form of enigmatic and irrational phenomena such as objective chance and anteaters. As film theorist Linda Williams in particular has noted in taking up this idea, surrealist filmmakers tend to represent the true functioning of thought in their screenplays and films by first invoking rational, aesthetic, and moral norms and then transgressing them.[53] In other words, liberated thought is made to stand out by placing it against a conventional background upon which it is dependent for visibility, and in *Un chien Andalou* this background is provided by norms of popular filmmaking that are instantiated only to be subverted. These familiar norms elicit expectations in the viewer about what is going to happen in the film, expectations that are then confounded, thereby drawing attention to the irrationality of the film's events and creating surprise and even humor owing to the incongruities that ensue. As Finkelstein has shown, this basic structure, in which "a conventional narrative . . . implying spatial and temporal continuity through indications of setting and temporal sequence . . . is undermined by the frenzied and hallucinatory quality of the actions and images," is one with which Dalí and Buñuel experimented in their creative writings before making the film, and it occurs in *Un chien Andalou* both on the level of the narrative, its characters and their goals and emotions, as well as on the moment-by-moment level of the editing of the shots and their composition.[54] On both registers, the filmmakers mix familiar forms of continuity that elicit conventional expectations with forms of discontinuity that ultimately frustrate those expectations.

The relationship between the prologue and the rest of the film establishes this pattern in exemplary fashion. The intertitle following the prologue provides temporal continuity by informing the viewer that the subsequent events occur eight years later, and the woman whose eye was slit in the prologue is quickly reintroduced. However, these continuities are mixed with discontinuities—there is no sign of her wound and it is never mentioned again. Nor does the person who slit her eye reappear. The continuities prompt the viewer to try to understand the relationship of the prologue to the rest of the film, but the discontinuities prevent a definitive understanding. This pattern occurs again and again. As the cyclist single-mindedly approaches the woman's apartment on his bike, we

might expect him to rush upstairs to greet her on his arrival. Instead, he falls onto the sidewalk, motionless and expressionless. This is the first of many times that a character's behavior alters abruptly and without explanation, thereby creating a discontinuity between earlier and later actions even while continuity is maintained by the physical presence of the character him- or herself.

The discontinuity between characters' actions is further accentuated by extreme emotional states that suddenly vanish for no reason and are often replaced by their opposites. Furthermore, although characters react conventionally to some things, their reactions to others are unusual. The woman runs downstairs and kisses the fallen cyclist passionately, and we might anticipate from the strength of her affection that she will continue to feel the same way in the next scene. But instead her affections are unexpectedly transferred onto items of his attire, which she carefully arranges, now back in her apartment, on a bed and which she stares at intently, while he seems to have disappeared. Again, continuity, this time in the form of a character's emotional attachment, is combined with discontinuity—the emotional attachment is inexplicably displaced from the cyclist to his clothing—leading the viewer to continue trying to understand the woman's relation to the cyclist to whom the clothes are connected. She suddenly notices him in another part of the room, now dressed only in his suit, mesmerized by some ants crawling in and around a wound on his hand, and she goes to join him. But gone are her amorous feelings toward him and her interest in his items of clothing. Instead, she appears as fascinated as he is by the wound, which is shown in close-up, instead of exhibiting disgust and horror, as one might predict.

As David Bordwell has shown, one of the major differences between "classical" characters and the art-film variety that Dalí and Buñuel for the most part hated is that "the Hollywood protagonist speeds directly toward the target; lacking a goal, the art-film character slides passively from one situation to another."[55] *Un chien Andalou*'s protagonists are definitely of the classical kind, as their emotions and goals are clear and recognizable just as they tend to be in mainstream genres such as melodrama. However, unlike those of classical characters and indeed of human beings in general, these goals and emotions change abruptly

and for no apparent reason, thereby rendering the psychologies of the characters mysterious. As film theorist Murray Smith has argued, our fundamental category of human agency, what he calls the "person schema," includes "persisting attributes."[56] But in *Un chien Andalou*, as we have seen, emotions that are strongly felt and goals that are single-mindedly pursued at one moment, such as the woman's passion for the fallen cyclist, are abandoned at the next and are frequently replaced by antithetical ones. Indeed, sometimes the contrasting attitudes of characters occur simultaneously, as when the woman kisses the cyclist passionately while he lies inert on the street, thereby creating incongruous, amusing juxtapositions. All human beings are inconsistent to varying degrees, changing their minds about their desires and feeling differently at different moments, but a degree of consistency in basic traits and objectives is a criterion of minimal psychological rationality, and it is this consistency that *Un chien Andalou* so effectively shatters.

In addition, various temporal and spatial discontinuities are prevalent in the film. Objects suddenly appear and disappear, most famously the two grand pianos with rotting donkeys that the cyclist drags into view while pursuing the woman in the apartment. The cyclist on several occasions occupies two spatial positions at once, thereby violating another tenet of the person schema, namely, that a human agent occupy "a discrete human body,"[57] and intertitles point to gaps in time that are not verified by the image. There are sudden jumps in space from the apartment to a forest and a beach, locations that are chosen for their obvious contrast with the city, and ellipses between different parts of the film are never filled in. Yet these various discontinuities are mixed with continuities of action, character, and mise-en-scène that encourage the viewer to try to understand the characters and expect certain outcomes. To cite one more example, as the cyclist's chase of the woman in the apartment comes to an end, she sticks out her tongue at the man, puts on a scarf, and exits through the door behind her. We cut to the other side of the door as she continues to stick out her tongue at the man before closing it and turning to look off-screen. A reverse shot shows a new man on a beach whom she waves at and then runs toward. Here, a continuous action—her waving at and running to meet the man—occurs across a

spatially discontinuous cut from an apartment building in the middle of a city to a beach.

The same principle, as film scholar Phillip Drummond has shown, is operative in the editing of the film and the composition of its shots.[58] Again and again, the continuity techniques I pointed to in the first scene in the apartment are mixed with subtle and not-so-subtle discontinuities. To take one of any number of examples, in the sequence in which the woman in the street is run down by a car, a high-angle shot shows a policeman dispersing a crowd, while the woman holds a box (containing the severed hand the policeman has placed inside it) in front of her and stands facing the apartment building (fig. 4.10). We know from previous shots that the couple in the apartment above have been looking down at her, and therefore we might be tempted to construe this high-angle shot as a point-of-view from their position—especially as in previous shots they have been looking down to the bottom right of the screen and the high-angle shot roughly accords with the angle of their gaze (fig. 4.11). In the next medium shot of the woman from street level, however, she is clutching the box instead of holding it in front of her, and she is turned slightly to the right of the apartment building toward the camera (fig. 4.12). We cut back to the cyclist, but he is now looking to the bottom left of the screen instead of the bottom right, even though the woman down below has not changed her position, thereby creating uncertainty about whether he is still looking at her (fig. 4.13). After another street-level medium-shot of the woman and a brief two-shot from behind of the couple at the window, a high-angle shot of the woman with a car passing near her shows that she is now facing to the left of the apartment building (fig. 4.14). Several shots of the cyclist and the woman follow before a point-of-view shot of an oncoming car, seemingly from the woman's position, occurs (fig. 4.15). We cut back to a reaction shot of her face as she notices it (fig. 4.16), followed by a reverse shot through the car's window that shows her with her hands up and the box on the ground (fig. 4.17). But in the next shot she is clutching the box again (fig. 4.18), while in the subsequent one the box is once more on the ground as she waves her arms in the air (fig. 4.19). Such inconsistencies—in the direction the woman is facing and her posture, the position of the box, and the direction of the cyclist's gaze—are nevertheless combined with continuity techniques such

Figure 4.10 Salvador Dalí and Luis Buñuel, *Un chien Andalou*, 1929.

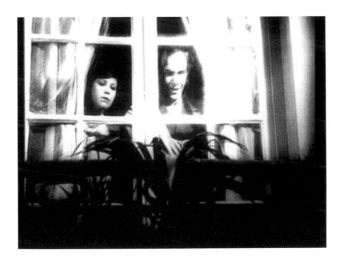

Figure 4.11 Salvador Dalí and Luis Buñuel, *Un chien Andalou*, 1929.

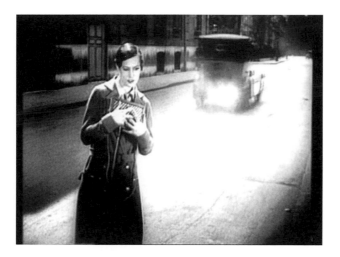

Figure 4.12 Salvador Dalí and Luis Buñuel, *Un chien Andalou*, 1929.

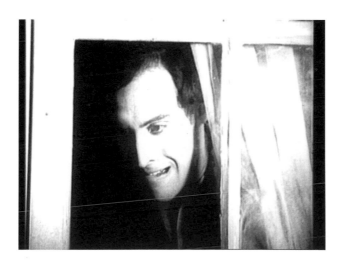

Figure 4.13 Salvador Dalí and Luis Buñuel, *Un chien Andalou*, 1929.

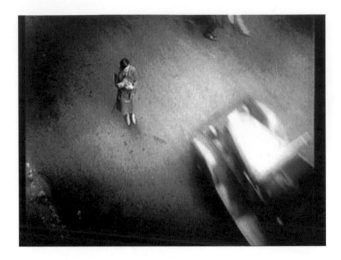

Figure 4.14 Salvador Dalí and Luis Buñuel, *Un chien Andalou*, 1929.

Figure 4.15 Salvador Dalí and Luis Buñuel, *Un chien Andalou*, 1929.

Figure 4.16 Salvador Dalí and Luis Buñuel, *Un chien Andalou*, 1929.

Figure 4.17 Salvador Dalí and Luis Buñuel, *Un chien Andalou*, 1929.

Figure 4.18 Salvador Dalí and Luis Buñuel, *Un chien Andalou*, 1929.

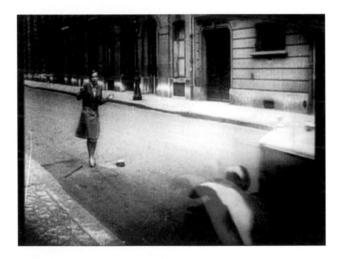

Figure 4.19 Salvador Dalí and Luis Buñuel, *Un chien Andalou*, 1929.

as (approximate) point-of-view shots, shot/reverse shots, and a rough adherence to the 180 degree rule (all the shots of the woman, with the possible exception of the reverse shot from the car, are taken from one side of her). There is also a strong continuity of action and character across these shots.

This systematic combination of continuity and discontinuity has resulted in two diametrically opposed approaches to the film. Emphasizing its continuities, interpreters have ascribed all sorts of latent meanings to it or one of its parts. Williams, for instance, focuses on the recurrence of motifs of mutilated flesh and gender conflation, interpreting the "woman's split eye as a metaphor for the vagina and the razor as a substitute penis," in her "rhetorico-psychoanalytic" analysis of the prologue, which she sees, along with the film as a whole, as about the fear of castration and the denial of sexual difference.[59] Drummond, however, has argued that the film's manifold inconsistencies and discontinuities render any such interpretation problematic if not impossible. The film is irredeemably "polyvalent," he claims; though there might be moments when coherent meaning emerges briefly, these are always short-circuited by the kind of incongruities we have examined here.[60] There is thus no general interpretive scheme that can account for the film unless its heterogeneity is ignored. Both approaches, however, overlook the insight contained in Buñuel's contradictory statement that "nothing, in the film, symbolizes anything" and that "the only method of investigation of the symbols would be, perhaps, psychoanalysis." This statement suggests that the film simultaneously lures the viewer with continuities that hint at a hidden logic that can make sense of everything, yet it ultimately keeps this logic just out of reach by way of its discontinuities. In other words, *Un chien Andalou* brilliantly instantiates the conception of surreality as contained within reality, one in which a mysterious order is sensed beneath the surface of reality that is mysterious precisely because it remains forever elusive and inexplicable. Breton articulated this paradox wonderfully in his first manifesto: "It is in quest of this surreality that I am going, *certain not to find it* but too unmindful of my death not to calculate to some slight degree the joys of its possession."[61]

Be this as it may, Dalí and Buñuel borrowed heavily from mainstream narrative filmmaking in *Un chien Andalou,* and they did so both because of their

admiration for the standardization and anonymity of the conventions of popular film and because these enabled them to put into practice their conception of surreality. Rather than employing what Benjamin calls "the outmoded," or mocking and parodying what Foster terms the "mechanical-commodified," they valued the mechanized commodities of the modern world for the anti-artistic objectivity they promised, and they saw in the surrealist concept of automatism a complementary notion of mechanization and ideal of objectivity. As with the other avant-garde filmmakers examined in this book, their stance toward bourgeois modernity was one of neither complete acceptance nor outright rejection. Instead, they drew on and celebrated its products while simultaneously undermining the rationality that made it possible.

CITY SYMPHONY AND *MAN WITH A MOVIE CAMERA*

Of all the avant-garde filmmakers discussed in this book, Dziga Vertov was the most influenced by machinism, the belief that reality should be transformed using the machine as both tool and blueprint. During the 1920s in the Soviet Union, he was affiliated with the Left Front of the Arts as well as constructivism. These groups consisted of avant-garde artists, many of whom had belonged to the prerevolutionary generation of futurists, who formulated a new concept of art, one that befitted the supposedly egalitarian Communist society that was being built around them. They conceived of the artist as a worker, much like an engineer, who produced socially useful objects. Art should serve a practical purpose and aid in the construction of the new Communist state, they believed, and they therefore railed against "art for art's sake," which they associated with the old, bourgeois society that had been overthrown by the revolution. They also, to varying degrees, modeled art-making on industrial production, using modern materials and methods as well as aiming for efficiency and economy. The artist, they thought, ought to be like a factory worker who manufactures socially useful objects using the tools and principles of industrial production, and they designed and manufactured furniture, utensils, advertisements, and clothing.

These ideas had a profound influence on Vertov's theory and practice.[1] He believed passionately that film should be socially useful, and he located its

social mission in the revelation and organization of facts about reality rather than in fictional storytelling: "*Revolutionary cinema's path of development has been found*. It leads past the heads of film actors and beyond the studio roof, into life, into genuine reality, full of its own drama and detective plots."[2] In addition, he attempted to model filmmaking on industrial production, envisaging a time when a film studio would be a centralized "factory of facts" organized according to principles of efficiency and economy. In *Man with a Movie Camera* (1929), the city symphony I will focus on in this chapter, we see Elizaveta Svilova, Vertov's wife, carefully cataloging and storing footage in her editing room, and the film compares her and the cameraman's labor to various forms of manual work in the service sector, factories, and heavy industry (fig. 5.1).

Vertov also exalted machines and their products, especially in his early writings, comparing them favorably to human beings. In his 1922 manifesto "We," for example, he argues:

> The machine makes us ashamed of man's inability to control himself, but what are we to do if electricity's unerring ways are more exciting to us than the disorderly haste of active men and the corrupting inertia of passive ones?
>
> Saws dancing at a sawmill convey to us a joy more intimate and unintelligible than that on human dance floors.
>
> *For his inability to control his movements, WE temporarily exclude man as a subject for film.*
>
> *Our path leads through the poetry of machines, from the bungling citizen to the perfect electric man. . . .*
>
> *The new man*, free of unwieldiness and clumsiness, will have the light, precise movements of machines, and he will be the gratifying subject of our films.[3]

Hence, we often find in Vertov's films the mechanization of human beings as encountered in *Ballet mécanique*. In *Man with a Movie Camera*, there is a frenetic sequence that interconnects shots of various types of labor. Close-ups of film

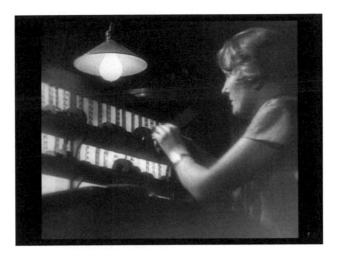

Figure 5.1 Dziga Vertov, *Man with a Movie Camera*, 1929.

celluloid being edited are interspersed with shots of typing, writing, a sewing machine, and a newspaper conveyer belt. Typically, only the workers' hands are visible in these shots, moving swiftly and precisely, with occasional cuts to their faces as they stare intently at their work. Within this fast-paced, exuberant sequence, there is a short series of shots of a woman folding boxes on a wooden block. It begins with a close-up of a machine processing similar boxes (fig. 5.2) and is followed by a close-up of the woman's hands rapidly folding a box on the block and a shot of her face as she stares down at her work and throws the completed box over her shoulder onto a pile (figs. 5.3, 5.4). The film cuts back and forth between identical shots of the woman's hands and face about five or six times. We then return to the box-sorting machine followed by a final shot of the woman. Her movements are identical in each shot, much like the repetitious movements of a machine, and the cuts between her hands and face follow a regular, mechanical rhythm. At first, each shot of her hands lasts for roughly two seconds, as she folds the box, while the shots of her face last a single, third second. This pattern is repeated five or six times and its pace accelerated, thereby endowing the worker with the mechanical rhythm of the box-sorting machine with which she works.

To understand Vertov's dedication to machinism, one must bear in mind that he worked in a society captivated by the materialist analogy between human beings and machines and, more generally, the authority of the natural sciences. In the middle of the nineteenth century, a new conception of the human body as a motor—a machine that converts energy into work—had arisen, one in which the body was viewed as identical to machines and natural forces in the sense that all were now considered to be systems of production subject to the same objective and universal laws of energy conversion and conservation measurable by science.[4] This so-called productivist vision of the identity of nature, machine, and human body had a profound impact on the organization of work in the latter half of the nineteenth century. It gave rise to the attempt by F. W. Taylor, Frank Gilbreth, and others to objectively measure and quantify labor power in the development of a science of work, the goal of which was to harmonize workers with machines and the industrial workplace to ensure the most

Figure 5.2 Dziga Vertov, *Man with a Movie Camera*, 1929.

Figure 5.3 Dziga Vertov, *Man with a Movie Camera*, 1929.

Figure 5.4 Dziga Vertov, *Man with a Movie Camera*, 1929.

efficient deployment of energy and the maximum productivity possible. And it resulted in vastly more efficient and productive working practices in the drive toward industrial modernization. By the 1920s it had become, in the words of the historian Anson Rabinbach:

> the common coin of European industrial management and of the pro-Taylorist technocratic movements across the European political landscape. . . . On all points of the political spectrum "Taylorism and technocracy" were the watchwords of a three-pronged idealism: the elimination of economic and social crisis; the expansion of productivity through science; and the reenchantment of technology. The vision of society in which social conflict was eliminated in favor of technological and scientific imperatives could embrace liberal, socialist, authoritarian, and even communist and fascist solutions. Productivism, in short, was politically promiscuous.[5]

Promiscuous it was. Productivism found fertile ground among Russian and other Eastern European revolutionaries and industrial reformers who desired to liberate their peoples from widespread poverty, primitive and often barbaric social conditions, and backward work practices. It gave rise after the October Revolution—although not without debate and controversy—to the Soviet cult of Ford and the experimentation with and implementation of various Taylorist work practices and forms of scientific management in an effort to industrialize rapidly.[6] Furthermore, its utopian dimension appealed strongly to Russian and Marxist visionaries, especially (in the words of Rabinbach) its "reenchantment of technology," the belief that the integration of human beings and technology in the name of the expansion of production would bring about the perfection and ultimate salvation of humankind.

As the historian Richard Stites has argued, this enchantment with technology probably found its most extreme expression in the "cult of the machine" of figures such as poet Alexei Gastev.[7] In his thirst for social and industrial modernization, Gastev eagerly embraced and extended Taylorism and the analogy

between human being and machine. For him, technology would not only emancipate human beings; it would also literally transform them into "new people," more perfect because more machine-like. While working, these new people would be able to coordinate and control their movements with the precision and efficiency of a machine, ensuring maximum productivity and eliminating wastage of time and energy. Their daily lives would be governed by self-discipline and the perpetual quest for the most expedient and efficient use of their time. Gastev's popular poetry from the 1910s is particularly well known for the way it envisages a mechanical paradise in which human being and machine are perfectly synthesized in their grand dominion over nature, and human beings with "nerves of steel" and "muscles like iron rails" have become perfectly harmonized to the movement and tempo of machines. Nor was this a marginal artistic vision. Following the Revolution, Gastev founded the Central Institute of Labor (1920), which received the support of Lenin and other leaders and was given the task of coordinating Soviet research on labor rationalization.[8] The institute was devoted to the scientific study of work and to training a cadre of advanced workers how to perfectly master both a series of core movements and complex machinery while eliminating superfluous expenditures of energy. Such workers would be knowledgeable about advanced technology and adept at thinking and moving in efficient, disciplined, and precise ways, their bodies trained to harmonize with factory machines. Gastev edited several major industrial journals, held various government positions, and was one of the leading Soviet popularizers of Taylorism.

This same desire to transform human beings into "new people," more perfect because more machine-like, can be found in Vertov's theory and practice. It is clearly evident in the following passage from "We": "In revealing the machine's soul, in causing the worker to love his workbench, the peasant his tractor, the engineer his engine—we introduce creative joy into all mechanical labor, we bring people into closer kinship with machines, we foster new people."[9] In another text, Vertov writes of being able to "create a man more perfect than Adam" using the machines of cinema, and, as we have seen, films such as *Man with a Movie Camera* contain sequences in which humans are mechanized.[10]

For these reasons, commentators have typically concluded that Vertov was an unambiguous proponent of machinism, employing the machine as the model for both his films and the new Soviet society depicted in them. Film critic Gilberto Perez summarizes this standard view eloquently and concisely: "[Vertov's] *Man with a Movie Camera* pictures the city as a vast machine seen by the omnipresent seeing machine that is the camera. The structure of Vertov's films, their aggregate space pieced together in the cutting room out of all the manifold things the mechanical eye can see, suggests the constructions of the engineer so prized in [the] new Soviet society."[11]

Yet, unsurprisingly given what we have discovered throughout this book, Vertov's stance toward machinism was more complicated than it might at first appear. To start with, the focus of commentators on the machine in Vertov's work has obscured the influence of other models as he was making *Man with a Movie Camera* in the late 1920s, including one that is often thought of as antithetical to the machine, namely, the organism.[12] *Man with a Movie Camera* is structured according to the daily cycle of a complex living organism such as a human being—waking, work, and relaxation—a structure established in earlier city films like Walter Ruttmann's *Berlin, Symphony of a Great City* (1927). After the prologue in which an audience arrives to watch a film in a movie theater, we see, first, a city's empty streets, still machines, closed shops, and sleeping people, including some who are homeless. Gradually, its inhabitants, including the cameramen, get up and go to work; streets are cleaned, transport systems start up, and machines begin operating. People are shown engaged in a wide variety of daily activities, from getting married and divorced to operating machines and manufacturing objects. Finally, the workday ends and leisure begins. Citizens congregate on beaches, exercise, and enjoy forms of entertainment such as chess and, of course, watching a film, which turns out to be *Man with a Movie Camera* itself, in the movie theater shown in the prologue, to which we return at the film's end.

Moreover, the model for the new Communist society depicted in the film is an organism, not a machine. As Annette Michelson has argued:

> This film . . . joins the human life cycle with the cycles of work and
> leisure of a city from dawn to dusk within the spectrum of indus-
> trial production. That production includes filmmaking . . . min-
> ing, steel production, communications, postal service, construction,
> hydro-electric power installation, and the textile industry in a seam-
> less, organic continuum. . . . The full range of analogical and meta-
> phorical readings thereby generated signify a general and organic
> unity.[13]

By "organic unity" and "organic continuum," Michelson means that Vertov
consistently depicts the different parts of Communist society as interdepen-
dent and interconnected into a whole by linking them through "strategies of
visual analogy and rhyme, rhythmic patterning, parallel editing, superimposition,
accelerated and decelerated motion, camera movement—in short, the use of
every optical device and filming strategy then available to film technology."[14]
Machines, too, can be described as wholes with interconnected, interdependent
parts. However, as Noël Carroll has pointed out, "in political philosophy, the
organic society is one in which the community is integrated by a common goal,"
and it is precisely goals that machines, because they are automatic and unthinking,
are thought to lack.[15] By linking otherwise separate human beings and activities,
Man with a Movie Camera attempts to show Soviet citizens that they are united
in the common goal of building the new Communist society, that their actions
have a purpose, a meaning, that they are part of a teleological, organic whole.
An obvious example is the exhilarating sequence in which filmmaking and
industrial production are connected through rapid editing and graphic matches.
After a sequence of cameramen filming a dam, several rapidly spinning machine
parts are shown, and these are intercut with a close-up of a hand cranking a
movie camera, the fast, circular motion of the hand crank rhyming with that of
the rotating machines (fig. 5.5, 5.6). Following a shot of smoke pouring from a
vent, a shot of the cameraman with his tripod slung over his shoulder is rapidly
intercut with shots first of factory chimneys and then small, spinning machine
parts (figs. 5.7–5.9), thereby creating a flicker effect in which the cameraman

Figure 5.5 Dziga Vertov, *Man with a Movie Camera*, 1929.

Figure 5.6 Dziga Vertov, *Man with a Movie Camera*, 1929.

Figure 5.7 Dziga Vertov, *Man with a Movie Camera*, 1929.

Figure 5.8 Dziga Vertov, *Man with a Movie Camera*, 1929.

Figure 5.9 Dziga Vertov, *Man with a Movie Camera*, 1929.

appears to be superimposed over the other shots. In this sequence, as in many others in the film, it is the rhythm of the editing that creates the impression that the activities it depicts are not just interconnected but goal-oriented. For as it progresses, the editing speeds up until the sequence climaxes in a burst of shots that are so short as to be virtually indistinguishable.

The film as a whole, as Vertov scholar Vlada Petrić has shown in his meticulous analysis, employs a unique style of editing he refers to as "disruptive-associative montage" to connect the various people and activities it represents:

> A sequence establishes its initial topic and develops its full potential through an appropriate editing pace until a seemingly incongruous shot (announcing a new topic) is intercut, foreshadowing another theme that, although disconcerting at first glance, serves as a dialectical commentary on the previously recorded event. The metaphorical linkage between the two disparate topics occurs through an associative process that takes place in the viewer's mind.[16]

This style of editing creates some complex sequences in which Vertov intercuts between several different activities rather than moving from one to the next in a linear fashion. In the sequences depicting marriage, divorce, death, and birth, for example, he cuts back and forth between these four themes rather than presenting them sequentially, and also includes shots of a traffic signal, the camera, and trams. As always, there are rhymes between the shots that suggest links between them, such as the physical similarity between a woman getting divorced who hides her face with her arm and another weeping over the death of a loved one, her head cradled in her arm in grief (figs. 5.10, 5.11). As Vertov himself puts it in his article on the film: "Each item or each factor is a separate little document. The documents have been joined with one another so that, on the one hand, the film would consist only of those linkages between signifying pieces that coincide with the visual linkages and so that, on the other hand, these linkages would not require intertitles; the final sum of all these linkages represents, therefore, an organic whole."[17] By way of these visual linkages, Vertov emphasizes

Figure 5.10 Dziga Vertov, *Man with a Movie Camera*, 1929.

Figure 5.11 Dziga Vertov, *Man with a Movie Camera*, 1929.

the essential oneness of the new Communist society, the fact that every human activity, whether it be mining, steel production, or filmmaking, is part of a larger organic whole. In this way, according to Michelson, Vertov's films attempt to instill in his Soviet viewers the belief that they are all interdependent and equal owners of the means of production, "the euphoric and intensified sense of a shared end: the supercession of private property in the young socialist state under construction."[18]

Furthermore, in addition to mechanizing human beings, Vertov just as often gives machines human attributes. There is a sequence toward the end of *Man with a Movie Camera* in which the movie camera, having enjoyed a starring role throughout the film, performs an encore (fig. 5.12). Emerging on its own onto a bare stage, it proceeds to walk about on its tripod, carefully displaying its parts to the appreciative audience within the film and almost bowing in the process. The people in the audience smile with delight, and in doing so echo the smiles of children from an earlier sequence who similarly delighted in the performance of a magician. Indeed, if we had to choose a human being whom the camera most clearly resembles at this moment, it would be the magician from the earlier sequence because of the cinematic magic trick (stop-motion) that enables it to move autonomously.

By conferring human attributes on his camera in this sequence, Vertov is replicating in his film practice a major rhetorical tendency of his film theory. He often ascribes to the camera predicates, primarily perceptual predicates, normally reserved for human beings and other living creatures. As the philosopher Ludwig Wittgenstein argued, "Only of a living human being and what resembles (behaves like) a living human being can one say: it has sensations; it sees; is blind; hears; is deaf; is conscious or unconscious."[19] But in his film theory, Vertov grants the camera the ability to do at least one of these things: to see. Here is a typical example, a kind of free indirect speech on behalf of the camera: "I am kino-eye, I am a mechanical eye. I, a machine, show you the world as only I can see it."[20] Vertov's theoretical writings are full of similar passages in which he bestows on the camera the power of sight and the capacity to show and reveal things to the film spectator. In these passages, it is as if Vertov's camera were alive, as if it

Figure 5.12 Dziga Vertov, *Man with a Movie Camera*, 1929.

were an agent of some kind with intentionality, a will, just as it appears to be when it emerges onto the stage. Nor is this scene the only example in the film. Although its title is *Man with a Movie Camera* and "the man," Boris Kauffman (Vertov's brother), is often shown operating the camera, sometimes it is framed in such a way as to exclude him and to make it appear that the camera is acting independently. For example, during the sequence in which a couple registers to get married, there are four shots of the camera perched on a rooftop overlooking the city (fig. 5.13). There is no sign of the operator, yet it swivels on its tripod as if scanning the horizon, and as the couple leaves it abruptly rotates almost 80 degrees, as if it has just noticed something new.

One way of understanding this anthropomorphization of the camera is to view it as an example of what Walter Benjamin called the "mimetic faculty," the "gift of seeing resemblances." Benjamin suggested that a mimetic faculty was responsible for the "magical correspondences and analogies that were familiar to ancient peoples" and that it continues to find "its school" in modernity in the play of children, who often imaginatively attribute human capacities and characteristics to nonhuman objects, especially those that bear a physical resemblance to humans such as dolls.[21] Vertov's anthropomorphized camera can perhaps be understood as a playful analogy based on morphological similarities between the camera and human beings. Certainly, *Man with a Movie Camera* repeatedly and deliberately underscores such resemblances. The famous shot of the human eye superimposed on the camera lens highlights the affinities of shape and function between the two (fig. 5.14), and the sequence already described in which the camera walks around on the stage exploits the isomorphism between the human form and the camera. Moreover, the audience in this sequence, shown smiling and laughing at the camera's movements, is not deceived by the "illusion" that the camera can move around on its own like a human being. The audience members do not take it literally. Rather, they smile and laugh as if it were a playful joke, an amusing conceit, which is a good indication that we—Vertov's viewers and readers—should take it in the same way.

Also, it is possible to locate in Vertov's film theory a plausible rationale for this analogy:

Figure 5.13 Dziga Vertov, *Man with a Movie Camera*, 1929.

Figure 5.14 Dziga Vertov, *Man with a Movie Camera*, 1929.

The mechanical eye, the camera, rejecting the human eye as crib sheet, gropes its way through the chaos of visual events, letting itself be drawn or repelled by movement, probing, as it goes, the path of its own movement. It experiments, distending time, dissecting movement, or, in contrary fashion, absorbing time within itself, swallowing years, thus schematizing processes of long duration inaccessible to the normal eye.[22]

This passage is typical of Vertov's writings in its argument that the movie camera is much more powerful than the human eye because it can show and reveal to human beings what the eye cannot see, and it is this reverence for the camera, expressed time and again in Vertov's film theory, that perhaps explains his anthropomorphization of it. By asking us to entertain the imaginative conceit that the camera can see, Vertov is perhaps suggesting that its power is so great that it is as if it were an independent agent of sight, like a human being. Vertov is in effect asking us to join him in his feeling of awe and reverence for the power of the camera as a machine, and he is trying to elicit in us a sense of almost childlike wonder and delight at the magnitude and potential of this power.

This interpretation of the camera eye, however, leaves certain questions unanswered. To start with—as is obvious from Vertov's argument that the movie camera is a much more powerful instrument of sight than the human eye—however important morphological similarities between human beings and the camera might be for Vertov, what is far more important for him, and what he points to again and again in his film theory, is the enormous difference between the two. For him, an immense gulf separates them, and it is this gulf that is at the center of his film theory rather than any morphological similarities. "The kino-eye lives and moves in time and space; it gathers and records impressions in a manner wholly different from that of the human eye. The position of our bodies while observing or our perception of a certain number of features of a visual phenomenon in a given instant are by no means obligatory limitations for the camera which, since it is perfected, perceives more and better."[23] The human eye, according to Vertov, is weak, flawed, and primitive in contrast to the

camera, and he constantly emphasizes its "imperfections" and "shortsightedness" in comparison to the infinite perfectibility of the camera, which he continually celebrates and exalts. "The weakness of the human eye is manifest," he declares. "We cannot improve the making of our eyes, but we can endlessly perfect the camera."[24] Thus, beneath the morphological parallels that Vertov draws in his film practice between camera and human eye lies a fundamental dissimilarity between the two that takes center stage in his film theory. At the very least, therefore, it seems strange that Vertov would extend human attributes to his camera because, for him, the camera and human beings are fundamentally dissimilar; the camera is much more powerful than the human eye.

Even stranger is the fact that Vertov would ask us to entertain the idea that the camera can see in the first place, that he would wish to place us in the "primitive" position of a child engaged in the mimetic game of imaginatively extending human capacities to nonhuman objects. Vertov advocated the "unstaged" film of fact as the most socially useful way of using the cinema, and his practice is usually seen as profoundly "anti-illusionist," dedicated to shattering myths and revealing truths about reality. This includes imperfections in the new Communist society—hence the shots of homeless people and drunkenness in *Man with a Movie Camera* and the acknowledgment of continuing class stratification in the scene of bourgeois women having their bags carried by servants. Hence, too, the honesty about the illusory power of film as a medium through the arrest of motion in the sequence of the bourgeois women in a horse-drawn cab and the reflexive gesture of showing Svilova at the editing table working on the very film we are watching. Such anti-illusionist and reflexive strategies have led commentators such as Michelson to argue that Vertov's project aspires to enlighten its viewers, to "render insistently concrete . . . that philosophical phantasm of the reflexive consciousness, the eye seeing, apprehending itself through its constitution of the world's visibility."[25] *Man with a Movie Camera*, she argues, is a film in which Vertov transforms his camera "from a Magician into an Epistemologist," in which he invites "the camera to come of age," to grow up and leave childish tricks and games behind.[26] If this is true, however, why would Vertov *also* be asking us to regress, to engage in the childlike game of extending human capacities to the very "tool of Enlightenment" itself, the film camera? Just as, for Marx,

the "social character of men's labor" is displaced onto the commodity, thereby becoming disguised as a magical property of the commodity itself, the camera in Vertov's theory and practice is fetishized. It is an object of reverence, far more powerful than we are, as if enchanted, as if possessed of a power independent of us. It is as though the camera were not our creation, our tool.

All of this is a roundabout way of saying that there is more to Vertov's camera–eye analogy than meets the eye. It is premised more on alterity than resemblance, and it seems to violate the Enlightenment trajectory "from Magician to Epistemologist" of Vertov's project by asking us to regress, to view the camera as something that is not subject, like a tool or instrument, to the control and manipulation of human beings, but that can see on its own, much like a human being, yet in a way far superior. Why this "surfacing of 'the primitive' within modernity," to use anthropologist Michael Taussig's words?[27]

We have seen that, like Gastev and other Soviet visionaries, Vertov in his early writings envisaged the transformation of human beings into "new people," more perfect because more machine-like. Vertov's conception of this transformation was not as excessive or obsessive as Gastev's, however, although it probably owed a lot to him. It lacks, for example, the exploitative and dehumanizing dimensions of Gastev's endorsement of Taylorism. Gastev argued that mechanization, standardization, and the division of labor in modern industry would necessarily eliminate creativity from work, resulting in a uniform, mechanized proletariat with a new psychology. These features of industrial production, he wrote, "will impart to proletarian psychology a striking anonymity, permitting the classification of an individual proletarian unit as A, B, C, or 325, 0'075, O, and so on."[28] Gastev was a controversial figure in the 1920s and was criticized by those who rejected Taylorism as exploitative, as well as those who argued that, as a product of capitalism, Taylorism should only be critically and selectively appropriated. Vertov, by contrast, retained a deep respect for the "organic" nature of human life, which is apparent in the organic structure of *Man with a Movie Camera* as well as the film's attempt to show Soviet citizens that they are interdependent, interconnected, and united in the goal of building the new Communist society.

Furthermore, if we look carefully at what Vertov says about the relationship between machines and humans as well as the way he represents this relationship on screen, we can see that he does not simply advocate the mechanization of human beings. Instead, his vision is an egalitarian one of machine and human being working in harmony, a harmony created by humans taking on attributes of machines such as their rhythms and efficient movements, and the machine being endowed with human qualities in order to render it appealing rather than alienating to its human operators. It is worthwhile to quote the relevant passage from "We" again: "In revealing the machine's *soul,* in causing the worker to love his workbench, the peasant his tractor, the engineer his engine—we introduce creative joy into all mechanical labor, we bring people into closer kinship with machines, we foster new people."[29] Here, rather than mechanizing human beings, Vertov recommends humanizing machines by giving them a "soul," and the result, he believes, will be a "closer kinship" between the two in which the worker comes to "love" his machine. Nor was Vertov alone in thinking this. As the art historian Christina Kiaer has shown, Vertov's fellow constructivists envisaged the replacement of capitalist commodity culture, in which objects are enslaved by their owners, with "something far more peculiar and psychologically powerful: the material object as an active, almost animate participant in social life."[30] Such socially useful objects were conceived of as "comrades" who play a role equal to that of humans in the construction of the new Communist society. Vertov extended this egalitarian, "animistic" approach to machines, and we can see this in *Man with a Movie Camera* in those scenes in which machines are given human attributes, such as when the camera walks around on the stage.

Another example occurs during the sequence of people awakening in the morning, in which we see a young woman during various stages of sleeping, washing, dressing, and preparing for the day ahead. At one point, a close-up shows her face as she towels it dry (fig. 5.15). As her eyes emerge from behind the towel to stare directly into the camera, we cut to what is presumably a point-of-view shot from her position of the blinds in her room, which are still shut. The flaps of the blinds open automatically and we cut to an extreme close-up of a camera lens adjusting its focus and moving in and out of the body of the camera (fig. 5.16). This is followed by another point-of-view shot from

Figure 5.15 Dziga Vertov, *Man with a Movie Camera*, 1929.

Figure 5.16 Dziga Vertov, *Man with a Movie Camera*, 1929.

the camera's position of a bank of flowers moving in and out of focus, thus rhyming with the movement of the lens. These two shots are repeated, and then we cut back to a shot of the blinds in the young woman's room, this time as they are slowly closing. There then follow several rapid cuts between the woman's blinking eyes and the flaps of the blinds closing and opening, cuts that produce a flicker effect, and finally the sequence ends on another close-up of the camera lens, this time with its aperture opening and closing. This sequence effectively uses intercutting and a series of graphic matches between movements and objects within shots to produce an extended analogy between camera and human eye. This analogy is predicated on the physical similarity of eye and lens as instruments that focus and admit light; and, in its evocation of the act of flexing and exercising in the early morning, it suggests a common physical activity shared by both human being and machine: preparing for a purposeful, active day ahead.

Machines are also aestheticized in order to make them attractive to humans. A typical example is that of the multiple, static shots of trams taken from street level that appear intermittently throughout the film (figs. 5.17, 5.18). In these, the trams tend to slide into and out of the frame unexpectedly, either from behind the camera or across its path. These highly geometric shots, which frame the street from its center, are usually divided in half by a street lamp that runs the length of the middle of the frame from top to bottom. Often, as a tram is moving out of the depth of the frame toward the camera, another will suddenly cross its path from left to right, momentarily obscuring it. Or, as a tram is moving from right to left across the frame, another will emerge from behind the camera and glide toward the first without slowing or stopping. In later shots of the trams, Vertov introduces superimposition and multiplies their number in the frame. With this technique, the trams now seem to glide effortlessly past and through each other, as if they have become ethereal, semitransparent, weightless objects. Through frame composition, camera placement, and superimposition, these shots foreground the beauty of the form and motion of the trams independently of the quotidian, practical purposes that they serve for human beings, presenting them to spectator-workers as not simply useful machines but as beautiful objects in their own right.

Figure 5.17 Dziga Vertov, *Man with a Movie Camera*, 1929.

Figure 5.18 Dziga Vertov, *Man with a Movie Camera*, 1929.

Finally, if we look closely at the sequences in which human beings are endowed with mechanical qualities of rhythm and movement, such as the matchbox scene, we can see that they differ considerably from their counterparts in *Ballet mécanique*. In that film, the faces and bodies of humans (Kiki, the washerwoman) are robbed of psychological depth and turned into plastic objects through rhythmical editing and repetition. But in the matchbox scene, though the woman's bodily movements are clearly endowed with the rhythm of the machines she works with, Vertov is careful to show her smiling face while she talks to someone off-screen (fig. 5.19). Her face is not, in other words, dehumanized by being robbed of its psychological depth or turned into a plastic object, and the same is largely true for the film as a whole, in which, as with the cameraman, Vertov will show the human being working *with* the machine rather than becoming one, as in *Ballet mécanique*.

Thus, even in the case of Vertov, who of all the filmmakers discussed in this book most eagerly welcomed modernization and the forces of mechanization and industrialism it unleashed, we find a complicated stance toward modernity. Eschewing the unequivocal embrace of these forces typically ascribed to avant-gardists, Vertov recognized that their acceptance by the Soviet citizens for whom he made his films would not occur if they were perceived as sweeping away the human and the organic. However much enthusiasm he might have had for the utopian vision of a new, mechanized populace and society that was prevalent in the avant-garde circles around him, and however superior to humans he believed machines such as the movie camera to be, he tempered this vision by inserting it within a humanized aesthetic and theoretical framework in which machines, the very emblem of modernity, are anthropomorphized and aestheticized to make them appealing to their human operators, much in the same way a child "primitively" attributes human capacities and characteristics to nonhuman objects. And it works, at least in *Man with a Movie Camera*. Does not the amused delight that we witness on the faces of the audience (fig. 5.20) watching the camera move around onstage perfectly manifest "the creative joy" of which Vertov speaks in his early pronouncement from "We," indicating that this audience "loves" this machine and feels a "kinship" with it?

Figure 5.19 Dziga Vertov, *Man with a Movie Camera*, 1929.

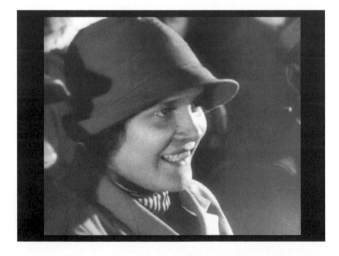

Figure 5.20 Dziga Vertov, *Man with a Movie Camera*, 1929.

Film, Distraction, and Modernity

Modernity is undoubtedly a precondition for the emergence of film.[1] Without capitalism, industrialization, technological progress, and a host of other modernizing forces, the cinema would not have been invented in the late nineteenth century and then gone on to flourish in the twentieth. These forces have continued ever since to influence and constrain filmmakers' choices about form, style, and subject matter in myriad ways, from the technologies they select to make their films to the types of stories they are inclined to tell in them. Sometimes, filmmakers consciously and deliberately address these forces in their work, as we have seen in this book. Nor does this occur only in avant-garde cinema, as film scholar Tom Gunning has shown in his fine study of the films of Fritz Lang, which he describes as "allegories" of modernity.[2] The various links between film and the changes in modern life can be—and indeed have been—profitably studied by examining specific films and filmmakers as well as the particular contexts in which they worked, and this is the approach I have adopted in this book.

Gunning and others, however, have suggested that there is another kind of connection between the cinema and modernity by drawing on the writings of Walter Benjamin and Siegfried Kracauer, and their arguments have been dubbed "the modernity thesis" by David Bordwell and Charlie Keil. Writing in the 1920s and 1930s, Benjamin and Kracauer claimed that in modernity, which Benjamin saw as beginning around 1850, a new type or "mode" of perception,

different from the modes of previous epochs, has arisen owing to the forces of change at work in modern societies. This new mode is characterized above all by *distraction*: the frequent, abrupt shifts in attention demanded of human beings by the overload of perceptual stimuli typical of modern environments such as cities. Film scholar Ben Singer, a modernity thesis proponent, puts it this way:

> The gist of the history-of-perception argument is that modernity caused some kind of fundamental change in the human perceptual apparatus, or "sensorium," as Benjamin and others called it. Immersion in the complex, rapid-fire environment of the metropolis and industrial capitalism created a distinctly modern perceptual mode. The city's bombardment of heterogeneous and ephemeral stimuli fostered an edgy, hyperactive, fragmented perceptual encounter with the world.[3]

By contrast, the prevailing mode of perception in the premodern era was one of "contemplation." Human beings were able to look at and think about something without being distracted by competing perceptual stimuli. But this is not possible, or at least is much less probable, in modernity. Art historian Jonathan Crary writes: "Perception for Benjamin was acutely temporal and kinetic; he makes clear how modernity subverts even the possibility of a contemplative beholder. There is never a pure access to a single object; vision is always multiple, adjacent to and overlapping with other objects, desires, and vectors."[4]

According to the modernity thesis, the modern, distracted mode of perception is also perpetuated by the visual art and culture of modernity, especially the cinema. Benjamin argued that the change from one shot to the next in a film distracts the viewer much as a modern environment does:

> The film corresponds to profound changes in the apperceptive apparatus—changes that are experienced on an individual scale by the man in the street in big-city traffic, on a historical scale by every present-day citizen.

> The distracting element [of film] is . . . primarily tactile, being
> based on changes of place and focus which periodically assail the
> spectator. Let us compare the screen on which a film unfolds with
> the canvas of a painting. The painting invites the spectator to con-
> templation; before it the spectator can abandon himself to his asso-
> ciations. Before the movie frame he cannot do so. No sooner has
> his eye grasped a scene than it is already changed. It cannot be
> arrested. . . . The spectator's process of association in view of these
> images is indeed interrupted by their constant, sudden change. This
> constitutes the shock effect of the film. . . .[5]

Kracauer made a similar argument, claiming that in the picture palaces of his day,
"the stimulations of the senses succeed one another with such rapidity that there
is no room left between them for even the slightest contemplation."[6]

The modernity thesis has become a major explanatory paradigm in film
studies in the last twenty years. All kinds of cinematic trends, traditions, genres,
and periods are now being explained using the claim that film is perceptually
distracting in a manner akin to a modern environment. Most famously perhaps,
Gunning has applied this argument to early cinema (1894–1905), which he calls
"the cinema of attractions":

> Attractions both mime and compete with the succession of shocks
> and distractions of modernity through an equally aggressive pur-
> chase on the spectator. . . . Attractions trace out the visual topology
> of modernity: a visual environment which is fragmented and atom-
> ized; a gaze which, rather than resting on a landscape in contem-
> plation, seems to be pushed and pulled in conflicting orientations,
> hurried and intensified, and therefore less coherent and anchored.[7]

Singer has used the modernity thesis to help explain the emergence of what
he calls "sensational" melodrama on stage and screen between 1880 and 1920.
Drawing on Benjamin's argument that the perceptually distracting modern

environment gives rise to "a new and urgent need for stimuli" among its in-habitants, he claims that this need was satisfied, in part, by forms of visual art and culture, such as sensational film melodrama of the cinema's transitional period (ca. 1905–1916), which "express[ed] in film style the tempos and shocks of modern life."[8] And film theorist Miriam Hansen has argued that classical Holly-wood cinema (1917 onward) was "the single most inclusive, cultural horizon in which the traumatic effects of modernity were reflected, rejected or disavowed, transmuted or negotiated."[9] By this, she seems to mean that, by way of its "sen-sory experience and sensational affect," the cinema can potentially make the viewer aware of modernity and its traumatic effects.[10]

The modernity thesis has received little careful scrutiny until recently. Scholars have tended to accept it on the authority of its most famous propo-nents without testing its conceptual and logical coherence, or looking to see whether there is any empirical evidence to support it. Thankfully, this situation has begun to change. Bordwell and Keil independently have argued that it has, so far at least, explained little if anything about early cinema and film style more generally.[11] Meanwhile, Bordwell and Noël Carroll have questioned the cogency of the claim that perception has changed in modernity.[12] In this chapter, I focus on another issue that has not been sufficiently addressed, namely, the analogy at the core of the modernity thesis between film and the modern environment. The perceptual experience of film, I claim, is not like the distracted perceptual experience of a modern environment, although some films in the history of the cinema do attempt to *approximate* this experience. The only way the anal-ogy between the two gets off the ground, I show, is through the use of what the philosopher Gilbert Ryle called "smothering expressions": concepts such as stimulation, sensation, and shock that are so vague that they can be applied to many different things, thereby hiding the differences between them.[13] As Carroll has pointed out, the use of analogies in itself is a "respectable form of reason-ing" that we engage in all the time, and there are some films in the history of the cinema that do attempt to imitate the distracted perceptual experience of a city.[14] But for an analogy to rise above being a critical insight about a few films and become a general characterization of the cinema, it must be examined in a

rigorous and systematic fashion to ensure that it is an accurate one. Modernity theorists have so far failed to do this with the analogy between film and the modern environment.

As already noted, Bordwell and others have challenged the modernity thesis partly on the grounds that it is highly unlikely that human vision has changed in modernity, at least if by "vision" one means the perceptual faculty, given that neurobiological changes take millions of years of natural selection and evolution to occur, not a century or two. Bordwell has suggested that a more plausible way of conceiving of vision as changing is on the level of visual skills and habits. But, as he has pointed out, even if vision could be shown to have changed in this way in modernity, skills and habits are "distributed unevenly across a population. They are intermittent, specialized, and transitory."[15] They are therefore too varied, and not possessed by enough people in a given epoch, to constitute a prevailing mode of perception, or to bring about a large-scale change in that epoch's visual art and culture.

There is, however, another way of conceiving of vision as changing, namely, that it is the *degree* of a particular kind of perceptual experience that is new to an epoch, not changes in the human perceptual faculty, skills, or habits. Singer chooses this option in his work on early film melodrama. According to him, people are perceptually stimulated in both desirable and undesirable ways by their environment to a degree they have never been prior to modernity: "Modernity multiplied and intensified both pleasant and unpleasant forms of arousal."[16] This generates in them a "psychological predisposition toward strong sensations," which is catered to by sensational forms of entertainment such as melodrama:[17]

> The basic hypothesis involves the notion of a general reconditioning or recalibration of the individual's perceptual capacities and proclivities to correspond to the greater intensity and rapidity of stimuli. Both the physiological and cognitive/behavioral changes . . . contributed to this synchronization, in which the senses shifted into

a higher gear of nervous arousal to keep pace with the geared-up world. Whatever the underlying conditioning process may have been, the key point is that the modern individual somehow internalized the tempos, shocks, and upheavals of the outside environment, and this generated a taste for hyperkinetic amusements.[18]

Though one might question whether the "taste for hyperkinetic amusements" is created by perceptually stimulating environments or is rather an innate predisposition that is exploited by such amusements, it certainly seems plausible to claim that more people in modernity experience more perceptual stimulation than ever before, owing to urbanization, capitalism, technological progress, and the rise of entertainments such as the cinema, television, and video games. As cultural commentator Virginia Postrel has argued recently, "Aesthetics is more pervasive than it used to be—not restricted to a social, economic, or artistic elite, limited to only a few settings or industries, or designed to communicate only power, influence, or wealth. Sensory appeals are everywhere, they are increasingly personalized, and they are intensifying."[19]

However, acknowledging that more people in modernity experience more perceptual stimulation than ever before, and that the cinema contributes to this increased perceptual stimulation, does not confirm the modernity thesis and its claim that the perceptual experience of film is *like* the perceptual experience of a modern environment. The fact that both modern environments and films can be perceptually stimulating is not enough, in itself, to make them alike. After all, many different things can be perceptually stimulating, can excite, arouse, or agitate the senses. An ancient ruin such as the Parthenon is perceptually stimulating, as is a tornado or a spectacular desert landscape; but none of these is like a modern environment. For film to be like a modern environment, it must be perceptually stimulating in a specific way, namely, in a distracting manner, because it is by giving rise to perceptual distraction that the cinema both "mimes and competes" (to use Gunning's words) with the overload of perceptual stimuli typical of a modern environment. This argument postulates at least two similarities between a film and the modern environment. First, a film distracts the

viewer by forcing her to switch attention repeatedly between different perceptual stimuli. Second, the frequency and abruptness of this switching, the inability to contemplate one perceptual stimulus for a long enough time, overloads the viewer and thereby shocks her.

But although a film could be said to contain different perceptual stimuli much like a modern environment does, these stimuli—a film's images and sounds—are typically presented *sequentially*. Film viewing usually consists of watching one thing—the film—change over time. By contrast, the modern environment contains multiple things that *simultaneously* compete for our attention, which is why it can distract us. Distraction by definition consists of having one's attention drawn away from one thing by another, and in order for this to happen the two things must be copresent. The various images and sounds of a film, however, are not standardly copresent because they are presented sequentially, and therefore cannot compete with each other for the viewer's attention and thereby distract her.[20] Certainly, the images and sounds of a film can be presented simultaneously. Chantal Akerman, for example, converted her fine film *D'est* (1993) into a video installation, *Bordering on Fiction* (1995), in which different parts of the film were exhibited simultaneously on multiple monitors. However, this is not how *D'est* is normally exhibited, and the same is true of films in general. This is why, when watching a film, viewers are typically looking at and paying attention to a single perceptual stimulus: what is being exhibited on the screen or monitor in front of them. They are not distracted away from this single perceptual stimulus in the way that competing perceptual stimuli in a modern environment distract its inhabitants away from a single perceptual stimulus. Films, in other words, do not usually cause their viewers to look around themselves, switching attention from one perceptual stimulus in one part of the exhibition space to another.

Given that films do not normally consist of different perceptual stimuli presented simultaneously, if filmmakers truly wanted to replicate the perceptual distraction of the modern environment, they would have to distract viewers away from the film they are watching with perceptual stimuli coming from the sides and back of the exhibition space that are unrelated to the film, a fact recognized

by Kracauer himself. In his essay "The Cult of Distraction," Kracauer argues that "The large picture houses in Berlin are palaces of distraction" because of their architecture and interior design: "The interior design of movie theaters serves one sole purpose: to rivet the viewers' attention to the peripheral. . . . The stimulations of the senses succeed one another with such rapidity that there is no room left between them for even the slightest contemplation."[21] In other words, according to Kracauer, the interior design of movie theaters distracts the viewer, making her switch attention frequently and abruptly from one feature of the design to the next. Later in the same essay, however, Kracauer acknowledges that such distraction does not actually occur because of "the programs of the large movie theaters. For even as they summon to distraction, they immediately rob distraction of its meaning by amalgamating the wide range of effects— which by their nature demand to be isolated from one another—into an 'artistic' unity. These shows strive to coerce the motley sequence of externalities into an organic whole."[22] Although Kracauer does not explain how this "organic unity" is achieved, one might hypothesize that what he is referring to is the fact that theater managers do things such as turn down the lights in order to minimize the distraction of interior décor and enable their patrons to concentrate on the film. But however such minimization is achieved, Kracauer is acknowledging that films and the exhibition spaces in which they are shown are typically designed to minimize distraction, not maximize it. Indeed, he ends his essay by complaining that distraction is a potential, but unrealized, possibility of film exhibition: film theaters "should rid their offerings of all trappings that deprive film of its rights," he demands, "and must aim radically toward a kind of distraction that exposes disintegration instead of masking it."[23]

Benjamin in effect concedes that films are not distracting in this way by arguing that it is the change from one sequentially presented shot to another that causes distraction. "The distracting element [of film] is . . . primarily tactile," he says in the same passage I quoted at length above, "being based on changes of *place and focus* which periodically assail the spectator. . . . No sooner has his eye grasped a *scene* than it is already changed" (my emphasis). But this is a major concession. For why should the change from one shot to another be thought of

as a form of distraction? Distraction by definition consists of having one's attention drawn away from one thing by another, not watching one thing change. To think that the two are alike is to confuse two types of change: the subjective change in our visual field as we switch our attention from one thing to another, and the objective change that occurs in one thing while we are watching it.

But let us assume, for the sake of argument, that distraction can occur as a result of watching one thing change. This still does not mean that film is distracting. Benjamin seems to think that it is for two reasons. First, unlike paintings, films do not allow us to contemplate their shots for an indefinite length of time. "The painting invites the spectator to contemplation," he suggests in the passage I quoted earlier. "Before it the spectator can abandon himself to his associations. Before the movie frame he cannot do so." But this argument fails to compare like with like. The cinema is a *moving* image art form, one that controls the duration of the viewer's experience of it. Paintings, however, are *still* images, and they typically cannot control how long a viewer looks at them. Change—both in the depicted content and the way that content is depicted—is therefore always a possibility in films, which is not the case in paintings, and films by definition control the rate at which this change occurs. In this respect, the cinema is not like painting, but rather like temporal art forms such as dance, theater, performance art, opera, and music, which also typically consist of material that changes and which control the rate of that change. Yet these temporal art forms are not considered distracting. A piece of music, for instance, usually consists of sounds presented sequentially, with one sound, often consisting of several notes, changing into another, but it does not follow from this that music is distracting. Just because we cannot contemplate a sound in a piece of music for as long as we want to does not mean that we are distracted away from it by the sounds that follow it. There is no reason to think, therefore, that film is distracting because we cannot contemplate a shot for as long as we want to. If this were true of film, then it must be true of all the temporal arts, most of which existed long before modernity

Benjamin also argues that the change from one shot to another is distracting because it "interrupts" the viewer's "process of association." In other words,

not only is the viewer not able to look at a shot for as long as she wants to, but her thoughts about a shot are inevitably cut short by the change to another shot. However, in advancing this argument, Benjamin equates two types of change that are different—a change in shot ("place and focus"), and a change in the subject that is depicted in the shot ("scene"). Now, if it were true that every time a shot changed, its subject changed as well, one might agree that films are distracting in this way. Just as the viewer was starting to think about the subject of one shot, the film would switch to a shot of a totally unrelated subject. But, as any film viewer knows, just because "the place and focus" of a shot changes does not mean that the subject it depicts changes. For example, a film can show a person looking at something in a room in a long shot, then cut to a close-up of the person's face followed by a close-up of what it is the person is looking at. The subject is still the same in these three shots—a person looking at something in a room—even though the place and focus of the shots has changed. Thus, although one could describe these shots as three different perceptual stimuli, these stimuli are not *unconnected*: the subject of all three is the same. The change from one shot to another in this scene does not therefore interrupt "the spectator's process of association." Indeed, it does the opposite: it enables this process to continue over the shot change by allowing the viewer to look at the subject the shots are depicting from different angles and positions and thereby see and think more about it. This is the exact opposite of a modern environment, where it is the switching of attention from one unconnected perceptual stimulus to another, and the inability to contemplate one thing before our attention is drawn away by something else, that distracts us.

There are certainly some avant-garde films in the history of the cinema in which a change of shot does entail a change of subject, and this change occurs quickly enough to prevent the viewer from fully understanding each shot and the subject it depicts. One thinks, for example, of the famous sequence in Jean-Luc Godard's *Pierrot le fou* (1965) in which short shots of Marianne and Ferdinand escaping from Paris are edited into a spatially, temporally, and causally discontinuous sequence, one that is rendered particularly difficult to understand because of its speed.[24] But even in this example, the shots are connected by the

characters in them, their voiceovers, and the act of escaping Paris as well as the music on the soundtrack. More important, the fact that such films are thought of as avant-garde shows that, normally, a change from one shot to another in a film does not constitute a change from one subject to another. Instead, shots in films are typically connected by their subject matter, by the agents in them, and by time and space. When Benjamin wrote the above words in the 1930s, most films consisted of narratives shot in the continuity style, a style designed to ensure that viewers could follow the narrative across shot changes without being distracted by these changes. Indeed, this style is often referred to as "invisible" precisely because viewers do not notice the shot change, let alone get distracted by it. And even in films not shot in the continuity style, such as Soviet montage films, the narrative can be followed fairly easily across shot changes because they are connected by characters and subject matter, if not time and space.

Early cinema, at first sight, appears to be a better candidate for distraction in the Benjaminian sense, since in the cinema's first few years of existence a typical film program consisted of a series of short, unrelated films, each of which was filmed in a single shot. Hence, a change of shot did entail a change of subject. However, it is the *frequent, abrupt* change from one unconnected perceptual stimulus to another, the inability to contemplate a single perceptual stimulus for enough time, that causes distraction in the modern environment. Early single shot films were anywhere from thirty seconds to two minutes long, and were designed to allow viewers enough time to contemplate their (often simple) subjects. Gunning sometimes writes as if the mere fact that the cinema of attractions had a "discontinuous and punctual temporality" is enough to provide a "link between the aesthetic of attractions and modernity."[25] This is hardly the case. After all, going to a gallery and viewing a series of paintings is "discontinuous and punctual" in the sense that the paintings are often unconnected to one another and a viewer will spend a period of time looking at each one, yet this does not make a gallery like a modern environment. Rather, for the cinema of attractions to be like a modern environment, it would have to force its viewers to watch films without enough time to contemplate each one, which, as I have already noted, it does not.

―――――

But even if films did routinely distract us by using quickly edited shots of unconnected subjects, this would still not make them distracting in the same way as a modern environment. Film theorist Rudolf Arnheim, writing around the same time as Benjamin, characteristically provides a much more accurate description of the perceptual experience of shot changes. "One might expect," he suggests, "the spectator to be overcome by a physical discomfort akin to seasickness when watching a film composed of different shots." "Yet," he continues, "everyone who goes to the movies knows that actually there is no sense of discomfort. . . . One looks at them as calmly as one would at a collection of picture post cards. Just as it does not disturb us in the least to find different places and different moments in time registered in such pictures, so it does not seem awkward in a film."[26] Arnheim's explanation for the ease with which viewers tolerate shot changes is that film shots, like postcards, are representations, and the film viewer both sees and knows that they are. When watching a film, we see a series of these representations, in the form of shots exhibited on a screen, just as we do when we look through a picture postcard book. This points to another fundamental difference between film and modern environments. When walking through a city and being distracted by competing perceptual stimuli, our entire visual field changes. We might look at, first, a shop window, then a billboard, then the traffic, and then an airplane flying overhead. But when we watch a film, our entire visual field does not change; it consists of a series of shots exhibited on a screen or monitor. While the depicted content of these shots and the way it is depicted change, their properties as representations—their two-dimensionality, their frame size and shape, and many of the formal and stylistic conventions governing their visual design—do not, nor does the screen, monitor or the space surrounding them; only part of our visual field changes when we watch a film. Hence, the transition from one shot to the next does not cause "discomfort" as it might if our entire perceptual field changed every time a shot changed.

What about shocks? Are films shocking in the way that modern environments sometimes are? Singer, citing social observers from the early twentieth century, suggests that they can be by using the concept of sensationalism:

As the urban environment grew more and more intense, so too did the *sensations* packaged in the form of commercial amusement. As modernity transformed the texture of random daily experience, synthetic, orchestrated experience necessarily followed suit. Commercial *sensationalism*, many critics believed, was simply the aesthetic counterpart to sensory overload in the capitalist metropolis. The commercialization of the thrill was a reflection and expression— as well as an agent—of the heightened *stimulation* of the modern environment.[27]

But there is a major conceptual slippage here from "sensation" to "sensationalism" to "stimulation" that allows Singer to equate two things—the perceptual shocks of the modern city and the sort of shocks that artworks traffic in—that are very different. If I read a book with a sensational narrative, I may be shocked, but I am not *perceptually* shocked in the way that I might be when walking around Manhattan for the first time. All I am seeing are words on a page. Similarly, when viewing a sensational film melodrama from the 1910s, I am watching characters doing shocking things, but I am not necessarily perceptually shocked. Take, for example, Louis Feuillade's serial melodramas, made from the early 1910s through to the mid-1920s. While the narratives of these films are often shocking, perceptually speaking they are the opposite. They employ long takes, mostly static long shots with modest editing, and rely largely on the graceful orchestration of mise-en-scène elements—faces, hands, bodies, blocking, setting—to draw the spectator's attention to the relevant part of the frame.[28] In other words, narrative shock is not necessarily equivalent to perceptual shock, as Singer seems to think. A sensational melodrama may have a very shocking narrative without being perceptually shocking. The same is true of early films. It may be shocking to see an elephant being electrocuted in *Electrocuting an Elephant* (1903). But this does not mean that it is perceptually shocking in the manner of a modern environment, for the electrocution is filmed in a single, largely static long shot.

The distinction I am trying to get at here is between a cognitive shock and a perceptual one. The end of Stanley Kubrick's *The Shining* (1980), for

example, reveals Jack Torrence in a photograph dating from 1921. This revela-
tion is cognitively shocking because his presence in the photograph (if it is him)
is metaphysically impossible given his role in earlier events in the narrative that
take place in the 1970s, thereby suggesting that the Overlook Hotel is indeed
haunted. However, there is nothing *perceptually* shocking about this scene. It
is filmed using a slow, forward-moving steadicam shot onto the photograph,
followed by several dissolves that more closely reveal Torrence's figure in the
photograph, accompanied by slow period music. Modernity theorists often
write as if shock alone were enough to establish a similarity between the per-
ceptual experience of film and modern environments. But it isn't, because there
are different kinds of shock, including the kinds of cognitive ones that artworks
have trafficked in at least since ancient Greek tragedy. For film to be like the
modern environment, it would have to shock the viewer in the same way as the
modern environment does, that is, perceptually.

Of course, a filmmaker *can* shock the viewer perceptually, as the Soviet
montage filmmakers did in the late 1920s, and as filmmakers continue to do
today, especially in the action and horror genres. Typical techniques for doing so
include fast editing, spatially and temporally discontinuous editing, rapid camera
movements, graphic discontinuity such as sudden alternations between light and
dark, aural discontinuity such as sudden alterations between loud and quiet, the
abrupt revelation of off-screen subjects, and so on. But, first of all, as historians
of film style have shown, these stylistic options were hardly used at all during the
first twenty years of the existence of cinema, during which Singer's melodramas
and Gunning's early films were made. And since the late 1910s, they have typi-
cally only been used in specific genres for specific effects, at least in mainstream
narrative filmmaking traditions. More important, these perceptual shocks are
not equivalent to the shocks caused by the perceptual distraction of a modern
environment. The latter shocks us by forcing us to switch attention frequently
and abruptly from one thing to another, thereby overloading us with uncon-
nected perceptual stimuli. Just as we see and try to contemplate one thing, we
are distracted away by something else. The former, however, are usually designed
to do the very opposite: to intensify our perceptual, emotional, and cognitive

involvement in the subject of a film, not distract our attention away from it. Consider an obvious example, such as the murder of Marion Crane in the shower scene in *Psycho* (1960). In this scene, Hitchcock employs almost every possible cinematic technique imaginable to perceptually shock the viewer—fast, discontinuous editing, graphic contrasts of various kinds, a musical score that alternates between sound and silence, and so on. But these perceptual shocks do not distract us from the murder of Marion Crane. Rather, they intensify the visceral impact of that murder on us.

Undoubtedly there are films whose style can be described as distracting in the sense that it draws our attention away, whether intentionally or not, from the film's subject rather than intensifying our involvement in it. The stylistic play in Yasujiro Ozu's films, which is arguably not motivated by their narratives or themes, might be an example. However, as Ozu's films illustrate perfectly, distraction and contemplation are not mutually exclusive when watching a film, as they are, according to the modernity thesis, in a modern environment. Again, there is a fundamental difference between the two. Film viewers watch one thing, a film, change over time, whereas inhabitants of modern environments have to switch attention between competing, copresent things. Hence, a film viewer can pay attention to various features of a film simultaneously, because she only has the film to look at. The observant viewer of an Ozu film, for example, is typically able to follow its narrative and notice its stylistic play, just as the viewer of the shower scene in *Psycho* can see that it depicts Marion Crane being murdered and can notice its stylistic effects. By definition, a distracted inhabitant of a modern environment cannot do this because her attention is drawn away from one thing to another. She cannot, in other words, pay attention to multiple features of one thing simultaneously because her attention is drawn away by something else.

Thus, although certain stylistic techniques can be described as perceptually shocking, and the cinema can be viewed as part of the burgeoning culture of perceptual stimulation in modernity, films are not distracting in the same way as the modern environment, as the modernity thesis claims. Films do not typically distract us, because their images and sounds are usually presented sequentially, not simultaneously. If we allow that the sequential presentation of images and

sounds can be distracting, this in itself would not give rise to distraction, as the other temporal arts demonstrate. For films to be distracting, their images and sounds would have to be unconnected and presented too quickly for the viewer to fully understand, which is not the case with the vast majority of films. And even if it were, they would still not distract us in the same way as a modern environment does because, as Arnheim pointed out, when watching a film only part of our visual field changes. Hence, it's not true that films viewers are forced to switch attention frequently and abruptly between unconnected perceptual stimuli and thereby are shocked as they are in a modern environment. Although films can shock us, they are often cognitively rather than perceptually shocking. And when they do perceptually shock us, they usually do so not in order to distract us, but to intensify our engagement in their narratives and subjects. Furthermore, when stylistic techniques do distract us from a film's subject, a film viewer can typically pay attention to the film's subject and style simultaneously because she has only one thing to look at.

I have argued that the analogy between the perceptual experience of film and the modern environment is founded on smothering expressions such as "shock" and "stimulation," which mask significant differences between the two. When one examines this analogy closely, one finds that, as a general characterization of the visual experience of cinema or one of its major periods, trends, movements, or genres, it is unconvincing. For this reason, in addition to the other problems with the modernity thesis as pointed to by Bordwell, Carroll, and Keil, I am not persuaded that film modernizes perception, or that the cinema is linked to modernity by virtue of the distracted perceptual experience it creates for viewers, and I have not relied on these claims in the preceding chapters.

This does not mean that there are no films in the history of cinema that *approximate*, or at least attempt to approximate, the distracting perceptual experience of a modern environment. There are hundreds, if not thousands, of films containing sequences that represent the distracted perceptual experience of the city-dweller through the use of rapid, discontinuous editing and fast camera movements. In Dimitri Kirsanoff's *Ménilmontant* (1926), to take one of the best

examples, two sisters move from the countryside to the city after their parents are brutally murdered, and when we first see them in their new urban environment, Kirsanoff conveys the perceptual distraction caused by the city using these techniques. However, although characters in this film are perceptually distracted by the modern environment, this does not mean the viewer is perceptually distracted by the film. This sequence is not discontinuous with the rest of the film; it does not distract us from it. Instead, it is part of a larger story about the sisters, their fall into prostitution and unwed motherhood, and their eventual reconciliation, and it serves an important narrative function: conveying their perceptual and mental state when they first arrive in the city. That characters sometimes experience perceptual distraction in films, and that this distraction is sometimes represented by rapidly edited, discontinuous shots and fast camera movements, does not mean that the viewer is perceptually distracted by the films in which these sequences occur.

It is only avant-garde filmmakers, I suggest, who have genuinely attempted to make the viewer experience the perceptual distraction of a modern environment through their films, and we have encountered two examples in this book: Fernand Léger and Dudley Murphy's *Ballet mécanique* (1924) and the first part of Francis Picabia and René Clair's *Entr'acte* (1924). In both, a change of shot does usually entail a change of subject because neither is unified by agents, or by time and space. Furthermore, their makers employ many of the techniques mentioned above to perceptually shock the viewer, such as fast, discontinuous editing and rapid camera movement. In the case of *Ballet mécanique* these formal and stylistic features are not surprising given that the perceptual distraction caused by modern environments was the major subject of Léger's painting, one that he pursued further in his filmmaking. As for the Dadaist film *Entr'acte*, it is worth noting that Benjamin may have derived his concept of distraction from Dadaist (anti-)art. Certainly he credited Dada with anticipating the distracted perceptual experience of film: "the work of art of the Dadaists became an instrument of ballistics. It hit the spectator like a bullet, It happened to him, thus acquiring a tactile quality. It promoted a demand for the film, the distracting element of which is also primarily tactile."[29] Perhaps Benjamin had in mind *Relâche* and

the first part of *Entr'acte* when writing these words. Either way, though this is an accurate characterization of some of the effects of these (anti-)art works, he was wrong to extend the concept of distraction to the cinema in general. The fact that films such as *Ballet mécanique* and *Entr'acte* exist does not confirm the modernity thesis. Indeed, it does the opposite. Both are avant-garde films that employ highly unusual formal and stylistic techniques; the attempt to perceptually distract the viewer in the way she is distracted by a modern environment is therefore very much the exception within the history of cinema, not the rule.

The aesthetic radicalism of these and the other films examined in this book should not obscure their complex stances toward bourgeois modernity. In none is modern life "either embraced with a blind and uncritical enthusiasm, or else condemned with a neo-Olympian remoteness and contempt," to repeat Marshall Berman's characterization of the attitude of twentieth-century avant-garde artists to modernization.[30] Berman might be right about the avant-garde since World War II. In the 1950s, the preeminent north American experimental filmmaker Stan Brakhage chose "isolation from mass society" by moving with his family to a nineteenth-century log cabin in the Rockies,[31] while in France Guy Debord and the Situationists waged war on modern mass culture and "the society of the spectacle" in part by way of an extremely iconophobic film practice.[32] It is important to note, however, that there is nobody equivalent to Brakhage or Debord among European avant-garde filmmakers of the 1920s, nobody, in other words, who retreats from the modern metropolis to make lyrical films about nature or who rejects commercial visual culture in toto. Even the Dadaists, who are perhaps closest in spirit to Debord and the Situationists, admired certain forms of popular and mass culture, such as the chase film, imitated by Picabia and Clair in *Entr'acte*. In general, the avant-garde of this period found much to like in modern life even while there was much else it objected to.

 In making this argument, I realize that I am challenging not only the standard story of the European avant-garde of the 1920s but also the widespread belief that its value lies in its complete rejection of bourgeois modernity and its vision of something radically new and better. But the fact that bourgeois

modernity is more pervasive today than it was when the films I have examined were made, and that viable alternatives to it are practically nonexistent, renders the true significance of these films even more profound. Their importance lies in their attempt to grapple in aesthetically innovative ways with the inescapable conflict that remains fundamental to modern societies and with which we moderns wrestle more than ever: the conflict between the desire for the enormous benefits modernization brings, such as personal (including artistic) freedom and material well-being, and disgust at some of its terrible costs, including the inequalities it seems incapable of eradicating.

NOTES

INTRODUCTION

1. Of course, the avant-garde was interested in film before the 1920s. I address this at the beginning of chapter 2.

2. See Livingston's defense of a "moderate intentionalism" in his *Art and Intention: A Philosophical Study* (Oxford: Oxford University Press, 2005). Other forms of moderate intentionalism are defended in *Intention and Interpretation*, ed. Gary Iseminger (Philadelphia, PA: Temple University Press, 1995).

3. Matei Calinescu, *Five Faces of Modernity: Modernism, Avant-Garde, Decadence, Kitsch, Postmodernism* (Durham, NC: Duke University Press, 1987), p. 95.

4. Quoted in Roger Shattuck, *The Banquet Years: The Origins of the Avant-Garde in France, 1885 to World War I* (New York: Vintage Books, 1968), p. 294.

5. Calinescu, *Five Faces of Modernity*, p. 96.

6. Boris Gasparov, "Development or Rebuilding," in *Laboratory of Dreams: The Russian Avant-Garde and Cultural Experiment*, ed. John E. Bowlt and Olga Matich (Stanford, CA: Stanford University Press, 1996), p. 133.

7. Calinescu, *Five Faces of Modernity*, pp. 41–42.

8. Ibid., p. 41.

9. Daniel Bell, *The Cultural Contradictions of Capitalism* (New York: Basic Books, 1978), p. xxi.

10. Peter Bürger, *Theory of the Avant-Garde*, trans. Michael Shaw (Minneapolis: University of Minnesota Press, 1984), p. 49.

11. See, for example, Peter Gay, *The Bourgeois Experience: Victoria to Freud*, volume I: *Education of the Senses* (Oxford: Oxford University Press, 1984), chapter 1.

12. *The Communist Manifesto of Marx and Engels* (New York: Seabury Press, 1967), p. 131.

13. Gay, *The Bourgeois Experience*, p. 36.

14. *The Communist Manifesto*, p. 136.

15. Gay, *The Bourgeois Experience*, p. 58.

16. Charles Taylor, *Sources of the Self: The Making of Modern Identity* (Cambridge, MA: Harvard University Press, 1989), p. 500.

17. *The Communist Manifesto*, p. 156.

18. Friedrich Schiller, *On the Aesthetic Education of Man*, ed., trans., and intro. Elizabeth M. Wilkinson and L. A. Willoughby (Oxford: Clarendon, 1967), p. 7.

19. T. J. Clark, *Farewell to an Idea: Episodes from a History of Modernism* (New Haven, CT: Yale University Press, 1999), p. 8.

20. Ibid., pp. 10–11. For overwhelming statistical evidence that, in the words of Stephen Moore and Julian L. Simon, "there has been more improvement in the human condition in the past 100 years than in all of the previous centuries combined since man first appeared on the earth" (p. 1), see their *It's Getting Better All the Time: 100 Greatest Trends of the Last 100 Years* (Washington, D.C.: Cato Institute, 2000).

21. Taylor, *Sources of the Self*, pp. 214–215.

22. Friedrich Nietzsche, *The Will to Power*, trans. Walter Kaufmann and R. J. Hollingdale, ed. Walter Kaufmann (New York: Random House, 1967), fragment 374, p. 202: "Every society has the tendency to reduce its opponents to caricatures. . . . Among artists, the 'philistine and

bourgeois' become caricatures." I thank professor Roy Brand for helping me to find this passage.

23. André Breton, *Manifestoes of Surrealism* (Ann Arbor: University of Michigan Press, 1972), p. 5.

24. See Kenneth E. Silver, *Esprit de corps: The Art of the Parisian Avant-garde and the First World War, 1914–1925* (Princeton, NJ: Princeton University Press, 1989); and Christopher Green, *Cubism and Its Enemies: Modern Movements and Reaction in French Art, 1916–1928* (New Haven, CT: Yale University Press, 1987).

25. Romy Golan, *Modernity and Nostalgia: Art and Politics in France between the Wars* (New Haven, CT: Yale University Press, 1995), pp. ix–x.

26. Richard Sheppard, *Modernism—Dada—Postmodernism* (Evanston, IL: Northwestern University Press, 2000), p. 24.

27. John E. Bowlt and Olga Matich, "Introduction," in *Laboratory of Dreams*, pp. 3–4. Not all revisionist scholars have adopted this view of the avant-garde, however. Boris Groys, for example, builds his controversial argument that the Soviet avant-garde of the 1920s was fundamentally continuous with socialist realism of the 1930s on the claim that socialist realism shared with the avant-garde the uncompromising commitment to social transformation that, according to the standard version, united avant-gardists and separated them from other artistic trends and movements. As Groys puts it: "Behind the external, purely formal distinction between Socialist Realism and the Russian avant-garde . . . the unity of their fundamental artistic aim—to build a new world . . . in place of 'God's world,' which the artist was able only to portray—should, therefore, be revealed" (Groys, "The Birth of Socialist Realism from the Spirit of the Russian Avant-Garde," in *Laboratory of Dreams*, p. 197). This reductive view of the avant-garde is only one of the many problems with Groys's argument.

28. Malte Hagener, *Moving Forward, Looking Back: The European Avant-Garde and the Invention of Film Culture, 1919–1939* (Amsterdam: Amsterdam University Press, 2007), p. 11.

29. Christopher Green, *Art in France, 1900–1940* (New Haven, CT: Yale University Press, 2000), p. 141.

30. Charles Baudelaire, *The Painter of Modern Life and Other Essays*, trans. and ed. Jonathan Mayne (New York: Da Capo Press, 1964), p. 13.

31. Clark, *Farewell to an Idea*, p. 8.

32. Jerrold Seigel, *Bohemian Paris: Culture, Politics, and the Boundaries of Bourgeois Life, 1830– 1930* (Baltimore, MD: Johns Hopkins University Press, 1986), p. 10.

33. Ibid., p. 391.

34. Marshall Berman, *All That Is Solid Melts into Air: The Experience of Modernity* (London: Verso, 1983), pp. 13–14.

35. Since China and India—which between them contain almost two-fifths of the world's population—began liberalizing their economies and integrating them into global markets in the 1980s and 1990s, China's per capita income has risen well over 400 percent while India's has more than doubled. This is one reason that, contrary to popular opinion, global inequality has declined over the last few decades and the percentage of people living in absolute poverty (defined as less than a 1985 dollar per day) has dropped by more than half to less than 18 percent. Nevertheless, because the standard of living in China and India was so low when they began to liberalize, the absolute gap in living standards between rich and poor countries continues to rise, making it appear that global inequality has also risen. See Martin Wolf, *Why Globalization Works* (New Haven, CT: Yale University Press, 2004), chapter 9; and Matt Ridley, *The Rational Optimist: How Prosperity Evolves* (New York: HarperCollins, 2010), chapter 1.

36. Berman, *All That Is Solid Melts into Air*, p. 35.

37. Ibid., p. 24.

38. See, for example, Kristin Thompson and David Bordwell, *Film History: An Introduction* (New York: McGraw Hill, 2003), pp. 173–182.

I ABSTRACTION AND *RHYTHM 21*

1. Standish Lawder, *The Cubist Cinema* (New York: New York University Press, 1975), p. 19.

2. Léopold Survage, "Colored Rhythm" (1914), in *French Film Theory and Criticism*, volume I: *1907–1929*, ed. Richard Abel (Princeton, NJ: Princeton University Press, 1988), p. 90.

3. William Moritz, "Abstract Film and Color Music," in *The Spiritual in Art: Abstract Painting 1890–1985*, exhibition catalog (New York: Abbeville Press, 1986), pp. 300–301.

———

4. *Rhythm 25*, which Richter reportedly hand-colored frame by frame, is, sadly, lost. Richter's next film, *Filmstudie* (1926), initiates his departure from pure abstraction.

5. John D. Erickson, *Dada: Performance, Poetry, and Art* (Boston: Twayne Publishers, 1984), p. 117.

6. Georges Ribemont-Dessaignes, "History of Dada," in *The Dada Painters and Poets: An Anthology*, ed. Robert Motherwell, 2nd ed. (Boston: G. K. Hall, 1981), p. 102.

7. Erdmute Wenzel White, *The Magic Bishop: Hugo Ball, Dada Poet* (Columbia, SC: Camden House, 1998), p. 103.

8. Ibid., p. 104.

9. Hans Richter, *Dada Art and Anti-Art* (1964), trans. David Britt (London: Thames & Hudson, 1997), pp. 49, 7. All references to *Dada Art and Anti-Art* are hereafter cited in the text in parentheses.

10. I explore the reasons why Richter might have conceived of his abstract work as a search for a universal language in my "Dada between Heaven and Hell: Abstraction and Universal Language in the *Rhythm* Films of Hans Richter," *October* 105 (summer 2003).

11. Hans Richter, "Dada and the Film," in *Dada: Monograph of a Movement*, ed. Willy Verkauf (New York: St. Martin's Press, 1975), p. 39. Although commentators have acknowledged that these films might be Dadaist—given that Richter himself was a member of Zurich Dada, that he saw his films as Dadaist, and that versions of the films were shown at the Dada "Soiree du Coeur a Barbe" in July 1923—there has been little attempt to demonstrate, at least in Anglo-American scholarship of recent years, why they might count as Dadaist. Nor has there been much of an attempt to understand them in terms of Richter's search for a universal language. Standish Lawder, in his chapter on Richter's and Viking Eggeling's abstract films in *The Cubist Cinema*, remarks in passing that it is a "paradox" that Richter turned to abstraction during his Dadaist period, without attempting to resolve this apparent paradox (p. 37). And though his formal analysis of the films is valuable, he has little to say about why Richter conceived of his abstract work in terms of a search for a universal language. Meanwhile, there is almost no mention of the films in Steven Kovacs's *From Enchantment to Rage: The Story of Surrealist Cinema* (Rutherford, NJ: Fairleigh Dickinson University Press, 1980), which includes a chapter on Dadaist film, nor in Inez Hedges's *Languages of Revolt: Dada and Surrealist Literature and Film* (Durham,

NC: Duke University Press, 1983). At the beginning of his influential anthology on Dada and surrealist film, Rudolf Kuenzli asks: "But in what ways are [Richter's abstract] films related to Dada?" without offering an answer (*Dada and Surrealist Film*, ed. Rudolf Kuenzli [Cambridge, MA: MIT Press, 1996], p. 1). Nor do any of the essays in his anthology attempt one. Thomas Elsaesser, for example, in proposing his performance-based definition of Dadaist film, also asks: "Should Hans Richter's *Rhythm 21* and *Rhythm 23* be discussed as Dada films because Richter makes a case for Dada as abstract art?," again without suggesting an answer (Thomas Elsaesser, "Dada/Cinema?" in *Dada and Surrealist Film*, p. 14). More recently, there is the analysis of the films by Justin Hoffmann in Stephen Foster's important anthology on Richter (Justin Hoffmann, "Hans Richter: Constructivist Filmmaker," in *Hans Richter: Activism, Modernism, and the Avant-Garde*, ed. Stephen Foster [Cambridge, MA: MIT Press, 1998]). But Hoffmann ignores Richter's own claims about the centrality of abstraction to Dada, arguing that "Richter's . . . efforts to develop an abstract language of forms cannot be explained by Dada," and locating these efforts instead within the context of de stijl and international constructivism (ibid., p. 74).

12. Hans Richter, *Hans Richter*, ed. Cleve Gray (New York: Holt, Rinehart, and Winston, 1971), p. 33.

13. Richter's *Rhythm* films are often considered together with Viking Eggeling's *Diagonal Symphony* (1924). However, though there are similarities between the films, there are also profound differences, as Richter himself noted. See also Louise O'Konor, *Viking Eggeling 1880–1925, Artist and Filmmaker, Life and Work*, trans. Catherine G. Sundstrom and Anne Bibby (Stockholm, Sweden: Almqvist & Wiksell, 1971).

14. Richter, "Dada and the Film," pp. 40–41.

15. It is commonly thought that Dadaists in general rejected essentialist or family resemblance definitions of the movement. However, Tzara's reported attempts to exclude Eggeling's work from his magazine *Dada* on the grounds of its visual similarity to classical art forms suggest otherwise (see Richter, "Dada and the Film," p. 40).

16. Friedrich Schiller, *On the Aesthetic Education of Man*, ed., trans., and intro. by Elizabeth M. Wilkinson and L. A. Willoughby (Oxford: Clarendon, 1967), p. 7.

17. Ibid.

18. Ibid., p. 43.

19. Ibid., pp. 33–35.

20. Ibid., pp. 37–39.

21. Ibid., p. 55.

22. Standish Lawder and Justin Hoffmann have traced the history of Richter's development of this form of abstraction from his initial experiments with black-and-white planes in his "Dada heads" to his scrolls and films, as well as the technical and aesthetic difficulties he encountered moving into the medium of film. See Lawder, *The Cubist Cinema*, pp. 35–38, and Hoffmann, "Hans Richter: Constructivist Filmmaker."

23. Richter, *Hans Richter*, p. 132.

24. Richter, "My Experience with Movement in Painting and in Film," in *The Nature and Art of Motion*, ed. Gyöegy Kepes (New York: George Braziller, 1965), p. 142.

25. Lawder, *The Cubist Cinema*, p. 51.

26. Richter, "My Experience with Movement in Painting and in Film," p. 142.

27. Piet Mondrian, "The New Plastic in Painting," in Mondrian, *The New Art—The New Life: The Collected Writings of Piet Mondrian*, ed. and trans. Harry Holtzman and Martin S. James (New York: Da Capo Press, 1993), p. 49.

28. Yve-Alain Bois, *Painting as Model* (Cambridge, MA: MIT Press, 1990), p. 103.

29. Ibid., pp. 104–105.

30. Van Doesburg quoted in Lawder, *The Cubist Cinema*, p. 48.

2 "Cinema pur" and *Ballet mécanique*

1. On these debates, see Richard Abel's essays "*Photogénie* and Company," "*Cinégraphie* and the Search for Specificity," and "The Great Debates" in *French Film Theory and Criticism*, volume I, *1907–1929*, ed. Richard Abel (Princeton, NJ: Princeton University Press, 1988), pp. 95–124, 195–223, 321–348.

2. René Clair, *Cinema Yesterday and Today*, trans. Stanley Applebaum, ed. and intro. R. C. Dale (New York: Dover, 1972), p. 100.

3. Germaine Dulac, "Aesthetics, Obstacles, Integral *Cinégraphie*" (1926), in *French Film Theory and Criticism*, pp. 395, 394.

4. Henri Chomette, "Second Stage" (1925), in *French Film Theory and Criticism*, p. 372.

5. His views were in some ways similar to those of his contemporaries Ricciotto Canudo and Elie Faure. See Richard Brender, "Functions of Film: Léger's Cinema on Paper and on Cellulose, 1913–25," *Cinema Journal* 24, no. 1 (fall 1984).

6. Léger, "A Critical Essay on the Plastic Quality of Abel Gance's Film *The Wheel*" (1922), in *Functions of Painting* (New York: Viking Press, 1973), p. 21.

7. Ibid.

8. Ibid.

9. Ibid., p. 22.

10. Ibid.

11. Ibid.

12. Ibid., p. 21.

13. There is some controversy over Léger's authorship of *Ballet mécanique*. In addition to Dudley Murphy, the photographer Man Ray and the writer Ezra Pound had a hand in its production along with Charles Delacommune, and it is likely that Murphy and Ray, who were experienced cameramen, shot most of its footage, while Léger, who had no such experience, was primarily involved in its editing. Having thoroughly examined the documentary evidence including letters from the various participants and witnesses, Judi Freeman concludes that "When the actual fusion of the images into a final film took place . . . it was Léger's evolving vision that dominated that of Pound, Man Ray, and Murphy," and most film historians concur (see Freeman, "Bridging Purism and Surrealism: The Origins and Production of Fernand Léger's *Ballet Mécanique*," in *Dada and Surrealist Film*, ed. Rudolf E. Kuenzli [Cambridge, MA: MIT Press, 1996], p. 38). An exception is William Moritz, who argues that "Léger's actual role in creating *Ballet mécanique* seems rather suspect" and that "Dudley Murphy was the primary

filmmaker" ("Americans in Paris: Man Ray and Dudley Murphy," in *Lovers of Cinema: The First American Film Avant-Garde, 1919–1945*, ed. Jan-Christopher Horak [Madison: University of Wisconsin Press, 1995], pp. 127, 129). According to Moritz, in the film's footage that "originated with Man Ray and Murphy, an ironic spirit pokes Dada fun at the seriousness of Machine Modernism, at Futurist and Purist gravity and utopianism. . . . Léger loved machines; *Ballet mécanique* does not" (ibid., pp. 128–129). But though it may be the case that the film bears traces of Murphy and Ray's influence, there is far greater continuity—in terms of style and iconography—between Léger's art and the versions of the film that survive than there is in the cases of Murphy or Ray, a continuity that supports the claim for Léger's primary authorship. For example, there is the repeated use of the close-up, the cinematic technique most prized by Léger; the depersonalization of the human face and body; the attempt to replicate the fragmented, dynamic perceptual experience of reality pointed to by Standish Lawder; the systematic effort at drawing attention to plastic similarities between mechanical and nonmechanical objects pointed to by David Bordwell and Kristin Thompson; and the film's iconography, drawn from purism. All of these were Léger's concerns, amply documented in his painting and writing prior to and around the time of the making of the film. None of these were concerns in Murphy's prior output, or in Man Ray's Dada/surrealist films of the 1920s. As for Moritz's claim that the film "pokes Dada fun at the seriousness of Machine Modernism," how, precisely, does it do this? Moritz cites Kiki de Montparnasse's face, which is "whitened like a clown's," as well as her "exaggerated expressions, intercut with machinery" which "serve to remind us that human emotions are in fact predictable muscular functions, as perfunctory as the 'work' of the pistons" (p. 129). But the idea that a human being is no different from a machine is a leitmotif of machinism, not a Dadaist strike against it. Moritz also mentions the sequences of Katherine Murphy in the garden and the headline about the pearl necklace as examples of "sarcastic wit" and "Dada irreverence" without explaining why they convey this "satirical perspective" or how they "poke Dada fun" at machines (ibid.). In fact, both scenes can be explained in part by Léger's embrace of the "call to order" and purism, as I show in this chapter. Finally, Moritz points to erotic footage that was shot by Ray and Murphy of themselves and their partners, Kiki and Katherine, and that was intercut with shots of machines in an early version of the film that no longer survives. But as Moritz himself notes (ibid.), Léger had these scenes edited out in the versions that do survive, thereby (inadvertently) confirming Léger's primary authorship of these versions.

14. Léger, "The Spectacle: Light, Color, Moving Image, Object-Spectacle" (1924), in *Functions of Painting*, p. 42.

15. Two excellent analyses of the film, to which I am indebted, already exist: Standish Lawder's in *The Cubist Cinema* (New York: New York University Press, 1975), pp. 117–67; and David Bordwell and Kristin Thompson's, which is in the eighth edition of their *Film Art* (New York: McGraw Hill, 2008), pp. 358–363. Both, however, appear to be based on the Museum of Modern Art's circulating black-and-white version of the film. My analysis is based on Frederick Kiesler's print, which his widow donated to Anthology Film Archive. Kiesler organized the premiere of *Ballet mécanique* in Vienna in September 1924, and this print is widely believed to be the one shown at that premiere and hence the most definitive version available.

16. See Lawder, *The Cubist Cinema*, p. 131.

17. The music that was originally intended to accompany the film similarly assaults the spectator's ears. While *Ballet mécanique* was being made in 1923–1924, the avant-garde composer George Antheil worked on a score for it, which he originally wrote for sixteen pianolas (mechanical, self-playing pianos) playing four different parts, as well as two grand pianos, three xylophones, four bass drums, a gong, three airplane propellers, seven electric bells, and a siren. However, the music was not ready by September 1924 when the film premiered in Vienna, and it was apparently shown silent. This was in part because the technology to synchronize sixteen pianolas did not exist and Antheil was forced to revise his score, which has typically been performed independently of the film, while the film has circulated in versions lacking synchronized music. Recently, however, given improvements in modern technology, musicians have been able to perform and record the score as originally conceived, and it has been synchronized with the Kiesler print of the film. Paul D. Lehrman, the composer responsible for its reconstruction, describes the piece as "unremittingly cacophonous and brutally rhythmic, incorporating more than 600 time-signature changes. The xylophones play in parallel major sevenths, the pianos boom out huge repeated chromatic clusters (which at times require the players to use their forearms), the siren rises and falls above the din, and the bells and airplane propellers provide 'pedal points' to keep the noise floor high. Snatches of jazzy melodies occasionally bubble up, only to be subsumed by the sheer wall of sound" (Lehrman, "Rediscovering the *Ballet mécanique*," *Electronic Musician* 16, no. 8 [August 2000], p. 24).

18. Léger, "The Origins of Painting and Its Representational Value" (1913), in *Functions of Painting*, pp. 3, 5.

19. Ibid., p. 8.

20. Lawder, *The Cubist Cinema*, p. 72.

21. Ibid., p. 166.

22. Ibid., p. 167.

23. Léger, "The Spectacle," p. 35.

24. Lawder, *The Cubist Cinema*, p. 121; Lawder extracts this remark of Léger's on p. 130, arguing that it "describes the base line *modus operandi* of the film." Lawder's interpretation of *Ballet mécanique* is still highly influential. For example, it is repeated almost verbatim in a catalog essay from 1994 by Dorothy Kosinski, "Léger, 1911–1924: A Language for the Modern World," in *Fernand Léger, 1911–1924: The Rhythm of Modern Life* (Munich: Prestel-Verlag, 1994).

25. Quoted in Christopher Green, *Léger and the Avant-Garde* (New Haven: Yale University Press, 1976), p. 244.

26. Léger, "A Critical Essay on the Plastic Quality of Abel Gance's Film *The Wheel*," p. 20.

27. Dziga Vertov, "We: Variant of a Manifesto," in Vertov, *Kino-Eye: The Writings of Dziga Vertov*, ed. and intro. Annette Michelson, trans. Kevin O'Brien (Berkeley: University of California Press, 1984), pp. 7, 9, 7.

28. Lawder, *The Cubist Cinema*, p. 150.

29. Bordwell and Thompson, *Film Art*, p. 358.

30. Léger, "Notes on Contemporary Plastic Life" (1923), in *Functions of Painting*, p. 24.

31. Léger, "Notes on the Mechanical Element" (1923), in *Functions of Painting*, p. 28.

32. Ibid., p. 29.

33. Ibid., p. 28.

34. Léger, "Notes on Contemporary Plastic Life," p. 24.

35. Léger, "The Machine Aesthetic: The Manufactured Object, the Artisan, and the Artist" (1924), in *Functions of Painting*, p. 53.

36. Ibid., p. 52.

37. Ibid., pp. 52–53.

38. Ibid., pp. 53–54.

39. See Kenneth E. Silver, *Esprit de Corps: The Art of the Parisian Avant-Garde and the First World War, 1914–1925* (Princeton, NJ: Princeton University Press, 1989); and Christopher Green, *Art in France, 1900–1940* (New Haven, CT: Yale University Press, 2000), pp. 201–205.

40. Quoted in Green, *Léger and the Avant-Garde*, p. 194.

41. Amédée Ozenfant and Charles-Edouard Jeanneret, "After Cubism," in Carol S. Eliel, *L'Esprit Nouveau: Purism in Paris, 1918–1925* (Los Angeles: Los Angeles County Museum of Art, 2001), pp. 132, 133.

42. Ibid., pp. 133, 137.

43. Ibid., p. 152.

44. Le Corbusier and Ozenfant, "Purism," in *Modern Artists on Art: Ten Unabridged Essays*, ed. Robert L. Herbert (Englewood Cliffs, NJ: Prentice-Hall, 1964), p. 61.

45. Ozenfant and Jeanneret, "After Cubism," p. 158.

46. Green, *Léger and the Avant-Garde*, p. 211.

47. Léger, "A Critical Essay on the Plastic Quality of Abel Gance's Film *The Wheel*," p. 22. My emphasis.

48. Quoted in Kosinski, "Léger, 1911–1924," p. 24.

49. Léger, "*Ballet mécanique*" (ca. 1924), in *Functions of Painting*, p. 50.

50. Quoted in Clair, *Cinema Yesterday and Today*, p. 20.

51. Ibid.

52. Léger, "*Ballet mécanique*," p. 50.

53. See Green, *Léger and the Avant-Garde*, pp. 277–285.

54. Epstein, "On Certain Characteristics of *Photogénie*" (1924), in *French Film Theory and Criticism*, vol. 1, p. 317. I examine Epstein's film theory in chapters 1 and 2 of my *Doubting Vision: Film and the Revelationist Tradition* (New York: Oxford University Press, 2008).

55. Léger, "The Spectacle," p. 46.

56. Ibid., pp. 46–47.

57. Quoted in Lawder, *The Cubist Cinema*, p. 131.

58. Ibid., pp. 130, 131.

59. Green, *Art in France*, p. 158.

60. Léger, "*Ballet mécanique*," p. 50.

3 Dada, *Entr'acte*, and *Paris qui dort*

1. Hugo Ball, *Flight Out of Time: A Dada Diary by Hugo Ball*, ed. and intro. John Elderfield, trans. Ann Raimes (New York: Viking, 1974), p. 63.

2. Ibid., pp. 223–224.

3. Ibid., p. 225.

4. Tristan Tzara, "An Introduction to Dada," in *The Dada Painters and Poets: An Anthology*, 2nd ed., ed. Robert Motherwell (Boston: G. K. Hall, 1981), p. 403.

5. Ibid.

6. Ibid.

7. Tzara, "Seven Dada Manifestoes," in *The Dada Painters and Poets*, p. 81.

8. Ibid., pp. 77, 92.

9. Mark A. Pegrum, *Challenging Modernity: Dada between Modern and Postmodern* (New York: Bergham Books, 2000), p. 62.

10. The scenario has been translated as "Scenario for *Entr'acte*," in Francis Picabia, *I Am a Beautiful Monster: Poetry, Prose, and Provocation*, trans. Marc Lowenthal (Cambridge, MA: MIT Press, 2007), pp. 314–315.

11. On Satie's score, see Martin Marks, "The Well-Furnished Film: Satie's Score for *Entr'acte*," *Canadian University Music Review*, no. 4 (1983).

12. Picabia, "Dadaism, Instantanism," in *I Am a Beautiful Monster*, p. 313.

13. Picabia, "Dada Cannibal Manifesto," in *I Am a Beautiful Monster*, p. 204.

14. Noël Carroll, "*Entr'acte*, Paris, and Dada," in Carroll, *Interpreting the Moving Image* (Cambridge: Cambridge University Press, 1998), p. 27.

15. My analysis is based on the version of the film restored by the Cinémathèque Française and Pathé. For other versions, see Ted Perry, "*Entr'acte* as Real Illusion," in *Masterpieces of Modernist Cinema*, ed. Ted Perry (Bloomington: Indiana University Press, 2006), pp. 61–64.

16. For an account of the ballet, see William Camfield, "Dada Experiment: Francis Picabia and the Creation of *Relâche*," in *Paris Modern: The Swedish Ballet, 1920–25*, exhibition catalog (San Francisco: Fine Arts Museum of San Francisco, 1995).

17. Siegfried Kracauer, *Theory of Film: The Redemption of Physical Reality* (Princeton, NJ: Princeton University Press, 1960), p. 182.

18. Carroll, "*Entr'acte*, Paris, and Dada," p. 29.

19. Gilles Deleuze, *Cinema 2: The Time Image*, trans. Hugh Tomlinson and Robert Galeta (Minneapolis: University of Minnesota Press, 1989), p. 57.

20. Though it is impossible to do an accurate shot count because superimposition renders the cuts between shots indeterminate in many cases, by my rough calculation there are about 100 shots in 5 minutes and 15 seconds.

21. Walter Benjamin, "The Work of Art in the Age of Mechanical Reproduction," in *Illuminations*, ed. Hannah Arendt (New York: Schocken, 1968), p. 238.

22. Carroll, "*Entr'acte*, Paris, and Dada," p. 31.

23. Ibid., p. 32.

24. Georges Ribemont-Dessaignes, "History of Dada," in *The Dada Painters and Poets*, p. 102.

25. Tzara, "Introduction to Dada," pp. 402–403.

26. André Breton, "Two Dada Manifestoes," in *The Dada Painters and Poets*, p. 203.

27. Charles Taylor, *Sources of the Self: The Making of Modern Identity* (Cambridge, MA: Harvard University Press, 1989), p. 462.

28. Marshall Berman, *All That Is Solid Melts into Air: The Experience of Modernity* (London: Verso, 1983), p. 23.

29. Renato Poggioli, *The Theory of the Avant-Garde*, trans. Gerald Fitzgerald (Cambridge, MA: Harvard University Press, 1968), p. 106.

30. Picabia, "Interview on *Entr'acte*," in *I Am a Beautiful Monster*, p. 317.

31. René Clair, *Cinema Yesterday and Today*, trans. Stanley Applebaum, ed. and intro. R. C. Dale (New York: Dover, 1972), p. 15.

32. Ibid., p. 35.

33. Steven Kovacs, *From Enchantment to Rage: The Story of Surrealist Cinema* (Rutherford, NJ: Fairleigh Dickinson University Press, 1980), p. 94.

34. Paul Sandro argues that Clair is parodying "continuity editing" in the chase sequence by frequently reversing the screen direction of the hearse and "cutting a number of unlikely objects into the chase" such as the plane and cyclists; in general, he claims, *Entr'acte* parodies both "classical narrative cinema" and "the esthetic practices of 'pure cinema'" (Sandro, "Parodic Narration in *Entr'acte*," *Film Criticism* 4, no. 1 [1979], pp. 52, 53). Perry also sees the film as a parody, the purpose of which is to "critique the then-current cinema practices by re-creating" the prenarrative cinema of attractions from film's first decade (Perry, *Entr'acte*, p. 77).

35. Richard Abel, *French Cinema: The First Wave, 1915–1929* (Princeton, NJ: Princeton University Press, 1984), p. 382.

36. Clair, *Cinema Yesterday and Today*, p. 54.

37. Ibid., p. 100.

38. Ibid., p. 55.

39. Picabia, "Interview on *Entr'acte*," p. 317.

40. Picabia, "Instantanism," p. 318.

41. R. C. Dale argues that the chase sequence is "a genuine masterpiece of rhythmic film cutting" and that *Entr'acte* is constructed on the principle of "motion vs. stasis." See his "René Clair's *Entr'acte*, or Motion Victorious," *Wide Angle*. 2, no. 2 (1977), pp. 41, 43.

42. Clair, *Cinema Yesterday and Today*, p. 24.

43. Annette Michelson, "Dr. Crase and Mr. Clair," *October* 11 (winter 1979), p. 33 (my emphasis).

44. Ibid., p. 44.

4 Surrealism and *Un chien Andalou*

1. Walter Benjamin, "N [Re the Theory of Knowledge, Theory of Progress]," in *Benjamin: Philosophy, History, Aesthetics*, ed. Gary Smith (Chicago: University of Chicago Press, 1983), p. 46.

2. Benjamin, "Surrealism: The Last Snapshot of the European Intelligentsia," in Benjamin, *Reflections: Essays, Aphorisms, Autobiographical Writings*, ed. and intro. Peter Demetz, trans. Edmund Jephcott (New York: Schocken Books, 1968), p. 181.

3. Benjamin, "Paris, Capital of the Nineteenth Century," in *Reflections*, p. 161.

4. Hal Foster, *Compulsive Beauty* (Cambridge, MA: MIT Press, 1993), p. 162.

5. Ibid., p. 127.

6. Ibid., p. 148.

7. Ibid., p. 136.

8. See Fèlix Fanés, *Salvador Dalí: The Construction of the Image, 1925–1930* (New Haven: Yale University Press, 2007), pp. 115–116.

9. Breton, "Manifesto of Surrealism," in *Manifestoes of Surrealism*, trans. Richard Seaver and Helen R. Lane (Ann Arbor: University of Michigan Press, 1969), p. 26.

10. Fanés, *Salvador Dalí*, p. 36.

11. "Anti-Artistic Manifesto (Yellow Manifesto)," in Salvador Dalí, *Oui: The Paranoid-Critical Revolution, Writings 1927–1933*, ed. Robert Descharnes, trans. Yvonne Shafir (Boston: Exact Change, 1998), p. 50.

12. Ibid., pp. 47, 48.

13. Quoted in Fanés, *Salvador Dalí*, p. 90.

14. See Fanés, "Film as Metaphor," in *Dalí & Film*, exhibition catalog, ed. Matthew Gale (New York: Museum of Modern Art, 2007), pp. 33–40.

15. Dalí, "My Paintings in the Autumn Salon," in *Oui*, p. 15.

16. Ibid., p. 16.

17. Ibid.

18. Dalí, "The Liberation of the Fingers," in *Oui*, p. 82.

19. Dalí, "Photography: Pure Creation of the Mind," in *Oui*, p. 12.

20. Dalí, "Poetry of Standardized Utility," in *Oui*, p. 43.

21. Dalí, "Art Films, Anti-Artistic Spool," in *Oui*, p. 24.

22. Ibid., p. 25.

23. Dalí, "Documentary—Paris 1929—I," in *Oui*, p. 93.

24. Breton, "Manifesto of Surrealism," pp. 28, 27.

25. Ibid., p. 26.

26. Ibid., p. 12.

27. Ibid., p. 20.

28. Ibid., pp. 36, 37.

29. Dalí, "An Andalusian Dog," in *Oui*, p. 109.

30. Breton, *Mad Love (L'amour fou)*, trans. Mary Ann Caws (Lincoln: University of Nebraska Press, 1987), p. 23.

31. Ibid., p. 22.

32. Maurice Nadeau, *The History of Surrealism*, trans. Richard Howard, intro. Roger Shattuck (New York: Macmillan, 1965), p. 21.

33. Breton, *Nadja*, trans. Richard Howard (New York: Grove Press, 1960), p. 19.

34. Dalí, "Reality and Surreality," in *Oui*, p. 61.

35. See Dalí, "The Liberation of the Fingers."

36. "Luis Buñuel," in *Oui*, p. 89.

37. Dalí, "An Andalusian Dog," p. 108.

38. Ibid.

39. Ibid.

40. "Luis Buñuel," p. 87.

41. Luis Buñuel, "*Metropolis*," in Buñuel, *Unspeakable Betrayal: Selected Writings of Luis Buñuel*, trans. Garrett White (Berkeley: University of California Press, 2000), pp. 99, 100.

42. Buñuel, "Buster Keaton's *College*," in *Unspeakable Betrayal.*, pp. 110–111.

43. Haim Finkelstein, *Salvador Dalí's Art and Writing, 1927–1942: The Metamorphosis of Narcissus* (Cambridge: Cambridge University Press, 1996), pp. 82–85.

44. Buñuel, "Carl Dreyer's *The Passion of Joan of Arc*," in *Unspeakable Betrayal*, p. 121.

45. Quoted in Francisco Aranda, *Luis Buñuel: A Critical Biography*, trans. and ed. David Robinson (New York: Da Capo Press, 1976), p. 58.

46. Buñuel, "A Night at the Studio des Ursulines," in *Unspeakable Betrayal*, p. 98.

47. Luis Buñuel, "Notes on the Making of *Un chien Andalou*," in *Art in Cinema: Documents Toward a History of the Film Society*, ed. and intro. Scott MacDonald (Philadelphia, PA: Temple University Press, 2006), p. 101.

48. Ibid., p. 102.

49. Dalí, "Poetry of Standardized Utility," p. 44.

50. Buñuel, "*Metropolis*," p. 99.

51. J. H. Matthews, *Surrealism and Film* (Ann Arbor: University of Michigan Press, 1971), p. 86.

52. Buñuel, "*Un chien Andalou*," in *Unspeakable Betrayal*, p. 166.

53. Linda Williams, *Figures of Desire: A Theory and Analysis of Surrealist Film* (Berkeley: University of California Press, 1981), p. 28.

54. Finkelstein, *Salvador Dalí's Art and Writing*, p. 86.

55. David Bordwell, "The Art Cinema as a Mode of Film Practice," in *Film Theory and Criticism: Introductory Readings*, 6th ed., ed. Leo Braudy and Marshall Cohen (New York: Oxford University Press, 2004), p. 776.

56. Murray Smith, *Engaging Characters: Fiction, Emotion, and the Cinema* (Oxford: Clarendon Press, 1995), p. 21.

57. Ibid.

58. Phillip Drummond, "Textual Space in 'Un chien Andalou,'" *Screen* 18, no. 3 (1977), pp. 55–119.

59. Williams, *Figures of Desire*, p. 83.

60. Drummond, "Textual Space in 'Un chien Andalou,'" p. 106.

61. Breton, "Manifesto of Surrealism," p. 14 (my emphasis).

5 CITY SYMPHONY AND *MAN WITH A MOVIE CAMERA*

1. For analysis and criticisms of Vertov's film theory, see chapters 1 and 2 of my *Doubting Vision: Film and the Revelationist Tradition* (New York: Oxford University Press, 2008).

2. Dziga Vertov, "On the Significance of Newsreel," in Vertov, *Kino-Eye: The Writings of Dziga Vertov*, ed. and intro. Annette Michelson, trans. Kevin O'Brien (Berkeley: University of California Press, 1984), p. 32.

3. Vertov, "We: Variant of a Manifesto," in *Kino-Eye*, pp. 7–8.

4. See Anson Rabinbach, *The Human Motor: Energy, Fatigue, and the Origins of Modernity* (Berkeley: University of California Press, 1990).

5. Ibid., p. 272.

6. See Zenovia A. Sochor, "Soviet Taylorism Revisited," *Soviet Studies* 33, no. 2 (April 1981); Mark R. Beissinger, *Scientific Management, Socialist Discipline, and Soviet Power* (Cambridge, MA: Harvard University Press, 1988).

7. See Richard Stites, "Man the Machine," chapter 7 of Stites, *Revolutionary Dreams: Utopian Vision and Experimental Life in the Russian Revolution* (Oxford: Oxford University Press, 1989).

8. See Kendall E. Bailes, "Alexei Gastev and the Soviet Controversy over Taylorism, 1918–24," *Soviet Studies* 29, no. 3 (July 1977).

9. Vertov, "We," p. 8.

10. Vertov, "Kinoks: A Revolution," in Vertov, *Kino-Eye*, p. 17.

11. Gilberto Perez, *The Material Ghost: Films and Their Medium* (Baltimore: Johns Hopkins University Press, 1998), p. 159.

12. I explore the differences between organisms and machines, as well as the possible sources of the influence of organicism on Vertov, in "Vertov: Between the Organism and the Machine," *October* 121 (summer 2007).

13. Annette Michelson, introduction to *Kino-Eye*, pp. xxxvii; xl.

14. Ibid, p. xxxvii.

15. Noël Carroll, "Causation, the Ampliation of Movement and Avant-Garde Film," in Carroll, *Theorizing the Moving Image* (Cambridge: Cambridge University Press, 1996), p. 176. Because machines lack goals and purposes, I disagree with Carroll's conclusion that "If the new Russia was to be a machine for Vertov, we can also say, without contradiction, that it was to be an organic machine" (ibid.).

16. Vlada Petrić, *Constructivism in Film* (Cambridge: Cambridge University Press, 1987), p. 95. Another technique used to link people and activities in the film is what Noël Carroll calls

"cinematic ampliation," which, in its "weak" form, occurs when "the screen directions and comparative velocities from one shot to the next are such that their movements seem to blend or fuse into each other"; and in its "strong" form consists of the movement of something in one shot appearing to cause the movement of something in another shot even though, according to the laws of physics, the two things cannot be interacting causally (Carroll, "Causation, the Ampliation of Movement, and Avant-Garde Film," pp. 171, 174).

17. Vertov, "*The Man with a Movie Camera*," in *Kino-Eye*, p. 84.

18. Michelson, introduction to *Kino-Eye*, p. xl.

19. Ludwig Wittgenstein, *Philosophical Investigations*, ed. G. E. M. Anscombe and R. Rhees, trans. G. E. M. Anscombe, 2nd ed. (Oxford: Blackwell, 1958), §281.

20. Vertov, "Kinoks," p. 17.

21. Walter Benjamin, "On the Mimetic Faculty," in *Reflections*, ed. and intro. Peter Demetz, trans. Edmund Jephcott (New York: Schocken Books, 1968), pp. 333, 334.

22. Vertov, "Kinoks," p. 19.

23. Ibid., p. 15.

24. Ibid., pp. 14–16.

25. Annette Michelson, "From Magician to Epistemologist: Vertov's *The Man with a Movie Camera*," in *The Essential Cinema*, ed. P. Adams Sitney (New York: New York University Press, 1975), p. 98.

26. Ibid., p. 111.

27. Michael Taussig, *Mimesis and Alterity: A Particular History of the Senses* (New York: Routledge, 1993), p. 20.

28. Quoted in Bailes, "Alexei Gastev and the Soviet Controversy over Taylorism," p. 378.

29. Vertov, "We," p. 8 (my emphasis).

30. Christina Kiaer, *Imagine No Possessions: The Socialist Objects of Russian Constructivism* (Cambridge, MA: MIT Press, 2005), p. 1.

6 FILM, DISTRACTION, AND MODERNITY

1. This chapter expands upon criticisms I make of the modernity thesis in my *Doubting Vision: Film and the Revelationist Tradition* (New York: Oxford University Press, 2008), pp. 89–93.

2. Tom Gunning, *The Films of Fritz Lang: Allegories of Vision and Modernity* (London: BFI, 2000).

3. Ben Singer, *Melodrama and Modernity: Early Sensational Cinema and Its Contexts* (New York: Columbia University Press, 2001), p. 104.

4. Jonathan Crary, *Techniques of the Observer: On Vision and Modernity in the Nineteenth Century* (Cambridge, MA: MIT Press, 1990), pp. 19–20.

5. Walter Benjamin, "The Work of Art in the Age of Mechanical Reproduction," in *Illuminations*, ed. Hannah Arendt (New York: Schocken, 1968), pp. 250n19, 238.

6. Siegfried Kracauer, "Cult of Distraction," in *The Mass Ornament: Weimar Essays*, ed. and trans. Thomas Y. Levin (Cambridge, MA: Harvard University Press, 1995), p. 326.

7. Tom Gunning, "The Whole Town's Gawking: Early Cinema and the Visual Experience of Modernity," *Yale Journal of Criticism* 7, no. 2 (1994), pp. 193–194.

8. Singer, *Melodrama and Modernity*, p. 103. Here, Singer is summarizing a central component of the modernity thesis, which he refers to as "the causal supposition" and which he endorses (p. 105: "I am inclined to agree with Bordwell that there is no getting around the causal supposition").

9. Miriam Hansen, "The Mass Production of the Senses: Classical Cinema as Vernacular Modernism," in *Reinventing Film Studies*, ed. Christine Gledhill and Linda Williams (London: Arnold, 2000), pp. 341–342.

10. Ibid., p. 343.

11. David Bordwell, *On the History of Film Style* (Cambridge, MA: Harvard University Press, 1997), pp. 143–146; Charlie Keil, "'To Here from Modernity': Style, Historiography, and Transitional Cinema," in *American Cinema's Transitional Era: Audiences, Institutions, Practices*, ed. Charlie Keil and Shelly Stamp (Berkeley: University of California Press, 2004). Keil's article is, in part, a response to Gunning's and Singer's defense of the modernity thesis against his and Bordwell's criticisms of it. See Gunning, "Early American Film," in *The Oxford Guide*

to *Film Studies* (Oxford: Oxford University Press, 1998), pp. 266–268; and Singer, *Melodrama and Modernity*, chapter 4. Bordwell also responds to Gunning and Singer in his *Figures Traced in Light: On Cinematic Staging* (Berkeley: University of California Press, 2005), pp. 244–249

12. Bordwell, *On the History of Film Style*, pp. 141–143; Noël Carroll, *A Philosophy of Mass Art* (Oxford: Oxford University Press, 1998), pp. 114–144; Carroll, "Modernity and the Plasticity of Perception," *Journal of Aesthetics and Art Criticism* 59, no. 1 (winter 2001).

13. Gilbert Ryle, *Dilemmas* (Cambridge: Cambridge University Press, 1954).

14. Noël Carroll, *Mystifying Movies: Fads and Fallacies in Contemporary Film Theory* (New York: Columbia University Press, 1988), p. 15.

15. Bordwell, *On the History of Film Style*, p. 143.

16. Singer, *Melodrama and Modernity*, p. 115.

17. Ibid., p. 103.

18. Ibid., p. 119.

19. Virginia Postrel, *The Substance of Style: How the Rise of Aesthetic Value Is Remaking Commerce, Culture, and Consciousness* (New York: HarperCollins, 2003), p. 5.

20. Of course, sounds and images are typically presented simultaneously in films. But this does not mean the sound necessarily distracts the viewer from the image, or vice versa. For we are not necessarily distracted from the sight of a bird singing by its song (or vice versa).

21. Kracauer, "The Cult of Distraction," pp. 323, 325–326.

22. Ibid., p. 327.

23. Ibid., p. 328.

24. This sequence is carefully analyzed by David Bordwell in his *Narration in the Fiction Film* (London: Routledge, 1986), pp. 318–320. Bordwell argues that "Much of Godard's film practice leads to perceptual and cognitive overload" (p. 312).

25. Gunning, "The Whole Town's Gawking," pp. 193–194.

26. Rudolf Arnheim, *Film as Art* (Berkeley: University of California Press, 1957), pp. 27–28.

27. Singer, *Melodrama and Modernity*, p. 97 (my emphasis).

28. See David Bordwell, "*La nouvelle mission de Feuillade*; or, What Was *Mise en scene*," *Velvet Light Trap* 37 (spring 1996).

29. Benjamin, "The Work of Art in the Age of Mechanical Reproduction," p. 238.

30. Marshall Berman, *All That Is Solid Melts into Air: The Experience of Modernity* (London: Verso, 1983), p. 24.

31. David E. James, *Allegories of Cinema: American Film in the Sixties* (Princeton, NJ: Princeton University Press, 1989), p. 35.

32. See Thomas Y. Levin, "Dismantling the Spectacle: The Cinema of Guy Debord," in *Guy Debord and the Situationist International: Texts and Documents*, ed. Tom McDonough (Cambridge, MA: MIT Press, 2002).

INDEX